The Artist &

the Emotional World

•

Psychoanalysis and Culture

Arnold M. Cooper and Steven Marcus, Editors

JOHN E. GEDO

•

The Artist &
the Emotional World

Creativity and Personality

•

Columbia

University Press

New York

Columbia University Press
New York Chichester, West Sussex
Copyright © 1996 Columbia University Press
All rights reserved
Library of Congress Cataloging-in-Publication Data

Gedo, John E.

 The artist and the emotional world : creativity and personality /
John E. Gedo
 p. cm. — (Psychoanalysis and culture)
 Includes bibliographical references and index.
 ISBN 0–231–07852–8 —ISBN 0-231-07853 (pbk.)
 1. Personality and creative ability. 2. Creation (Literary,
artistic, etc.)—Psychological aspects. 3. Artists—Psychology.
4. Psychoanalysis. I. Title. II. Series.
BF698.9.C7G42 1996
153.3'5—dc20 95-26644
 CIP

∞

The gods don't make us terrible or great
with ease: fame comes to those who work for it.
 —Theognis, *Elegies,* 2:463–64

CONTENTS

●

privileged to work with an unusual group of creative people. More than twenty analysands are described at greater or lesser length in this volume; each of these histories, however brief, represents several hundred hours of observation. About half as many persons seen in briefer psychotherapy or met in other than therapeutic settings have also been included. These observations involved creative endeavors in a wide variety of fields from mathematics, the humanities and social sciences, law, psychological medicine, business, engineering, and religion, to literature, music, the performing arts, art, and architecture. Several patients engaged in creative activities in more than one field. I have worked therapeutically with individuals in still other creative occupations whose histories I have not used in this book explicitly, although they did have a role in formulating my hypotheses.

Although some of the individuals I describe have had very distinguished careers, it is entirely possible that, as a group, my patients cannot be regarded as members of the same sample as historical figures whose creativity has been universally recognized. Consequently, I have studied some biographies of a series of outstanding creative persons and have found that the hypotheses I developed on the basis of my clinical experience seem to be equally applicable to them. Throughout this book I deal with the lives of more than fifty historical figures of this kind. I have had to use biographies that supply reasonably adequate data about the personality and childhood background of their subjects; moreover, to make it possible to correlate personality and creative activities, I have had to focus on fields of endeavor in which the works produced are accessible both to me and to my potential readers. Hence my historical sample is somewhat skewed in the direction of literature and the visual arts (and away from public affairs and scientific research). No doubt this bias also reflects my personal preferences in selecting biographies to read. At any rate, there is a great advantage in featuring as many practitioners of the visual arts as possible, for by illustrating some of their creations I can make many of my points more concisely than it would be possible in the case of works in other media. Moreover, the imperfections of my sampling may not matter much, because I do not claim that my hypotheses are validated by the cases I cite: the crucial scientific question at issue in scientific progress is whether hypotheses will be *invalidated* by further study.

In addition to the foregoing disclaimer, it is worth noting here that this is *not* a book about the origins, methods, or effective strategies of creative work. I shall offer no explanation of creativity in

This book is an attempt to articulate the role of personality in creative pursuits. The term *personality* is part of the technical vocabulary of psychoanalysis; it is probably preferable to its near-synonym, *character*, because no moral connotations are attached to it. To make it doubly clear that the term refers to the enduring predispositions that channel behavior in certain predictable directions, psychoanalysts often refer to *personality structure*. This metaphor conveys the implication that the term means more than a description of what is overtly apparent. Personality should not be confused with attractive manners or an interesting social facade, rather, it refers to enduring qualities one may infer from observing the individual's behavior for a considerable period, matters such as lasting preferences either for interdependence or for autonomous activity, to give only one example.

To my knowledge, this concept has never before been applied in a systematic way in the study of creativity. Because this monograph is the first exploration of this field, it cannot pretend to validate the numerous hypotheses—some original, others previously proposed in the psychoanalytic literature—that it will discuss. Instead, those I believe to merit further study will be illustrated by means of one or more life histories. Many of these biographies have been obtained in the course of four decades of psychoanalytic practice—I have been

general—nor even partial theses focused on that vast topic. Instead, I shall confine the discussion to the interrelationship of creativity and personality—the only part of this scholarly domain about which a psychoanalyst can claim professional expertise. Albeit many of the points highlighted in this book may strike some readers as matters of common sense—or even as truisms!—the synthesis of these notions with a variety of psychoanalytic conclusions does ultimately yield a new model of the creative person's inner world.

This model has to deal, on the one hand, with those aspects of personality that are invariable prerequisites for all creativity and, on the other, with characteristics that are present in fewer individuals and make possible some particular achievement of an unusual kind. The first three sections of this book deal with issues common for all creative endeavors. In part 1, I define creativity, review the psychoanalytic literature on the subject, and present an overview of the personality traits required for creativity. Part 2 deals with the crucial developmental experiences that determine whether a given personality is suitable for creative endeavors: the childhood transactions that turn constitutional potentialities into specific talents for creativity in particular domains, the manner in which the possession of talents may skew the later development of personality, and the influence of the opportunities provided by the potential creator's human surround on the commitment requisite for successful endeavor in a specific field.

In part 3 I discuss the principal psychological issues talented persons must struggle with in order to be creative—matters such as the emotional price to be paid in various family and social settings for commitment to the creative life, the effects of creative activities on overall adaptation, the manner in which psychopathology may interfere with creative efforts, the emotional consequences of creative paralysis or exhaustion, and the question of creativity and psychosis.

In part 4 I shall attempt to give several examples of the special attributes generally required of persons in order to be able to meet a particular creative challenge—either in terms of a specific activity, such as live performance, or in some unique historical circumstance, like the development of a novel artistic style. This section concludes with a case study of the manner in which Paul Cézanne effected a proper fit between his talents and the challenge faced by his discipline as he reached maturity.

The next section begins with an illustrative case, that of Eugène Delacroix, in which most of the issues related to personality previ-

ously discussed had an important bearing on a great artistic career. Finally, a concluding chapter will outline once again the main points of the model I have constructed of the personality issues relevant for creativity and will articulate a program for future research on the role of personality in the creative life.

Throughout the book (with the unavoidable exception of my review of past contributions), I have kept the use of the construct language of psychoanalysis to a minimum, in order to make my text as accessible as possible to an interdisciplinary readership. In the notes I have supplied the essential psychoanalytic references on the subject of creativity; I have not tried to be comprehensive in my review of the literature but have confined myself to items of current interest. As for the dozens of historical figures mentioned in the book, I give no citations for data available in any adequate encyclopedia. Wherever further details are supplied, I have at a minimum listed one or more standard biographies of that subject. Nowhere do I attempt to document the entire scholarly literature on the work of the person in question, although in most instances the references I do provide offer more extensive bibliographies for those interested in further reading. I must underscore my assumption that, for the study of the role of personality in creativity, it is the biographical facts and not the interpretation of the work itself that are of greatest relevance.

And that brings me to the great sticking point of interdisciplinary dialogue: historians of culture are much more interested in created products than in the people who conceive them; psychoanalysts are interested in personal motivation, almost to the exclusion of everything else. Dialogues across these disciplinary boundaries often amount to nothing more than arguments over whose agenda should be adopted. Creativity research is a relatively new field of endeavor, thus far mercifully free of such rigidity. On this neutral ground we can all agree that W. B. Yeats's rhetorical question, "How do you separate the dancer from the dance?" need not be answered.

<div align="right">

Chicago
July 1995

</div>

ILLUSTRATIONS

•

The Artist &

the Emotional World

PART ONE

•

The Psychology of Creativity

•

Creativity and Its
Psychoanalytic Conceptualizations

What Do We Mean by "Creativity"?

We tend to think about creativity in two ways that might also be seen as mutually exclusive. On the one hand, we are intuitively certain that the spark of creativity is present in us all; at the same time, society often idealizes "creative genius" as the rarest of the gifts of the gods. This inconsistency in our opinions is not entirely lacking in justification. On the one hand, finding novel solutions to active problems in living is, indeed, an everyday necessity for everyone and certainly deserves to be called creative. On the other hand, the achievements of the greatest thinkers, artists, and scientists are truly out of the reach of the vast majority of humankind. Even most people who are active within these "creative domains" have only modest achievements to their credit. Perhaps the apparent paradox can be resolved by calling the capacities to find new solutions for ordinary problems, which are to some degree possessed by most human beings, "the creativity of everyday life."[1]

Traditionally, the areas of endeavor in which outstanding accomplishments have been held in high esteem are art, science, philosophy/religion, humanistic scholarship, and statesmanship (as distinguished from holding office). These are the domains in which respected contributions are universally considered "creative." In our age of popular culture, however, the number of domains in which

achievement is believed to depend on creative genius has been expanded to embrace mass entertainment, sports, entrepreneurship, and other activities bordering on the creativity of everyday life. The pathological end of the creative spectrum is occupied by the activities of impostors—a difficult field, requiring originality of a high order, but one in which public recognition is entirely contingent on ultimate failure!

The issue of imposture is of major significance for the understanding of creativity because of the frequency with which persons destined for major creative achievements but temporarily deprived of positive feedback experience a period of imposture before they hit their stride in their ultimate discipline. It seems that some foreknowledge of potential greatness is, for many ambitious youngsters, a spur to gain affirmative responses without delay. In this sense, successful imposture is truly a work of art—performance art, if you will, or the staging of a "happening."

Another way to think about this is that imposture is creative activity in the realm of establishing one's identity. Perhaps self-creation is, for every human being, a necessary creative act that must precede other creative efforts.

One of the most dramatic exemplars of a beginning for a creative career through imposture is the life of the eminent Armenian-American painter "Arshile Gorky," who was actually Vosdanik Adoian. After a childhood filled with tragic vicissitudes, this exotic youth appeared in New York at the age of twenty, using the Gorky pseudonym. He claimed to be a cousin of the Russian novelist Maxim Gorky and to have studied in Moscow with the pioneer abstractionist Wassily Kandinsky. The impossibility of this claim was evident to the émigré Russian community, because "Gorky" was not the novelist's family name either, but a nom de plume. The tale was naively accepted at face value in the art world for over twenty years. Those in the know also understood how appropriate the fiction invented by the future artist actually was. The painter was "related" to the novelist by sharing an attitude toward life: in Russian, *gorky* means bitter. It is no coincidence, by the way, that for some years the artist's closest friend was the pseudonymous painter John D. Graham (Ivan Dombrowski), a man of uncertain Slavic origins whose impostures were even more picaresque than his own.[2]

To return to the creativity of everyday life, in these activities general acknowledgment is not to be expected at all. For example, however successful efforts to improve one's appearance may turn out to be, their end result is likely to be noted without bringing one credit

for their success—in fact, trying too hard in such matters may even be regarded unfavorably. Of course, the extremes of creative self-improvement, such as sex-change operations, are somewhat akin to imposture . . .

In other words, the community is probably justified in being willing to classify an activity as truly creative only insofar as it does not focus on changing the individual's physical person, especially if doing so is merely for the sake of personal advantage. In the same way, we tend to regard activities with "merely" practical goals—the supreme skills of a jack-of-all-trades, for example—as too prosaic to be honored for their creativity. Another way to put the same point is that endeavors seem to be classified as creative only if they focus on some general problem, beyond the realm of one concrete instance. To qualify for such laurels it is insufficient to produce a wonderful meal: at the very least, the creative chef is expected to be able to provide its recipes. We might say that an action will be perceived as creative only if the person who performs it formulates its aims in terms of some "higher," idealized realm of activity. It is no coincidence that the best of cooking is honored by being called haute cuisine.

Hence, simply establishing a human relationship is seldom regarded as a creative achievement; in order to qualify, such activities must have certain moral dimensions, as does the work of a Mother Teresa. The most difficult and most essential of our tasks, the upbringing of our children, is almost never looked upon as a creative domain, probably because it is rightly regarded as an aspect of our narrow self-interest. Analogous demands that the created product possess some ethical content disqualify a variety of impressive feats, such as the production of pornography, practical jokes, or the organization of criminal syndicates. These, too, are merely forms of self-enhancement, through the direct or indirect exercise of power—in the last analysis they are merely outward manifestations of desperate efforts in self-creation.

We may therefore conclude that creative genius operates in domains that permit the observer to assess some product that is independent from the person of the creator. It is also essential that the novel configuration created represent the individual's authentic point of view, that it transcend one specific instance by transmitting as clearly as possible something of wider significance, and that it should have a commitment to ethical values, at the very least in terms of formal or technical excellence. In all these ways creativity goes beyond utilitarian goals—without disregarding the value of social utility.

The personality of an individual who is capable of accomplishments that meet these difficult criteria must have a long series of attributes to make such achievements possible—attributes beyond the constitutional characteristics that endow the person with the specific "talent" required in any particular field of endeavor.

METHODOLOGICAL PROBLEMS

The study of creativity and of the personality attributes upon which it depends is greatly complicated by difficult methodological problems. Historical figures of undoubted creative distinction seldom leave behind documents or other evidence capable of answering our specific concerns about their psychology, particularly with regard to their emotional development. Living persons, on the other hand, are seldom willing candidly to reveal themselves to the investigator, and are by and large very difficult to evaluate in terms of the ultimate value of their contributions. We certainly cannot rely on current public success to give us an index of lasting accomplishment: the history of culture is full of instances of towering reputations destroyed by the critical judgments of posterity.

Per contra, recognition often comes late precisely to those who are most original and thus depart from prevailing standards—witness the example of Franz Kafka, who, in conformity with traditional literary values, regarded some of his writings as unsuitable for publication. Individuals who only produce works of "genius" at a relatively advanced age also crop up with some frequency. Had one studied Giuseppe di Lampedusa as he entered his sixth decade, he would have appeared to be an aristocratic idler, the last person one would expect to create a masterpiece of literature such as *The Leopard*. Finally, if we study the creative person after he or she has achieved success, we are very likely to obtain information skewed in the direction of sustaining a "personal myth" about that individual's life.[3]

Psychoanalytic Contributions to Creativity Studies

The psychoanalytic literature on creativity has concerned itself almost exclusively with the nature of the motivational impetus for creative activities and, to a minor extent, to the cognitive operations required to succeed in them. Before proceeding to the agenda of this book—the role of personality in the creative process—it may be appropriate to begin with a brief but critical review of the principal propositions extant about these controversial matters.

MOTIVATIONS FOR CREATIVITY

Of necessity, psychoanalytic hypotheses concerning the motivational impetus for creativity have had to reflect their proponents' views on the wider issue of the sources of all human motives. From the early 1890s, when Freud first postulated a theory of mentation fueled by psychic energies,[4] until well beyond his death almost a half-century later, there was no serious alternative for his view that all human behavior is motivated by instinctual drives. Freud periodically revised his proposals for classifying the relevant drives,[5] but all versions of his drive theory consistently maintained that creative activities did not make use of sexuality (or aggression) in raw form—that, in the service of creativity, the drives are somehow "sublimated."[6] In Freud's lifetime, therefore, the ability to be creative was explained by all psychoanalysts as a function of a putative capacity for sublimation. Freud's own pronouncement, that the artist seeks fame, fortune, and sexual love, was merely a restatement of the assumption that creativity amounts to the operation of sublimated libido, in the realm of narcissistic aims as well as that of object seeking.[7]

The retreat from this essentially sterile viewpoint (untestable because there was no way to detect sublimatory capacities *before* the success of the creative act), was a by-product of the advent of ego psychology. This was a theoretical trend ushered in by Freud's last revision of his views of mental function, in the mid-1920s, a change that gave equal weight to the drives and to the regulatory functions that inhibit their immediate gratification.[8] This new conceptualization sanctioned a fresh look at creativity, a research program pioneered by the art historian-turned-psychoanalyst Ernst Kris, whose work on this topic earned him a leadership role within ego psychology.[9]

The cumulative impact of Kris's contributions on creativity did not make itself felt until their publication in book form in 1952. Before the appearance of his *Psychoanalytic Explorations in Art*, much of his work had only been available in German. His familiarity with the lives of numerous artists and his interest in the creative activities of psychotics cast doubt on Freud's facile assumptions about artistic motives. As Kris gained greater expertise in the realm of psychoanalytic theorizing, he began to assert that the mental processes crucial for creativity were not those of the id (as previously assumed by psychoanalytic authors) but rather preconscious aspects of the ego.

It should be noted here that large segments of the psychoanalytic community remained unconvinced by the arguments of ego psychology and continued to elaborate further drive psychological theories. Even today, the heirs of Melanie Klein (mainly in England and Latin America) and those of Jacques Lacan (in France) remain loyal to the "early Freud." It may be no coincidence that these schools of psychoanalysis have had relatively little to say on the subject of creativity.[10]

By contrast, the ego psychologist Phyllis Greenacre pointed out that creative activities are far from lacking in passion, despite what the theory of sublimation would require; on the contrary, they seem to be characterized by as much intensity as human beings can muster.[11] To account for this fact as well as the supreme control required in carrying out the creative act, Kris devised an ingenious theoretical oxymoron, the notion of "regression in the service of the ego."[12] By this he meant that creativity requires the ability to use ego functions at their best while allowing regression to primitive modes of drive organization.

Although a putative ability for such selective regression is as inexplicable as is that for sublimation, from a scientific point of view, the new hypothesis represented a major advance because it opened the door within psychoanalysis for detailed examination of the nature of specific talents. These were now dealt with in terms of the manner in which ego functions of various kinds are exercised in the process of creative work. I shall return to the question of the cognitive operations involved in creativity in a later section of this chapter. Here, I would merely note that, through his theoretical tour de force, Kris succeeded in preserving for another generation the Freudian hypothesis that all motivations have their sources in instinctual drives.

Probably the most fruitful ideas on creativity produced by the school of ego psychology were those published by Greenacre.[11] Basing herself on extensive clinical experience with a range of creative persons, Greenacre concluded that children destined to become "artists" (in the broadest sense of that term conceivable) were relatively protected from the expectable unfortunate consequences of difficult vicissitudes in life by what she called a "love affair with the world"—a lessened reliance on good relations with the caretakers. She also noted that creative endowments seem to involve constitutional differences from anticipated norms in terms of various psychological criteria.

Yet the best exposition of the overall ego psychological view of

creativity was offered in 1967 by K. R. Eissler. Eissler drew the essential distinction between ordinary creative accomplishments, those achieved by individuals who possess mere "talent," and productions of "genius." He proposed that the latter tend permanently to remain open to the reorganization of their personality in a manner that will set free their psychological "energies." Eissler asserted that such a reorganization first takes place during the adolescence of the future genius, a crisis that often appears to be a descent into severe psychopathology but proves not to be damaging—on the contrary. He also postulated that individuals organized in a manner that makes this possible often experience seemingly pathological psychological states that do not constitute maladaptation but actually form a preliminary stage of the creative process, an autoplastic enactment that gives the person the subjective experience of a human potentiality that will be part of the subject matter of the work of art being created.[13]

As this era of psychoanalysis drew to a close, Joseph Coltrera stated that the focus of study should shift to the "autonomous functions" involved in conflict-free thought processes, particularly those of perception and consciousness. Coltrera's prescient article of 1965 forms a bridge to more recent conceptual innovations in the psychoanalytic study of creativity.[14]

About twenty years ago Freud's original paradigm for motivation gradually collapsed, in parallel with the realization that mental functioning cannot be analogized to the operation of a machine driven by some form of energy.[15] The statement of a new conception most directly relevant for the study of creativity was made by George Klein, who proposed a list of "vital pleasures" that motivate everyone; one of these is the pleasure of "effectance"—the joy to be had through the sheer exercise of competence.[16] Among others, I soon applied this concept to the problem of creativity, for I had previously made clinical observations suggesting that the self-esteem born of great accomplishments irresistibly pulls persons with major talent into ceaseless exercise of their gifts.[17] In my clinical experience children destined for greatness are frequently misperceived by their caretakers, precisely because of the physiological peculiarities that are harbingers of their unusual talents, as defective (rather than outstanding). As a result of such childhood vicissitudes, creative persons often suffer from vulnerabilities in self-esteem and need the kind of affirmation provided by success in creative endeavors.

At any rate, it was George Klein's abandonment of the equation of motivation with instinctual drive that made it clear that the crux

of the matter in creative activity was not the need to overcome nar-
cissistic injury, as some authors have continued to insist. These stu-
dents of creativity have been so impressed by the anecdotal evidence
encountered in clinical work that they postulate that preexisting
injuries to self-esteem constitute the *universal* driving forces of cre-
ative endeavors. In particular, William Niederland has stressed the
frequency of physical handicaps underlying the self-esteem prob-
lem.[18] In my judgment, such views are based on inadequate and
biased samples of creative persons. The pleasure of effectance is also
irresistible for persons who suffer from no problems of self-esteem.
When, in 1983, I reviewed the psychoanalytic literature on creativ-
ity for my book, *Portraits of the Artist*, I cited the work of Klein's
collaborator, Pinchas Noy (on the question of creativity in music), as
the model to be followed in this investigative domain.[19]

I must emphasize at this point that I have been discussing
hypotheses about creativity that were intended to be universally
applicable. In particular instances these indispensable factors may be
supplemented by a variety of additional motives that are not to be
found in other cases. Many of the psychoanalytic hypotheses I
would dismiss as universal explanations were developed on the basis
of sound clinical evidence but turned out to be applicable to limited
segments of the creative domain. Thus it is perfectly true that the
creativity of certain persons is enhanced by a need to counterbalance
their deficient self-esteem (caused, let us say, by psychological
injuries inflicted by the childhood caretakers or by bodily defects).[20]
In other instances a competitive factor is part of the motivational
spectrum, and such a state of affairs may well reflect childhood com-
petitiveness with parental figures, sometimes on the basis of awe of
the mother's quasi-miraculous ability to create new life.[21] Not infre-
quently, creative activities are stimulated by a need to make repara-
tion for fantasied or real destructiveness (as the followers of Melanie
Klein believe), to substitute order for chaos, or to accomplish a work
of mourning.[22] Even the tendentious motives Freud believed to be
central for creativity—money, prestige, sexual rewards—are impor-
tant in certain instances. But none of these ancillary motives will
suffice by itself to maintain the difficult commitment to a creative
life.

Although he never made his theoretical position on the question
of creativity (or, for that matter, on most other issues) entirely
explicit, D. W. Winnicott was probably the most influential contrib-
utor to the literature to espouse the emerging consensus about a
new psychoanalytic theory of creativity. Winnicott located "cultural

experience" in what he called a "transitional space" wherein the person operates playfully. In this volume I do endorse Winnicott's position; however, in my view creativity depends equally on the joy of effectance and on a preference for novelty.[23]

These novel psychoanalytic views preclude the conceptualization of creativity as a by-product of psychopathology.[24] In this regard, the psychoanalytic consensus has tended to depart from the views of an influential psychiatric faction who propose correlating creative accomplishments with a propensity for depressive illness. The most cogent statement of the objections to such a reductionist view of creativity is probably that of Albert Rothenberg; recent statistical studies have also demonstrated that this view was based on skewed samples of creative persons.[25] However, the psychologist H. J. Eysenck has proposed a much more sophisticated hypothesis linking creativity with a measurable set of personality traits he calls "psychoticism." He has chosen this term because similar traits are also found in testing psychotic patients. However, Eysenck explicitly acknowledges that such traits may be acquired on the basis of manifold constitutional variables interacting with a great variety of infantile experiences.[26]

Whenever the subject matter of artistic activities is focused on the artist's personal disturbances, that preoccupation is in the service of mastery (as I shall try to show in chapters 7 and 8), and the creative effort itself cannot be involved in intrapsychic conflict. More often than not, creative persons primarily desire to transmit an artistic (or scientific or ethical or scholarly) message that represents their highest ideals in the form of a perfected offering.[27]

THE TOOLS OF CREATIVITY

A decade ago the psychoanalytic revolution I have just summarized led me to conclude that creativity can no longer be conceptualized as the outcome of manipulating sets of fantasies; it must be understood, instead, as the ability to process percepts (or abstractions concretized in terms of perceptual metaphors) in an extraordinarily flexible and sophisticated manner.[28] The most extensive exposition of this new point of view can be found in the work of Anton Ehrenzweig, an art educator also trained in gestalt psychology and psychoanalytic theory.[29]

Ehrenzweig spelled out what is extraordinary about the manner in which the creative person (in Ehrenzweig's publications, exemplified by musicians and practitioners of the visual arts) manipulates

the percepts relevant within a particular creative domain. In his view, this process involves the integration of two distinct modes of perception: the gestalt-free mode that characterizes the first several years of childhood and a mode, acquired later in development, that makes use of gestalten. Ehrenzweig assumed that in most people the ability to perceive an accurate gestalt (that is, to apprehend a percept as one whole rather than as an assembly of uncoordinated details) gradually suppresses gestalt-free perception. From this perspective, talent in any particular creative field implies the preservation and development of gestalt-free perception and its use in conjunction with gestalten. (In music, for example, the gestalt-free elements are the interpretive variations not to be found in the written score as well as the unfocused polyphony that coexists with the harmonic gestalt.) Rothenberg proposed calling such an ability to think simultaneously in two disjunctive ways "Janusian."[30]

Pinchas Noy may have been the first to exploit Ehrenzweig's conclusions within the theoretical domain of psychoanalysis proper.[31] Noy proposed that Freud's classification of thought processes into "primary" and "secondary" varieties should no longer be understood to represent a development from a more primitive to a more mature position; rather, Noy conceived of the two modes of thought as having independent developmental lines, so that, once available, both remain serviceable throughout life. As a result of recent advances in cognitive psychology and brain science, this conclusion has become widely accepted.

Wilma Bucci has carried the argument even further: she has pointed out that the availability of both primary and secondary process mentation does not constitute the ultimate stage in the development of thinking. Bucci looks upon the integration of these distinct modes of thought, through what she calls "referential activity," as the culmination of this line of development.[32] In these terms, creativity depends on the availability of a maximal degree of referential activity, particularly as this involves both modes of perception. This complex set of requirements for creative thinking can only be met if superior constitutional endowments are channeled at crucial junctures into a particular form of referential activity as a result of rich environmental input.

•

The Creative Personality: A Portrait

Despite the numerous methodological problems in studying the subject, a fair degree of consensus prevails about the expectable personality of creative people. If I may begin with the obvious, nothing ventured, nothing won: the creative person must be able to *try*. In psychoanalytic practice one is likely to encounter seemingly talented persons who have lain fallow, either because they did not dare to risk success or failure or because other goals in life took precedence over whatever creative ambitions they may have had. I have treated one person who had overt fantasies of literary success and impressive verbal facility, but until late in his analysis hardly ever sat down to write more than a paragraph. On the rare occasions when he tried to create a story, he quit in disgust after writing a page or two because he felt he was producing garbage. Of course, I have no idea of the actual merits of these aborted efforts, but I did learn that my analysand despaired of success because he expected himself to produce first drafts that would stand comparison with the best stories of Chekhov or Tolstoy. By such criteria, anyone has good reason to fear failure.

Contrary to popular stereotypes, fear of success is just as prevalent as is fear of failure, often because the fulfillment of creative ambitions would evoke severe guilt vis-à-vis some cherished person or threaten the creative individual with some loss of love. This is

particularly likely to be true of people who feel obligated to prop up a member of their family by maintaining symbiotic ties to that person; in the mind of such a loyalist, autonomous creative achievements may appear to rupture the bonds safeguarding the beloved other.[1] It is not uncommon for marriages to fail if one of the spouses becomes markedly more successful than the other; in countless parallel instances the marriage is preserved because the partner who has the greater opportunities shies away from success.

The clearest example of such a sequence of events I have actually witnessed occurred in the case of a promising social scientist who was married to a man who was internationally renowned in the same discipline. My patient undertook analysis because of interpersonal difficulties with her male colleagues—these transactions took place at a time when women had almost no recourse in dealing with sexual bias within the academy. The analysis proceeded smoothly and was reasonably successful; one of its results was that the patient learned how to gain appropriate recognition for her intellectual work. Two or three years later, she returned for help, in great distress because her husband had left her.

At first, this Medea was almost ready to believe her Jason's charges that she was a witch; however, she soon realized that when her husband angrily accused her of deliberately making him ill, he was giving voice to a paranoid delusion. He was adamantly opposed to her consulting me about this crisis because, not without reason, he blamed the analysis for the changes in his wife he now regarded as harmful to himself. As it turned out, there was a similar nugget of truth at the core of his delusion: he was actually suffering from hypertension, and this condition was greatly relieved when he kept away from his wife. With profound regret—and empathy for the man's plight—the patient decided to let him go.

One tends to be surprised that noncreative goals may deter some persons from making a commitment to a promising creative endeavor. Probably the most common reason for such a circumstance is the adoption of a utilitarian value system opposed to creative ambitions, which, in families with such an ideology, are generally labeled "impractical." One person who ultimately sought psychoanalytic assistance, largely because of the devastating consequences of having yielded to such pressure, had considerable musical talent but turned away from performing in favor of a safe and remunerative service profession, in conformity with the values of his community and family of origin. By the time treatment helped him to resume an immersion in music—a change that decisively

altered his subjective experience for the better—it was too late for this man to establish a career as a performing artist, although competent judges of musical talent assured him that he had missed his true vocation.

In order to be able to damn the torpedoes and make full speed ahead, a person with creative aspirations must have the feeling that pursuing these is morally worthy. In his inimitable way, W. B. Yeats[2] stated this as a choice between perfection of the life and perfection of the work. I know a family whose values are the reverse of the utilitarianism that prevented my analysand from attempting a career as a musician. For these people, the creative life is a summum bonum; they were perfectly happy to make considerable sacrifices in order to make it possible for one of their children to become an artist. It was scarcely surprising that the latter was for many years comfortable in accepting their assistance, despite a lack of outward success. But in our culture familial attitudes facilitating creative efforts seem to be relatively unusual; it is more common to teach one's offspring to be less ambitious but more prudent. The Flauberts steered Gustave into law; the Monets would have preferred Claude to enter their thriving grocery business; Dr. Proust would have been reassured had Marcel been able to hold any respectable job. I shall come back to these instructive cases in subsequent chapters.

Sometimes the stumbling block in the way of creativity is neither excessive pragmatism nor mere modesty—even families of ample resources and careerist achievements may be opposed to the creative hopes of their children. I was once consulted about such a conflict by the daughter of a highly successful businessman: she was in great distress because of her family's moral revulsion toward the ways of the artistic world she wanted to join. They fervently urged her to preserve their religious commitments, their upper-class manners, their traditional family structure. I had occasion to talk to the father, and he was no philistine; he would have been happy if his daughter had become a collector of old master paintings. He was frightened and scandalized because she chose to live like most students at her art school. The young artist was unable to reject her parents' objections because she did not fully believe that her goals were morally superior to her family's social ambitions.

Compare this emotional vulnerability to the attitude of Paul Gauguin, probably the most celebrated artist to have sacrificed the best interests of his family in the service of his creative goals.[2] Before ultimately abandoning his wife, Gauguin moved with her to her native Copenhagen, where he made an unsuccessful effort to

support his family as an artist. Subsequently, Gauguin never forgave his spouse for joining her relatives in urging him to take a remunerative job of some kind instead of concentrating on his creative activities. It is true that Gauguin had become confident of being an artist of the first rank even before the move to Denmark, so that he felt justified in charging that his wife was selfish in putting mundane concerns ahead of promoting his creative work.

However, self-confidence did not constitute the sole determinant of the artist's attitude, for there can be no doubt that Gauguin regarded the plastic arts as the highest of callings. When he had money he avidly collected the best avant-garde art of his day, and even when he became impoverished he valiantly held on to the gems of his collection as if they were the relics of a private religion. Clearly, Gauguin was willing to sacrifice perfection in life for the sake of perfection in work; at the same time, he regarded the quest for artistic perfection as the guiding ideal of his life.

We might well ask what enables a person to idealize a vocation in this manner. The question is difficult to answer because the choice of a creative endeavor, like other vocational choices, is generally made relatively early in life, often in adolescence or even sooner. In my experience, an idealized vocation is in fact often chosen without proper regard for the individual's actual range of talents. Of course, we are scarcely likely to call people who have little talent for their chosen field "creative personalities"—the name of *that* game is to fall in love with a field of endeavor for which one is well endowed! A mismatch between talent and vocation is a severe misfortune, which, if not rectified by making a more appropriate choice, can only lead to progressive loss of self-esteem and chronic depression.

Because my clinical experience is most extensive with mental health professionals, I have most frequently encountered mismatches of the foregoing kind among those who idealize psychoanalysis as a clinical discipline. Often, such an unfortunate commitment comes about as a result of early therapeutic experience with an analyst who does admirable work: it is the idealization of a particular person that is transformed, in a manner quite common in adolescence and through the college years, into the idealization of his activities. In principle, such an attempt to identify with an admired person is no different from following in the footsteps of an idealized parent—except for the fact that parents and children are more likely to have similar constitutional endowments than are randomly matched therapists and patients. One person with such a history, for example, was determined to learn to perform "talking cures" despite

having severe cognitive deficits that prevented him from being able even to grasp the narrative of a movie. Needless to say, this man was condemned to remain desperately fallow as long as he persevered in this hopeless endeavor.

This instance of a catastrophic mismatch between endowments and field of endeavor also serves to illustrate the manner in which the choice of an idealized vocation is generally made. Studies of the careers of cohorts of creative people show that the most common form in which the choice of an appropriate vocation is facilitated through the influence of an admired person is exposure to a master teacher, usually in adolescence.[3] Families who discern that their child has a specific talent will often go to great lengths to find such an instructor. In truly excellent schools, a variety of outstanding teachers are alert to the special abilities of their students and tend to give them private encouragement and extraordinary attention. If such a mentor becomes idealized, the youngster may be led into an identification with vocational commitments that are in harmony with her talents. Unfortunately, many talents are sadly wasted because they receive no recognition and essential nurture of this kind.

I have had the opportunity to work analytically with a highly gifted young woman who had been a scholarship student at one of the outstanding women's colleges devoted to the promotion of intellectual careers. This girl came from a relatively deprived background and had numerous emotional problems, but one of the most prestigious professors recognized her academic promise and offered her supportive guidance in a manner my patient was able to accept. She decided to enter the professor's scholarly discipline and began to discuss with her an exciting project for writing a book that would be an expansion of her senior thesis.

These promising beginnings did not bear fruit because this psychologically vulnerable girl was unable to maintain these commitments without the continued personal involvement of her mentor, who tragically died shortly after the patient's graduation. Without the steady input of positive feedback from this admired person, my analysand lost her self-confidence and decided that she had best settle for a "practical" vocation of the kind other members of her family had chosen. For the next decade, she was extremely successful in such an enterprise but, despite achieving financial security, she felt unfulfilled because she had "betrayed" her ideals.

In contrast to such a story, many youngsters destined to become creative do manage to fall in love with a discipline for which they are well-suited, even without having the advantage of finding an

admired person to follow in their immediate environment. The biographies of these unusual children often provide moving testimony about their wonderful capacity to find inspiration in a historical account of the life and/or work of a relevant predecessor. Such was the story of one of my analysands, who did good work in the domain of intellectual history after he completed the treatment.

This man was brought up in a middle-class home with a narrow, anti-intellectual bent. The school system he attended singled him out for a study of intellectually gifted children almost as soon as he enrolled, but he did not receive any special help or encouraging personal input from anyone. Nonetheless, while still in the early primary grades, he began on his own to study the biographies of great scientists and, prior to the age of eight, he was so inspired by the story of Einstein's work that he decided to become a physicist. When he reached college, he discovered that his talent for pure science did not match that of the best aspirants in the discipline and that it was, in fact, the epistemology of scientific discovery that most interested him—hence he gradually refocused his practical goals without having to relinquish his love affair with the broader field of scientific investigation.

It must also be acknowledged that vocational passions of this kind are fueled by more than the satisfaction of fulfilling an ideal. In fact, they tend to take on the qualities of an addiction, because few can resist the pleasure of doing something difficult unusually well.[4] Remember the thrill of mastery when one manages to become effective in skills such as swimming, driving a car, or conversing in a foreign language? And these achievements are very ordinary, hardly comparable to attaining novel solutions in the most honored of creative domains! Even the *promise* of being able to strive for such rare achievements is often sufficient to pull a young person in the direction of a career wherein the exercise of the skills in which he excels will be the crux of the matter.

Just how decisive this consideration seems to be may be demonstrated through the bizarre impression created by the occasional exception—the person who is too arrogant to become committed to a vocation for which her talents would be maximally useful. Such an attitude was best summed up by the megalomanic idea of one of my patients that it is a matter of dull routine to succeed through the exercise of God-given capacities, but it would really be an impressive trick to achieve success in the face of actual handicaps! Indeed, it would—but such tricks are generally too difficult to pull off. This is not to say that the determination to overcome an initial handicap

might not provide as strong a motivation and as much pleasure as the exploitation of ready-made talent. Plutarch reports that the great Athenian orator Demosthenes, through fanatical diligence, overcame a severe speech impediment that previously stood in the way of his career as a public man.[5]

In my judgment, creative personalities tend to prefer the satisfactions to be gained through the effective exercise of their skills to other possibilities of pleasure or profit. In this regard, their personalities probably differ from those of many people whose talents, as such, are of the same magnitude. To illustrate this point, I can cite the case of a talented and well-established artist who sought treatment because of repeated marital failures, based on choosing women who, like his mother, were selfish and exploitive. The analysis was in many ways successful; not too long after termination, the patient formed a relationship with a woman of a very different sort, with whom he was able to live in contentment. After their marriage, his career went into decline, at least in part because he devoted himself in an unprecedented degree to this gratifying relationship.

Obviously, other considerations may also have played a part in this person's lessened productivity—I have only bits and pieces of information about this phase of his life—but it is striking that, in childhood, he became interested in the artistic domain he was to choose for a career at a time of estrangement from his mother. In other words, for this person creativity initially did serve as narcissistic compensation for a defeat in love; it is tempting to assume that, had it been available, he would always have preferred personal happiness to any compensatory achievement by way of creative work. And who are we to say that artistic creativity is always preferable to "perfection in life?"

In exact parallel with a preference for the rewards of using one's skills, creative personalities appear to have a greater than usual propensity to seek out novelty.[6] By this I do not simply mean the twentieth-century preference for an avant-garde position; novelty does not necessarily imply an effort to supersede traditional forms. Picasso was one of the artistic giants of our century not only because he was the originator or coinventor of an unusual number of formal innovations (such as the cubist style, collage, or welded metal sculpture) but also because he was able to work within established traditions (for example, that of neoclassical draftsmanship) to achieve novel expressive possibilities.[7]

Within every discipline there is never-ceasing tension between the pull of traditions and the need for renewal through innovation.

Although traditionalism is quite consonant with creativity, without concurrent change every tradition eventually becomes exhausted, lapsing into some form of tired academicism. This sequence is just as applicable in the sciences as it is in the arts and humanities: no field better illustrates the point than does psychoanalysis. The most creative of psychoanalysts, Sigmund Freud, was a tireless innovator; in his old age he confessed with malicious pleasure that he thought his disciples needed to be shaken in their complacent acceptance of the conventional wisdom![8] Yet the vast majority of analysts react to proposed innovations with pronounced skepticism, not to say aversion. I believe that this conservative bent extends to their own scientific position almost as much as to those of colleagues: most analysts (most people!) react to new ideas as the start of a slippery slope into the unknown—even into perdition.

There can be no question that one of the most important features of a congenial environment is a rate of change slow enough to permit comfortable accommodation, but of sufficient degree to avoid boredom. For most people it is difficult enough to adjust to the changes wrought by others; hence they do not spontaneously seek novelty on their own. Creative activity of any sort therefore poses an unwelcome challenge for all but a minority of persons—it is comparable to the experience of visiting a foreign country for the first time. Most of us adapt to the overwhelming strangeness of such an adventure by seeking out experiences that are as familiar as possible: Japanese tourists abroad prefer Japanese restaurants, Americans gravitate to MacDonald's! Creative work is comparable to forging constantly ahead, into terra incognita.

Those persons who are ever eager for such a challenge are probably the products of relatively unusual formative experiences or special constitutional endowments, or both. We know very little about the transactions in early childhood that may tip the balance in either direction, but it is clear that by the third or fourth year of life some children are more adventuresome than most in exploring the unknown—others are more reluctant to expose themselves to anything unfamiliar. The most striking instance I have encountered clinically of the kind of expansiveness that is a harbinger of future creativity was that of a man who became an architect and painter. Already as a three-year-old he was busy exploring how he could solve the twin problems of transforming three-dimensional percepts into two-dimensional imagery and vice versa. From the life histories of certain creative individuals of great accomplishment, we learn about even more astonishing feats early in life. Witness the account

of how Mozart began to play the violin shortly after he became physically big enough to manage the instrument: having been raised by a violinist father, the child, already a proficient pianist, simply took up a violin and *played it*.[9]

Of course, Mozart's legendary example illustrates the truism that revolutionaries should always be bold. Although this requirement applies to innovative activities beyond the sphere of public affairs, it is worth recalling in this connection the daring of the most recent creative act that transformed a commonwealth, Boris Yeltsin's address to the people of Moscow from the roof of a tank. But creative acts invariably do defy some establishment—no incident better illustrates the spirit that must animate scientific work than Galileo's legendary parting shot after his hearings at the Inquisition, "Eppur si muove"—the earth moves, whatever the theologians may proclaim . . .

The creative personality must therefore possess courage, above all. I have already referred to the importance for productivity of transcending fears of success or failure—but the boldness required to be creative involves more than that. In a fundamental way, it demands of would-be innovators the capacity to tolerate isolation within their own discipline. Individuals who succeed in pioneering important enterprises generally understand that their work has great value, but for some time they may have to persevere without positive feedback or support from their colleagues. In this regard, the evolution of psychoanalysis offers the most dramatic of examples: Freud managed to cut himself off from collegial approval at the threshold of middle age, when his hypotheses about the etiology of neuroses alienated his mentor, Josef Breuer. For a dozen years or more his isolation within neuropsychiatry was almost complete, broken only by the interest shown by an occasional student. As we know from his correspondence of the period, Freud was confident that he had grasped an important key to the "secrets of nature," but he had to turn for emotional support to a friend whose own scientific activities explored a different domain.[10]

Individuals differ enormously in terms of their capacity to tolerate lack of appreciation for their work on the part of competent judges. At one extreme there are grandiose characters, messianic in the conviction of their own excellence—such qualities are probably most essential for would-be religious innovators. I suspect that it is much more common to feel intolerable discomfort about being isolated within one's creative discipline. Such was the reaction of a woman I once treated who sought help in despair about her inabil-

ity to accept various doctrines of the rigid religious community of which she was a member. Her own beliefs struck me as cogent and original, but she was utterly incapable of standing up to the intolerant responses of her coreligionists and she was therefore fearfully concealing her private beliefs from them. But the domain of religion is by no means unique in using excommunication as the ultimate measure for keeping in line those who propound heresies. The inability of my analysand to find anyone to give her support made it impossible for her to become creative in the religious sphere.

As Joseph Conrad described in his novella *The Secret Sharer*, it is essential to be able to overcome the consequences of professional isolation by forging emotional bonds with someone who can serve as one's alter ego.[11] Such was the role of Freud's friend, the medical visionary Wilhelm Fliess, who lent him courage as a result of a large measure of messianic self-confidence, which, as a matter of fact, did not prove to be reality-based. Perhaps the most celebrated partnership of this kind was the pact between Vincent van Gogh and his brother Theo, which, for a full decade, overcame Vincent's suicidal despair about his lack of human acceptance; we now know that the artist killed himself when it became clear that Theo was about to succumb to tertiary syphilis. Vincent fully understood that, in addition to such fraternal support, he also needed to feel like a member of an artistic community; that was the rationale of his ill-fated effort to establish a studio to be shared with Gauguin.[12]

The value of a creative partnership with a member of one's own professional community is, of course, even greater than that of a "secret sharer." Conrad's story of that title was largely autobiographical: he was able to do his greatest work, in a span of about a dozen years, while he was on the closest terms with Ford Madox Ford, a fellow author with whom he actually collaborated on certain novels. (These collaborative efforts were not up to Conrad's standards when working alone; clearly Ford's importance for him was not primarily a matter of craft.) The Picasso-Braque partnership in the creation of Cubism, arguably the finest achievement of each man's long career, is another example of the way in which individuals may lend each other courage to tackle a supremely difficult endeavor that neither one might be bold enough to undertake alone. In later years Braque compared the manner in which he and Picasso functioned in creating Cubism to the actions of mountain climbers who rope themselves together for safety.[13]

In my experience, whatever else may be accomplished in the psychological treatment of people who have creative ambitions, psy-

choanalytic services will be enormously helpful if only we assume the role of a secret sharer to ease the burden of the neophyte's isolation. I realize that I have put this in an ambiguous manner: I do not mean to say that it is appropriate to imitate a Theo van Gogh or a Ford Madox Ford as part of a deliberate program to promote an analysand's creativity. At the same time, the analyst will not automatically become a catalyst for creativity, no matter what she does. I suspect that analysands will cast their therapist in such a role only if the analyst's conscious and unconscious attitudes are congruent with sharing a creative goal.

I may best be able to convey what I have in mind by recalling that many analysts formerly considered the onset of creative activities during treatment as a resistance that interferes with the analytic task. It is therefore not surprising at all that one of my older colleagues ruefully shared with me that, although she had treated many promising people, none had ever become productive in a creative sphere.[14] It is even more damaging if the analyst's unwillingness to promote creativity is based on unconscious sources: for example, potentially creative analysands may be undermined by unwarrantedly patronizing attitudes or by interpretations of their ambitions as prima facie grandiose. One of my analysands taught me how to classify people who act that way: he called them "artichokes," because they delight in choking the artist.

Thus another way to differentiate creative personalities from other talented persons is to note that they have the social skills needed to build for themselves a network of human relationships that will support their creative activities—and the wisdom to avoid the artichokes! From a slightly different perspective, the same point might be contained in the commonly held belief that creative persons often exploit their family and friends and are willing to sacrifice human ties for the sake of their work. I have already alluded to Paul Gauguin as someone willing to abandon his family in order to be free to pursue his art. He was also skillful in gaining the assistance of the van Gogh brothers and a succession of other helpful friends to promote his career; in most instances he was quite ruthless in failing to reciprocate such helpfulness—witness his abrupt departure from Arles when van Gogh's collapse necessitated hospitalization.[15]

Doubtless there are a number of other personality traits that enhance creativity; there are certainly a great many that interfere with it; the mere absence of unfavorable personality attributes can tilt the balance in the direction of making better use of one's natural

endowments. Instead of trying to draw a more detailed portrait of the creative person at this point, let me simply review the outlines of my conception of the personality required for creativity.

This begins with the assumption that the creative person gives priority to the ambition to do great work, whatever consequences that might entail. To make this aim feasible, it is generally necessary to idealize the work as the highest good, for the sake of which other considerations may be sacrificed. Such a love affair with a field of endeavor must usually start in adolescence, if not earlier; it is essential that it be congruent with the youngster's actual talents. Unless this love is promoted by the example of an admired mentor, a person destined to become creative must have the rare capacity to find inspiration in the example of a historical predecessor.

The passion for a particular vocation is usually enhanced by the unparalleled pleasure provided by the exercise of superior capacities in a difficult endeavor; creators must be satisfied by the mere opportunity to make use of whatever talent they have been given. Moreover, the satisfaction of exercising these gifts must outweigh the promise of alternative pleasures, however seductive or profitable they might be. This preference is most likely to occur in people who are also unusually attracted to novelty—or, if you will, in those who have great tolerance for change.

Finally, I have emphasized the boldness that characterizes the creative person—courage that overcomes fears of success and failure, the risks of alienating one's community, and the pain of being misunderstood or not appreciated. In this regard, successful creators seem to have the capacity to find companions who support and encourage them in their difficult quest; conversely, they also know how to avoid relationships that might interfere with creative activities.

The Development of a Creative Gift: Challenge and Opportunity

•

What Is Bred in the Bone

The collective portrait of creative personalities I drew in the preced-
ing chapter is focused on their characterological attributes; these are
the variables most likely to be affected by childhood experience and,
consequently, also those the effects of which are best observed in the
psychoanalytic situation. In contrast, the question of the "native
endowments" required for various creative achievements tends to
be given short shrift, especially in the psychoanalytic literature,
through the simple expedient of being relegated to the status of con-
stitutional variables.[1] In one sense, of course, such a designation is
merely a truism, for all human potentialities are functions of our
soma; the body, including the brain, can only perform in accord with
its biological attributes. (Such, at least, is the view of natural science;
it must be admitted that the public at large is hardly committed to
this axiom, preferring instead a variety of mentalist or spiritualist
notions, postulating the operation of mind, or soul, beyond matter.)

We would do well to pay greater heed to the constitutional
sources of creativity, because these transcend the question of the
individual's genetic endowment. It is now generally understood that
what biologists call the phenotype—the ultimate consequences of
inborn potentialities—is codetermined by the meshing at key
moments of genotypical givens with certain characteristic qualities
of the environment. To mention only some of the most obvious

examples demonstrating this principle: children, born without abnormality, will remain blind if they are raised in the total absence of light; normal infants who are deprived of the experience of being reached by human communications will not acquire the capacity to use any language in full. These irremediable consequences of experiential deprivation have to be understood in terms of the essential role of appropriate stimulation in the course of critical periods for the optimal maturation of the higher cerebral centers.[2]

Gross perceptual deprivation of the foregoing kinds is, fortunately, relatively infrequent; for our purposes, what is truly significant is the ubiquity of subtler environmental variability—of circumstances that happen to provide more stimulation of certain specific kinds at the expense of a relative deficiency of other types of input. If such variance takes place during certain critical periods, this peculiarity of the child's nurture will decisively influence the organization of its cerebral functions. The development of the human brain thus depends not only on inborn potentials but also on environmental variables; the possibility of alternative ways of functional organization (and of underlying anatomical arrangements of various kinds) is called brain plasticity.

As a consequence of these biological principles, it is never possible to ascertain the relative contributions of nature and nurture to the crystallization of any specific talent. The proper way to approach the question, instead of trying to resolve such a meaningless conundrum, is to look upon the development of creativity from an ecological point of view. An excellent example of this approach is the comparative study of musical creativity in various cultures; such studies have been conducted by numerous ethnomusicologists.[3] These researchers have established that, contrary to the situation in our postindustrial society, various isolated human groups (such communities still exist in places like New Guinea or Malaysia) who conceive of music as a natural—even primary—channel of human communication, immerse their infants in a milieu that is continuously provided with music, as a result of which all children learn to sing and to compose as part of their socialization. In these cultures, making music does not constitute a vocation or even a specific domain of creative activity—it is a capacity that is simply part of the human repertory, like speech or food gathering. The excellence of the paintings produced by a large number of Australian aboriginals (who have been provided with Western materials) is probably the result of analogous immersion of these populations until recently in "everyday" activities such as decorating their bodies with paint. As

these tribal customs fall into disuse, the incidence of these special "talents" can be expected to diminish.

In exact correspondence with these reports from exotic places, certain professional musicians in our own culture have recounted that they were imbued with the spirit of music "from the cradle." We can hardly doubt that this must have been the case with Mozart, who was accomplished enough as a piano virtuoso to give private recitals for heads of state by the time he was five years of age. As we know, this musical prodigy was raised in a household where the father, a professional violinist and music teacher, was already training the boy's older sister to become a piano soloist. Moreover, as I have already mentioned, the child clearly witnessed his father's violin practice at sufficient length to learn to play the instrument without any explicit instruction.[4]

I do not mean to imply that the development of musical talent is invariably directly dependent on early immersion in a music-filled environment. The evidence I have cited merely suggests that such immersion constitutes one of the avenues that leads to the attainment of a meaningful level of musical competence. The crystallization of talent for something as broad as "music" is much more complex than the simple correlations I have thus far noted would suggest. Musical talent actually consists of a combination of independent functional abilities—not to speak of such differences as those among singers, instrumentalists, composers, and conductors. One classification of the components of general musical ability is competence with regard to pitch, rhythm, intensity, tone color, and harmonic gestalt.[5] There is no reason to suppose that all these competencies can only develop in response to early exposure to music as such—a variety of auditory stimuli may evoke the requisite developments within the infant's central nervous system.

To make this point clearer, let me switch to a different illustration: I submit that it does not make sense to collapse a broad spectrum of specific competencies into a vague general category such as "artistic talent." Creative achievement in three-dimensional activities such as architecture or sculpture require abilities different from those employed in working on a flat surface (as in painting, drawing, etc.)—and the development of these distinct talents is probably enhanced by childhood experiences of different kinds. A painter cannot succeed without special sensitivity to the aesthetics of color; for a sculptor, this aspect of talent is certainly not primary and may even have no importance. Competencies with regard to color, shading, localization, and gestalt are probably independent variables in pro-

ducing "artistic talent," and it is reasonable to suppose that they arise as a result of different maturational events. The complexities I have tried to indicate concerning musical and artistic talent are undoubtedly echoed in analyzing the abilities needed for any other complex creative activity.

It should also be kept in mind that the acquisition of particular competencies like a sense of color or rhythm does not constrain an individual to use her talents within any particular discipline. A talented colorist may become a painter but could, given a different combination of additional abilities, choose another creative domain, such as costume design or interior decoration. A virtuoso of rhythm might best be suited to become a percussionist or a conductor, but if talent for other components of music does not match rhythmical ability, such a person may be better suited for a domain in which his array of additional specific capabilities is more important—poetry, for example. According to his widow, Osip Mandelstam, the outstanding Russian poet, always began to create his works by becoming haunted by a rhythmic sequence, without words. After he arrived at a definite rhythmic armature for a poem, Mandelstam set about to find appropriate words, possessing a number of other attributes necessary for poetic diction, that conformed to this schema.[6]

The overlap between musical talent and an endowment for poetry is perhaps illustrated even more clearly in the case of Federico García Lorca, arguably the greatest of Spanish-language poets. Scion of a prosperous family of Andalusian landholders, Lorca was raised in an atmosphere impregnated with both music and poetry. Numerous members of his paternal family had been locally famous instrumentalists and singers, and his paternal grandmother was a devotee of Spanish and French literature who held readings for a large circle, including the García children. According to his mother, Lorca started humming folk songs before he acquired speech. As an adult, he was an accomplished pianist and folksinger, able to give public performances of Andalusian music.

As a child, the future poet spent hours every day practicing the piano. When his parents found him an admirable, elderly male music teacher, he wanted to devote himself exclusively to that art. While he was a student at the University of Granada, Lorca actually composed several short pieces of music—only to turn away from a musical career upon the death of his teacher, when Federico was eighteen years old. As he put it in a notable non sequitur many years later, "Since his parents refused to allow him to move to Paris to

continue his musical studies, and his music teacher died, García Lorca turned his creative urges to poetry." His artistic associates were, however, completely astonished by Lorca's abrupt metamorphosis. Yet even years later the poet took lessons on the flamenco guitar from gypsy performers, and he formed a friendship with the older Granada composer Manuel de Falla on the basis of their shared interest in the music of Andalusia.[7]

Let me restate what these examples imply about "poetic talent." This branch of literature requires, at a minimum, an ability to correlate the acoustical properties of a sequence of words with their lexical meaning in a syntactical context. (I am deliberately oversimplifying this example, for the sake of didactic clarity: poetry requires a host of other difficult achievements such as superior use of imagery and of grammatical structure, and unusual command of the vocabulary of the language employed.) This ability to correlate several independent requirements is the "Janusian thinking" noted by Albert Rothenberg, the psychoanalyst who has done most empirical research on creativity. I also believe that the quality of mind most important for creative achievement is an ability simultaneously to make use of two discordant modes of thinking—such as the poet's attention to meaning on the one hand and, on the other, to the physical properties of prosody, that is, to the intonation patterns of the poetic utterance. Incidentally, Rothenberg calls such feats "Janusian" after the Roman god Janus, who was represented as having two faces, looking in opposite directions.[8]

Although we do not as yet know when the capacity for Janusian thought might have its genesis, it seems reasonable to assume that, insofar as it involves the integration of different aspects of spoken language, its earliest occurrence would take place when the syntactical dimension of human communication is superimposed on the capacity to make use of the gamut of phonemes that makes up our speech. The integration of other specific sets of cognitive operations probably occurs at other junctures, whenever the relevant functional capacities become available. As I noted in chapter 1, gestalt psychologists have shown that the ability to discern the details of a visual percept supervenes relatively late, around the age of eight—this maturational step is the prerequisite for the establishment of a gestalt.[9] Because the ability to draw in the manner required by the high art of the West depends on the integration of gestalt perception with a more archaic way of seeing that is gestalt-free, by implication, the talents necessary for creativity in the visual arts must be decisively influenced by experiences during the early school years.

Neither the biographies of successful creative personalities nor their personal recollections, whenever they are questioned about their past, are likely to include much relevant information about those transactions in early childhood that may have influenced the development of their presumably inborn potentialities. One major reason for this lack of information is the fact that childhood experience seldom eventuates in the enhancement of skills in the precise combination required in adult life for creative success in any particular domain. For example, no specific transaction in childhood is likely to stimulate the development of the manifest talents needed to succeed as an attorney; it is more probable that one particular skill, such as the ability to create a dramatic narrative, could be influenced by certain childhood experiences—an attorney specializing in litigation would be greatly assisted in influencing juries by superior abilities in this area.

A concrete illustration based on my psychoanalytic work may help to underscore this point. I once treated a young attorney who became a clerk to a distinguished Federal judge and demonstrated outstanding skill in sorting through the arguments of opposing counsel and writing well-reasoned judicial opinions. These abilities later earned him further opportunities in the judiciary—challenges he was always able to meet in an exemplary way. This successful professional career was somewhat surprising, for, until he was halfway through college, this man had not done well in school—despite attending an institution with mediocre standards. It was only a desperate twelfth-hour effort in his senior year and unexpectedly high scores on the law school aptitude tests that resulted in his admission to the kind of professional school from which Federal judges hire their clerks. Even in law school he failed to do well in certain courses; he felt that his talents for various aspects of law were quite uneven.

This person's aptitudes for the tasks analysands must carry out to have a successful psychoanalysis were also distressingly spotty. His greatest handicap was a continuing inability to listen to my communications from the vantage point of trying to determine whether they contained anything of value; rather, the patient was single-mindedly focused on a passionate effort to discover what might be wrong with my statements. He engaged in endless arguments about these matters, thus showing that he had forgotten that we were engaged in a collaboration to discover the truth. To put all this briefly, he treated my input as if it had been a clever brief submitted by a manipulative advocate. I certainly came to see how skilled he was in the mental operations required for his judicial work.

It required a lengthy analysis to discover that the patient's seeming misuse of treatment constituted a reenactment of a pattern of behavior that had, during the analysand's early school years, characterized his relationship with his father. The father was a fundamentalist clergyman who tried to indoctrinate his children in his rigid creed. Although the patient did not dare to rebel against this "instruction," as his older brothers had done, his father's ideas struck him as arbitrary and flawed—a position on the boy's part covertly supported by the patient's mother. At the same time, the boy actually loved his father and wished as much as possible to prolong his private dialogues with him. It was in this context that he adopted the adversarial stance that challenged his father to prove his every point. After a number of years of this loving debate, the boy's acuity in detecting flawed arguments became highly developed. It did not take too long before he started to have the fantasy that he could serve on the U.S. Supreme Court.

Unfortunately, in many cases—perhaps in most—it is much less evident than in the foregoing instance what a particular skill acquired in childhood might be good for in the adult world. The biographies of a number of individuals of very great creative stature suggest that they acquired a wide array of special skills in early life, so that they were originally well-suited for careers in a variety of fields of endeavor; by the same token, it was by no means clear that they would ever be able to make constructive use of their heterogeneous armamentarium to achieve anything of significance. One person who exemplifies such an uncertain youth was the Swiss psychiatrist Carl Gustav Jung, who emerged in maturity as a highly creative and original thinker. It is true that, even in retrospect, it is difficult to pin down the exact nature of Jung's creative domain—should we regard him as a writer, as a scientist, a humanist scholar, a mental health professional, or as a twentieth-century prophet? In some respects, he was all of these; ultimately, in combining many features of these varied domains, he became a unique phenomenon.[10]

As a young professional, Jung showed unusual cultivation, dedication to the calling of a healer, originality and enterprise in carrying out empirical research in psychology—his celebrated association experiments—and a flair for expository writing and oral presentation. These were the outstanding talents that seduced Freud into a misguided attempt to recruit Jung to become his heir presumptive as the leader of psychoanalysis. Such a program made no sense, because it disavowed Jung's overt commitment to a weltanschauung

incompatible with psychoanalysis, repeatedly demonstrated in his efforts to convert Freud to mystical beliefs. It was no coincidence that Jung's doctoral dissertation in medicine dealt with the subject of parapsychological phenomena—and not from a skeptical point of view! After several years of unfounded hopes and mutual disappointment, both Freud and Jung accepted the painful inevitability of going their separate ways.

As Jung revealed in the superb spiritual autobiography he wrote in old age, *Memories, Dreams, Reflections*,[11] his rupture with Freud and repudiation of psychoanalysis precipitated him into a profound psychological crisis. In this personal emergency Jung found his unique inner resources and forged a mature identity as the founder of a religious movement in the guise of a school of psychotherapy. Instead of lapsing into any form of psychopathology, Jung's spirituality allowed him to master his crisis of disillusionment (with Freud, with psychoanalysis, with natural science) and to devote the remaining decades of his life to the creation of a majestic body of mystical writings. (I believe Eissler's hypothesis about the ability of the genius to reorganize himself at various critical junctures refers to events of this kind.) If the general public has been slow to realize the true nature of Jung's oeuvre, this delay was caused by Jung's extreme caution, explicitly stated in the autobiography, about revealing the fundamentally religious thrust of his work.

One way to sum up Jung's achievement is to credit him with having been a skilled therapist, a thoughtful psychologist, an excellent writer, and a genius of mysticism. Perhaps this set of accomplishments is not too surprising for the son of a cultivated clergyman from Basel—where the university can boast of having nurtured Erasmus, Burckhardt, and Nietzsche—but the hints Jung himself provides in *Memories, Dreams, Reflections* attribute the development of his mystical propensities to the influence of his mother. He implies that his identification with his mother's uncanny immersion in the transcendental led him to the gnostic attitudes that permit a prophetic vocation. Yet for the first thirty-five years of his life Jung was afraid to acknowledge his conviction that he possessed the power to apprehend the Divine. He desperately yearned for paternal guidance, tried to elevate Freud to the status of a guru, and apparently regarded any manifestation of his own genius as a stigma of psychopathology. In other words, he failed to realize that his greatest talent could in any way be of actual service to him.

The history of the development of Jung's talent is very scanty precisely about the crucial events that skewed his repertory of skills

in the direction of mystical thinking. We are seldom if ever in possession of more detailed information about such matters in the case of figures from the past. Unfortunately, one tends not to get data relevant to these issues in the course of performing psychoanalysis, either, for the exercise of talents is seldom regarded as a problem per se, so that their presence is usually simply taken for granted and passed over in silence. In order to obtain such information, it would be desirable prospectively to follow the upbringing of an adequate sampling of children and arrive at correlations of various outcomes with typical transactions in the course of development. Because such studies have not yet been done (and their potential cost is enormous!), we are for the moment constrained to make sense of whatever anecdotal evidence becomes available.

For example, a recent day's newspaper[12] contained an account of the Polgár sisters, three girls then twenty-three, seventeen, and sixteen, respectively, who are among the ten best female chess players in the world. Until now, very few women have achieved the status of "grandmasters," so that this accomplishment of the Polgár sisters is a very rare feat indeed. They are daughters of a Budapest psychologist who was apparently determined to prove that the development of "genius" is a matter of training. He initiated his "experiment" with his first child, Zsuzsa, when she was four; chess was casually chosen as the targeted activity because the little girl showed an interest in it. It is of relevance that neither parent was a serious chess player. No doubt, chess was a happy choice for these well-endowed children, who profited so markedly from the concentrated effort to raise them to be champions in that specific arena. What is of the highest interest is that the greatest "talent" turned out to be the youngest girl, Judit, who was born when Zsuzsa was already well on the road to chess mastery. Thus her training was exactly analogous to that of Mozart in music.

Of course, most parents do not engage in psychological experiments in raising their offspring, nor do they tend to focus the children's instruction on as restricted a field as did the family of the Polgár sisters—or that of the Mozart children. Perhaps more typical of the kind of upbringing that often leads to the crystallization of outstanding talent is the example of the author and filmmaker Marcel Pagnol, as he describes it in a memoir of his childhood.[13] Pagnol was the eldest child of a Marseilles family barely emerging from the working class but solidly established in the social fabric of the region. His father was an *instituteur*—a primary school teacher trained in a normal school and thus lacking a classical education. As

Pagnol remembered his family environment, he was raised in a secure, loving milieu, and he had great admiration for both parents—as the title of his reminiscences, *The Glory of My Father and the Castle of My Mother,* clearly indicates. The author looked back on these beginnings with moving affection and gentle irony, but his portrayal of his upbringing does ring true.

What I have cited thus far is conventional enough, albeit sunnier than the atmosphere in most families. Where Pagnol's experience apparently transcended the expectable norms was in the unceasing instruction provided by his father, a master teacher who never failed to impart relevant information or rational inferences about anything his children encountered. At the same time, the father was a modest person who never overestimated his knowledge or his capabilities and showed himself willing to accept instruction whenever he lacked expertise. In this way, he created an optimal learning environment, and the child Marcel became endlessly curious about the world around him, intellectually precocious, and phenomenally observant about people as well as his physical surroundings—as his films were to demonstrate.

Did these developments presage Pagnol's career as a dramatist and a cinematic *auteur* (a filmmaker who conceives and produces the entire work) who would be elected to the Académie Française? The magnitude of his gifts might have been inferred on the basis of his learning to read, more or less spontaneously, at the age of three, but the specific domain of Pagnol's creative activity could not have been predicted from his childhood interests. As he presents himself in his memoir, the boy was passionately devoted to the kind of life led by his friends in the village where the family spent its vacations—so much so that his empathic mother moved heaven and earth to make it possible for them to go there on weekends as well. Pagnol's younger brother actually chose to become a shepherd in the hills of Provence, and this is the career one might predict for the boy Marcel on the basis of the information provided in the memoir of his childhood. In other words, Pagnol's great literary/cinematic talent was certainly enhanced by his early experiences, but there was no direct correlation between the details of those experiences as he describes them and his creative activities in adulthood. I assume that this lack of specificity is more common than is the pattern I outlined in the instances when a child was from the beginning destined for a particular career.

Having said all this, I must acknowledge that the evidence for the effects of certain kinds of nurture on the development of talents is

not as yet conclusive. If I credit the validity of the anecdotal data I have collected, this bias is justified by the well-documented outcome of inadequate nurture during the early years. We know about the devastating consequences of any deficiency in intellectual stimulation—particularly when this involves the very process of human communication by means of some symbolic system (i.e., either a verbal language or one of gestural signs). The beneficial long-term effects of education at a prekindergarten level on the school performance of large groups of children from deprived backgrounds has been convincingly demonstrated.

It is more than reasonable to assume that the same self-sustaining enhancement of skills will occur with children who do not start out with any particular disadvantage—whenever they are provided with effective training, whether that input is focused on a relatively restricted range of skills or is more broadly applied. Yet we have no information about the childhood experiences that might have developed some of the special capacities of a genius such as Gustave Flaubert, for example. We happen to know about some of these extraordinary endowments, for in 1866 Flaubert responded to a questionnaire (from Hippolyte Taine, who was preparing his book *On Intelligence*) about his powers of imagination.

Flaubert reported that he visualized many more details than he actually included in his descriptions, "In the passage I am writing just now I see an entire set of furniture (including the stains on certain of the pieces); not a word will be said about this." He stated that artistic intuition resembles hypnagogic hallucination: "It flits before your eyes; and that is when you must grasp it, avidly." He claimed that these percepts were so vivid that, when he was writing about his heroine, Emma Bovary, taking poison, he got such a taste of arsenic in his mouth that he began to vomit. Flaubert scholars credit the recollections of the novelist's old nursemaid that the boy Gustave was quiet and meditative, spending hours lost in thought, with a finger in his mouth. I have little doubt that he was already exercising his vivid imagination—but we have no indication that any actual experience could have served to set this process in motion.[14]

In some previous publications about the childhood of persons of genius,[15] I noted that the earliest manifestations of their special talents are often misperceived as stigmata of some sort of defect. I shall discuss this possibility in greater detail in the following chapter; here I merely wish to mention that this was certainly true in the case of Flaubert and his nursemaid: even after the novelist's death, the old woman talked about the boy Gustave as if he had been feebleminded!

CHAPTER FOUR

•

The Burdens of Talent

In certain respects, children endowed with unusual constitutional capacities necessarily behave differently from their peers, if only because of the sheer pleasure of exercising their talent. Such satisfaction will pull them into frequent spells of certain repetitive activities that do not occur with the ordinary child, like the private games my architect-patient had played in the attic. In many cases, their constitutional assets appear, simultaneously, to entail relative handicaps in terms of some other functional capacities, so that (as I mentioned in chapter 2) any particular child may be misidentified as having a deficit rather than potential talent. In any case, it is likely that a child who has the potential to grow up to be a creative person may be atypical in her development. Such a circumstance presents caretakers with a more difficult task than does raising an "ordinary" youngster. Performing well as a parent is, at best, a challenge seldom met with unqualified success; any condition that makes it more difficult will defeat most families. It stands to reason that rearing talented children has turned out to be quite problematic.

Fairly typical of the difficulties of raising a child destined to be a major artist is the history of Lucian Freud—albeit his own accounts have not as yet been subjected to much scrutiny and may in some respects turn out to be the kind of myths Kris frequently found in the biographies of artists.[1] At any rate, the current official version is

that this grandson of Sigmund Freud, raised by wealthy parents in Berlin, joined a delinquent gang at the age of seven. The family emigrated to England as soon as Hitler came to power, when Lucian was eleven, and he was sent to an exceedingly progressive boarding school, where he concentrated on horseback riding—so much so, that he is said to have forgotten German faster than he was learning English.

After several transfers, Lucian ended up at a private art school that he was allegedly responsible for burning to the ground, having engaged in forbidden smoking in bed. He ended his adolescence by running away to join the merchant marine (amid the perils of the Second World War). He apparently enlisted in some irregular manner; he was mustered out because of an illness, the nature of which is thus far undisclosed. (Although Freud is generally secretive, in conformity to family tradition, such a gap in his history suggests that the problem may have been psychological in nature. It may be too embarrassing for a Freud to acknowledge any emotional difficulty.) John Richardson, who met Freud soon afterward at the Royal College of Art, reports that Lucian was the envy of his fellow art students because of his dazzling capacity as a draughtsman.[2] Even if some of the delinquent exploits Freud claims to have pulled off turn out to have been self-promoting fantasies rather than facts, such daydreams must signify that the boy could not tolerate his actual status in an ordinary upper-middle-class Jewish household. (I am skeptical about the reliability of Lucian's accounts because of the frequency of imposture in the life histories of artists, such as those I have mentioned in chapter 1.)

The psychoanalyst/clinician is obviously more likely to encounter creative individuals whose parents failed to solve the problems presented by a gifted child than those whose families successfully mastered these obstacles. Hence I cannot claim to know whether talented children are more likely to develop personality problems than is the general population, although (by extrapolation from my clinical experience) I infer that this hypothesis is valid. What my actual observations do confirm is the finding that the specific configuration of such problems in creative persons is most frequently that of difficulties in the regulation of self-esteem. Talented people, even those with creative achievements to their credit, tend to be very uncertain about their own worth (often fluctuating wildly between extremes of self-depreciation and self-love). They are often excessively vulnerable to criticism; they may angrily attempt to disprove unfavorable judgments of their performance through

renewed creative efforts—or lapse into depression and inactivity. As one author I have worked with analytically told me, "Some of the things I need to be rescued from are publication experiences, and then I write a book to rescue me from a publication, thus guaranteeing a further one, so my career has the general shape of a snake eating its tail."

What accounts for such vulnerability to narcissistic injuries in the very people who, from an "objective" viewpoint, have more reason than most to esteem themselves? In my judgment, this fragility can only mean that such persons have sustained severe wounds to their self-esteem in the past—probably the childhood past—and that current criticism, especially if it is experienced as unjust, is likely to reopen those wounds. In other words, my clinical work with creative people has often led us to the conclusion that, when these persons were very young, the caretakers had seriously underestimated their worth. As I have already stated, in many instances, with the best will in the world, the parents can only view the early manifestations of what will turn out to be giftedness as problematic.

The most dramatic example I have seen of such a misdiagnosis concerned the son of a patient; I have followed the mother's course for half a lifetime. Soon after her baby was born, my patient noted that something was seriously amiss; the pediatrician recommended a neurological workup. The results of this examination were in some ways confusing, but the parents were told to expect severe mental retardation. As a toddler, the child was wild, difficult to soothe, and hard to communicate with. With much coaching from me, the mother made heroic efforts to mitigate these handicaps, but she felt that having a defective child was also an indication of her own basic worthlessness. (For the mother, this almost intractable vulnerability in self-esteem is the problem that necessitated a series of therapeutic interventions scattered over close to forty years.)

In her last visit to deal with her own residual self-contempt, my patient mentioned that her son, then in his early thirties, had become very successful as an audio-engineer. Not only did he have a university degree in this complex technical field; his highly unusual perceptual capacities in the acoustical sphere enabled him to do specialized creative work in the communications industry for which very few others are qualified. The young man had married a defective woman whom he nurtures as his mother once nurtured him; from a social perspective, he might be described as an eccentric—but there can be no question of his superior intellectual capacities in general and of his possession of a rare talent. Will he ever be

able to transcend the consequence of the fact that his mother believed him to be living proof of their joint unworthiness?

In the biographies of certain eminent creative figures, we find echoes of similar misdiagnoses. For example, the poet and philosopher Friedrich Nietzsche was thought by his parents to be mentally retarded because of a delay in the development of his language functions. (I have discussed Nietzsche's development in greater detail in a previous publication.)[3] Among many other greatly talented persons, Albert Einstein also developed unusually slowly in this regard.[4] Nietzsche's family consulted a physician, who misdiagnosed the condition in his turn. Although he did not suspect that the child was retarded, this "expert" falsely attributed the absence of linguistic competence to the ill-effects of overindulgence, and the Prussian regime of frustration he instituted in place of the parents' natural inclinations very likely aggravated the derailment of dialogue between the child and his caretakers.

Nietzsche's exceptional, broadly based talent manifested itself quite early in life: by the time Friedrich reached school age, he arranged elaborate performances of plays he had written for miniature theaters of his own design, with musical accompaniments he had composed, etc. In adolescence he produced some fiction; as a university student, he became a distinguished scholar, granted a doctorate without having to write a dissertation because of the distinction of his earlier publications, and appointed to a professorship at Basel as soon as he received his degree, at the age of twenty-four. As a personality, he was a strange, somewhat isolated person, prone to depression but proudly aware of his vocation as a secular prophet. In his poetry as well as his spiritual autobiography, *Ecce Homo* (the last work he produced before his collapse into confusion, probably due to a brain disease), Nietzsche articulated profound introspective insights: he knew that he was hopelessly disillusioned with people and frozen in his isolation. Because he begins the climactic section of *Ecce Homo* by enjoining the reader not to mistake him for someone else, I assume that Nietzsche was stating that his being nauseated by others was due to the fact that his caretakers had so radically misunderstood him.[5]

Of course, ordinary parents can hardly be blamed for being unable to see past childhood developmental anomalies, still less to discern in them the roots of adult creativity. Medical histories such as that of Nietzsche actually suggest that, in some instances, it is precisely the atypical organization of the nervous system that simultaneously handicaps the person (especially in childhood) and

permits the development of special skills that may facilitate certain creative endeavors. In my clinical work I have encountered a number of histories of this kind; among these perhaps the most dramatic was that of a young scholar whose parents had distinguished themselves as scientific investigators. My patient had failed to achieve creative success, having chosen a discipline precisely because he found it difficult. Both his academic record and aptitude tests indicated that he was best suited to the type of quantitative scientific work in which both mother and father excelled, but this man had, with supreme arrogance, disdained following in their footsteps because any success that might have resulted would have been too easy.

The analysis soon revealed that the patient's grandiosity was borrowed from his mother, who had always treated him, her eldest child, as superior to everyone—except for herself. For example, she taught him to have contempt for his father. Although this was not stated explicitly, the underlying message was that only her blood relatives were persons of real value. That much we were able to learn easily enough; it was much more difficult to discover that, as a small child, my analysand had accepted his mother's unrealistic assessments, however absurd, because they served to deny his own unfavorable conclusions about his worth. These were based on the realization that he was constitutionally defective and, if left to his own devices, unable to perform at age-appropriate levels. Never did his mother indicate, by word or deed, that she was aware of his glaring handicaps; rather, she consistently intervened to assist him to adapt in spite of them. This covert symbiosis did not adequately prepare this man for autonomous functioning as an adult, and it was because of the resultant difficulties that he sought analytic treatment. At the same time, he was always impelled to test his capacity to master any fresh challenge on his own because he was continuously humiliated by his need to depend on the assistance of "secret sharers." It was the characterological attribute of having to deny his handicaps that determined his choice of a demanding career for which he was not as well suited as he would have been for following in his parents' footsteps.

Ultimately, the history of this man's grossly atypical development in early childhood did come to light. Among other handicaps, he was extremely slow to acquire language—unlike Nietzsche, however, he did not eventually become a virtuoso of self-expression. His motor development was also retarded: he had great difficulty in maintaining equilibrium and continued to walk on a broad

base (i.e., with feet planted widely apart) until middle childhood—so much so, that he remembered that, for a long time, he thought of himself as a penguin. Even more troublesome was the fact that as an infant and toddler he suffered from severe digestive disturbances that caused his caretakers great concern and unpleasantness. Although this functional problem was thoroughly investigated, no cause for it was ever found, so that it came to be attributed to a maturational lag of unknown origin. Be it noted that all the childhood handicaps from which this person suffered gradually disappeared in the course of development; by the time he was ready for college, he was functionally adequate in every respect and very superior in quantitative skills. His tragedy was that by then he needed to prove that he could overcome any and all obstacles.

It would be misleading to imply that in childhood the atypical organization that is "talent" invariably shows itself primarily in terms of deficiencies. In the biographies of most eminent people, it is actually the early manifestations of special skills that are likely to be recorded. For example, the copious literature on Pablo Picasso tends to emphasize his interest in drawing at a time when he could only say a few words, his early immersion in art, and his claims later in life that he could draw like the adult Raphael before he reached the age of twelve. As psychologically astute historians have noted, Picasso was a disturbed child; like the analysand I have just described, he felt helpless when he was separated from his family (although in his case, the secret sharer was apparently the father). Although some biographers (John Richardson, for one) prefer to argue with his self-assessment, Picasso was consistent in describing himself as intellectually impaired in childhood; he was especially handicapped in learning arithmetic because he was unable to see numerals as symbols, viewing them instead as concrete representations of figures in action. Moreover, Picasso implied that his learning impairment was pervasive, extending well beyond arithmetic.[6]

In the majority of instances, however, there is no record of any impairment of bodily functions during childhood; rather, talented children are frequently described as psychologically atypical. To be sure, these claims are mostly inferential; they are based on the high correlation in certain groups of adults who engage in "creative" activities (like students enrolled in writers' workshops) between putative talent and depression or talent and "psychoticism"—a technical term applied to a combination of personality characteristics among creative persons also to be found in most people afflicted with psychoses.[7] Some authors rightly view the childhood psycho-

logical difficulties of persons who grow up to be creative as mani-
festations of early injuries to self-esteem; because such injuries
inevitably follow either chronic physical impairment or any consti-
tutionally determined disorder of thought, affectivity, or learning,
"narcissistic" problems are expectable whatever the source of child-
hood handicaps may have been.[8]

I do not doubt that the foregoing correlations, reported by vari-
ous observers, are valid; however, because they are not universally
present, it cannot be concluded that creativity is a reaction to child-
hood depression or to narcissistic injury, as some of these authors
have claimed. The evidence merely suggests that, whenever children
do sustain severe blows to self-esteem, creative success is an effec-
tive way of trying to overcome these wounds, in a manner I shall try
to illustrate in chapter 7. In my clinical experience, early narcissistic
injury is often caused by the disadvantages of atypical developmen-
tal patterns (often confined to the psychological sphere), and these,
in turn, are to be expected in individuals with special talents, as anla-
gen of the functions that will permit superior performance in adult
life.

The degree to which the child's differences from his peers will
impair self-esteem depends on the parents' ability to discern that
these differences may be advantageous. I have the impression that
this may be particularly difficult to do precisely when the potential
talent is truly great. How could Einstein's family have known that
his difficulties in language acquisition were harbingers of an extra-
ordinary capacity for abstract thinking? Why should Flaubert's
affectionate nursemaid have believed anything but the most plausi-
ble alternative, that he was feebleminded?

Because any physical or psychological handicap, whatever its
cause, is very likely to lead to unfavorable consequences with regard
to personality organization, it is extremely difficult (especially ret-
rospectively) to differentiate the original derailment of development
from the psychological complications its presence will inevitably
produce. Let me try to illustrate this difficulty by returning to the
history of the eminent French novelist Marcel Proust.[9] The future
author was sickly throughout his life; he suffered from severe aller-
gies and, from the age of ten on, bronchial asthma. However, there
is no reason to believe that these specific health problems were in
any way connected either to his talent or to his upbringing. The
behavioral manifestations of the transactions between advantageous
constitutional endowment and the child's environment lay else-
where.

Proust was the older of two sons of a distinguished Paris physician and a cultivated woman descended from a family of considerable wealth. Educated at home for a number of years, the boy was eventually enrolled at one of the best schools in Paris, the Lycée Condorcet. Despite spotty attendance due to his poor health, Marcel soon showed an unusual devotion to French composition, arousing the sympathetic interest of an instructor in literature. Proust's writings were often read to the class; however, they struck the other students as mannered and peculiar—only an expert critic like his master teacher was able to discern that these odd performances were signs of a great linguistic talent.

These quasi-bizarre productions actually betray the fact that Marcel was exquisitely attuned to the example of his mother and maternal grandmother, both passionate devotees of literature, whose conversation echoed past literary conventions in a precious and outmoded way. Marcel's ability early in adolescence to adopt their style foreshadowed the path through which he was to enter the literary world: for a considerable period, he wrote pieces for journals in the style of famous authors of the past, making an art out of the despised activities of the pasticheur. Already in his school days this supreme prose stylist was supremely sensitive to the nuances of words and to the music of phonemic juxtapositions.

The defect inherent in these virtues was that the adolescent Proust was utterly unable to establish friendly relations with his peers, who simultaneously found him to be offensively aloof and, in an emotional sense, excessively demanding. No doubt these social difficulties were in part premonitory signs of Proust's homosexual destiny, which appears to have crystallized when he reached the age of seventeen or eighteen. At the same time, these objectionable traits were consequences of the boy's exclusive attachment to and identification with his mother—a conclusion shared by many observers. If in *Swann's Way* the narrator's mother was modeled on Mme. Proust, as is widely believed, she was portrayed by her son as sweet and compliant—a characterization seconded by the novelist's biographers. In actuality, her behavior toward Marcel was often rigid and disapproving, especially about his attempts to cling to her.[10]

Ronald Hayman explains this apparent paradox on the ground that Mme. Proust treated her difficult child in accord with the ill-advised counsels of her own mother. I am more inclined to suspect that, under her yielding exterior, Proust's mother was actually rather self-willed. At any rate, Marcel's insistent clinging had a

decidedly aggressive quality: he consistently forced his mother to abandon her efforts to make him "grow up." When these unpleasant patterns of behavior were repeated with others, they led to their ostracizing Marcel. It is also fascinating to note that, not many years later, as a young man-about-town, Proust became extremely sought after, because he was deemed to be the best conversationalist in Paris. The personality characteristics that were unacceptable in a schoolboy became valued in the world of the salons.

Because we have no data bearing on such a "psychoanalytic" question, I find it impossible to judge whether Proust's mother lost the battle to stop Marcel from clinging to her because on a deeper level she was gratified by his symbiotic wishes or because she recognized, in an empathic mode, that he really needed her to comply. Proust's autobiographical masterpiece, *Remembrance of Things Past*, begins with a section entitled "Overture" that describes such transactions between a child and his caretakers—subtly indicating that his own caretakers' early responses to his emotional needs were crucial determinants of Proust's creative potential.

Proust portrays himself as a child at the mercy of a propensity for overstimulation, one who could only be calmed down by his mother, preferably by her compliance with his demands that she read to him in bed. In the vocabulary of the late nineteenth century, Marcel was overly sensitive, a "nervous child." This stood in marked contrast to the constitution of his robust younger brother. Yet Proust also made it very clear that he only became overwrought at bedtime because his imagination tended to run riot. In other words, these childhood "difficulties" were, at the same time, manifestations of the exercise of skills that were to enable him to compose an immense novel in seven volumes! In Nietzsche's words, Proust's caretakers were guilty of mistaking him for someone else . . .

It would seem that the constitutionally determined "talents" of many children have the potential of giving rise to psychopathology insofar as their early behavioral manifestations have a tendency to be mistaken for difficulties the caretakers have to do their best to eliminate—to suppress at the very least. If the "remedial" measures taken are unempathic and seriously frustrating, they may poison the parent-child relationship, as they did in the cases of both Nietzsche and Proust. In this regard, it is instructive to compare the laissez faire response of Flaubert's family to his peculiarities as a child, and the harmonious relationship this man whom many women loved maintained with his mother throughout her life, to Nietzsche's withdrawal and misogyny or Proust's bitchiness and

sexual aversion to women after the unempathic and/or frustrating upbringing they suffered.

I do not mean to imply that, in either instance, the parents would have been sure to avoid provoking the child's ambivalence if the issues involving the latter's unusual endowments had not arisen—clearly, both mothers were ready to apply draconian methods, despite their affable exteriors, so that power struggles with their eldest sons could well have broken out in any case. At the same time, a manageable equilibrium may be disrupted by a relatively small shift in the balance of forces, so that it would not be safe to assert that these relationships would have ended up as badly as they did without the added burden caused by the misdiagnosis of the children's "difficulties."

Although such a misunderstanding almost inevitably arouses the child's hostility, ambivalence to one or both parents does not, in itself, constitute psychopathology. As I have already mentioned, such a situation will lead to maladaptation if the child reacts to perceived handicaps by denying their significance and lapses into compensatory fantasies of grandiose preeminence (such as that of the young man who felt like a penguin). More frequently, however, pathology ensues because the child comes to accept the caretakers' low valuation of his or her worth. Take the instance of my long-term patient whose son became the prominent audio-engineer. This woman's self-esteem was undermined by the desertion of her father when she was about five years old; she was confirmed in her sense of worthlessness because her mother merely laughed when, a few years later, she repeatedly complained that certain male relatives began to molest her sexually. The coup de grâce came when, in adolescence, the girl became sexually very appealing: the father who had neglected her for a decade now became quite interested in selling her to older members of the criminal underworld as an expensive concubine. She did not find it difficult to fend off these repugnant suggestions, but she did accept her father's underlying value judgment that a woman's intellectual assets count for nothing. She also knew that it was in the undervalued realm of the intellect that she could hold her own with anyone.

As the historical examples I have cited demonstrate, however, the childhood difficulties in adaptation to unusual endowments may also lead to pathology in the realm of human relationships—whether a chilly avoidance of intimacy (characteristic of Nietzsche as an adult) or insistent symbiotic entanglements (like those Proust forged with his mother and later with certain lovers) or labyrinthine

sexual complexities (such as Lucian Freud's innumerable affairs and hordes of offspring). Of course, beyond patterns such as these commonly encountered difficulties in human relatedness, the variety of psychopathological outcomes to be found in creative persons is enormous; this variability is due to the influence of determinants in their character formation unconnected with their endowments as such.

•

The Nurturant Matrix

As I tried to outline in the two preceding chapters, the development of inborn capacities into specific talents that might be put to use for creative work probably depends on a series of facilitating transactions within the child's (and adolescent's) environment. If these potentials are to yield actual results, it is also helpful if the talented individual is spared the development of various psychopathological possibilities that might derail creativity. (I shall discuss the complex topic of the dialectical relationship of psychopathology and creativity in some detail in chapters 8–11.) To be ready, willing, and able to create is certainly necessary for success—but in itself it is seldom sufficient: a specific talent will be properly applied only if the individual's social matrix provides reasonably clear opportunities to exercise it within vocational structures ready to accommodate aspirants.

Stating this truism is merely to underscore the historical fact that creative activities of particular kinds are much more likely to take place (or at least to yield memorable results) at certain times and places than at others. It is a commonplace that Athens in the fifth century B.C. or Florence in the fifteenth century A.D. were loci of a remarkable creative efflorescence—or that, throughout the twentieth century, a surprisingly small number of academic centers in Europe and North America have garnered most of the Nobel Prizes in science. Although we cannot rule out that these outcomes might

have resulted from some serendipitous concentration of unusual talent within certain restricted populations, it is much more reasonable to attribute these extraordinary achievements to the operation of felicitous social structures that privileged the creative domains involved in such stellar production. Where there are no facilities for scientific research, there is no realistic chance of developing world-caliber scientists. Stone age cultures cannot produce writers but may develop numerous musicians. And so on.

The societies that most successfully foster creativity in any particular domain are those in which the relevant discipline is organized in a manner that searches out and recruits youngsters with the requisite talents and motivations. The most dramatic instance of the unlikely discovery of a young genius that has come to my attention (through my psychoanalytic work, as it happens) concerned a man who was raised in a provincial backwater and groomed to become a clergyman. After attending a junior college near home, he received a scholarship to one of our most celebrated universities on the East Coast, where he intended to study theology. Exposed for the first time to a pluralistic environment and to religious conceptions different from those with which he had been reared, this naive adolescent lost his bearings and became highly disturbed. It is not irrelevant for my thesis that he was able to obtain excellent psychotherapeutic assistance at the university health service—without this, it is highly probable that his history could have ended in tragedy.

But the crux of the story begins with the fact that, while still greatly upset, this person attempted to calm himself by trying to solve some mathematical puzzles he had come across on campus. One of these was a problem that had never been solved before, and, to his astonishment, this untutored amateur thought he found its solution. He could not actually believe that he had it right—he suspected that he was deluding himself—and he hastened to the department of mathematics to get an expert judgment on the matter. It is remarkable, as well as reassuring about our best educational institutions, that he received an attentive hearing, confirmation of his solution of the problem, and an urgent invitation to change his vocational plans because of his enormous potential in mathematics. In the interest of confidentiality, I must confine myself to the statement that he did not disappoint the talent scouts who discovered him.

The point I have tried to make with this vignette is that the mathematical community more than met this talented recruit halfway. In the first place, it was not sheer coincidence that the materials on

which he assayed his capacities came to his attention at this university. Moreover, the professor he consulted was receptive and competent to determine the value of his work, and, even before the climactic episode, scholarship funds had been available to bring him from rural isolation to this intellectual acropolis. Finally, the university provided first-rate psychiatric services for its students, and was thereby instrumental in keeping him productively engaged in the highest intellectual pursuits. Most mental health professionals are familiar with numerous case histories that provide the sad counterpart of this happy transaction.

To give a simple example of wasted talent: one of my patients acquainted me with the history of his older half-brother in the course of mourning the latter, who died in the middle of my work with this analysand. The brothers were brought up in an immigrant environment in an Eastern metropolis, sons of the same mother but different fathers. The family was adequately provided for until the patient's father deserted them when the boy was five and his brother was twelve. In the ensuing financial emergency, the older brother, who had hopes of becoming a violinist, drifted into jobs requiring heavy physical labor. Eventually he dropped out of high school and wound up working for a beer distributor, delivering enormous kegs to taverns. Needless to say, by the time he was eighteen, his hands were so badly injured that he could no longer play a musical instrument. . . . Of course, with the handicaps of such an awful home environment, this poor youngster might not have done any better even if he had shown signs of genius in some field that did not require bodily integrity for its practice.

In the past fifty years American society has been prosperous and liberal enough to give most of its young a very broad range of opportunities to make the best use of their talents. However, there have been numerous exceptions, even during this sevenfold succession of "seven fat years," providing striking reminders of the importance of appropriate institutional supports for creative activities. For example, the world of American ballet has been organized in a manner making entry into classical dancing all but impossible for most aspirants. The most difficult obstacle has been the fact that the kind of advanced training that will prepare a dancer to become a true professional has, for the most part, only been available in New York City. This constraint has meant that youngsters unready to live independently (that is, the great majority of adolescent ballet students) could only attend these specialized schools if their families were in a position to move with them—an impossible condition for

most.[1] Similarly, ballet has been widely viewed in America as a feminine activity; this prejudice has until relatively recently discouraged boys from pursuing a career in this field, particularly those who were afraid of being regarded as homosexual.

In an important sense, therefore, the nurturance of creativity is a function of socioeconomic and political choices. Witness the vitality of musical life in Germany, where ample public funds are devoted not only to the organization of performances but also to the construction of concert halls and theaters, the support of conservatories, and to the musical education of children. American singers and conductors could scarcely count on surviving without the opportunities available to them early in their careers in Germany and other European countries with comparable policies. In recent years French musical activities have greatly improved, even in the provinces, as a result of deliberate government decisions.[2] Such quantitative and qualitative improvements doubtless encourage more youngsters to pursue musical careers.

Our native tradition of voluntarism in support of music is scarcely sufficient to sustain activities beyond the ambition of church choirs—indeed, we are currently seeing the collapse of symphony orchestras and dance ensembles in several of our major cities. If the trend continues, more youngsters with the talent to become performing artists will choose to enter nonmusical domains. (Witness the near collapse of graduate programs in the humanities in the recent past because of the difficulty of obtaining teaching positions in these fields.) In all likelihood, as public exposure to classical music diminishes, public support for maintaining the infrastructure it needs will shrink even further. As Einstein reportedly said when queried about the consequences of the nuclear age, "No more Mozart." In an electronic age perhaps Mozart will be available only on your television screen. Who will then bother to learn to perform him?

Instead of further elaborating the institutional aspect of what it means to provide opportunities for creative activities, let me focus on one of the most essential preconditions for recruiting appropriate prospects into creative fields of endeavor—the availability of inspiring predecessors, generally in the role of idealizable teachers. This prerequisite for adopting a particular career is probably a byproduct of the dynamic social conditions of the modern world; in static, preindustrial societies there was little leeway for occupational choice: the vast majority of children identified with the social role enacted by the parent of the same sex, usually as a result of the age-

appropriate, idealized conception of "father" or "mother." Not only were the children of peasants likely to remain peasants, and those of aristocrats to become ladies and gentlemen—musicians bred musicians, artists produced artists, and so forth. (I shall present a prototypical example of such a destiny, that of Eugène Delacroix, in chapter 15.) The broadest avenue of social mobility was formerly that of careers in religion.

We may glimpse the effects of the social structure before the modern age on the development of a creative genius in the story of Mozart's education for a musical career in the third quarter of the eighteenth century.[3] Mozart's father, Leopold, was a violinist and composer employed at the court of the Prince-Archbishop of Salzburg. Wolfgang was the younger of two surviving children; as I have already mentioned, his sister Nannerl preceded him in joining their father in the profession of music. The children were "educated" at home; aside from literacy, this training consisted solely in learning music. Both children were taught to play keyboard instruments and became performing prodigies. The entire Mozart family went on lengthy concert tours featuring these child virtuosi; Leopold acted as their canny impresario. No such force-feeding of a musical prodigy is permissible in the contemporary world, which would rightly look upon such exploitation as child abuse.

Leopold Mozart was discerning enough to realize quite early in Wolfgang's life that the boy was endowed with dazzling musical talent. He taught him composition, so that the child was able to write symphonies by the time he was eight years of age. On their travels, he brought Wolfgang into contact with greater musicians than was Leopold himself, like Johann Christian Bach, whom they met in London. This careful guidance culminated in taking the fourteen-year-old Mozart to Bologna to study with the greatest music master of the time, Padre Martini. The fact that after a few weeks of instruction the latter awarded the boy a degree from the musical academy put an official seal on Mozart's status as a composer of genius. Shortly thereafter, Wolfgang was commissioned to create operas for Milan—an honor so great that henceforth he must have had difficulty in maintaining an idealized image of his father. In the last twenty years of his short life, Mozart encountered only one musician, Josef Haydn, from whom he could profitably learn more about his craft, but he remained open to influences from those he could admire, like this great Austrian predecessor. Of course, this is merely the brighter side of the story of Mozart's upbringing; its dark underbelly was the devastating effect such parental exploitation had on

the boy's character. Contrary to the picture of the great composer's fecklessness propagated recently on stage and screen, more sober assessments view his behavior as ruthless and delinquent.[4]

It is uncommon to find similar examples of parental influence in the modern world, although at the end of the nineteenth century, in provincial Spain, Pablo Picasso could still be trained almost entirely by an art teacher father.[5] Nowadays, one is more likely to hear that the impossibility of using the natural parents in various respects as role models has damaged their offspring; this is particularly true if the latter wish to pursue creative goals. Such complaints have been most explicit in terms of the handicaps suffered by women whose own mothers confined themselves to the traditional division of labor within "patriarchal" families. Whenever the daughters of these housewives attempt to devise for themselves a different life plan, they find that, all too often, a primary identification with the mother's way of life deflects them from their vocational goals and interferes with their creativity.

Of course, there are many children able to identify with whatever admirable qualities their parents possess and to put these to good use in activities different from those pursued by the latter. For instance, the past generation has produced for the first time a fair number of female mathematicians; these women clearly did not literally follow in the footsteps of their mothers. Some years ago a survey of American women in mathematics revealed that most of these individuals had identified with the quantitative interests of fathers to whom they had been unusually close.[6] In other words, the crucial identification opening the way for a creative career may be with any specific quality of either parent and need not involve that person's actual profession.

If a talented child forms early identifications encouraging creative activities (better stated: identifications that do not interfere with a quest for novelty and excellence), she will be able to profit from the assistance of a succession of teachers and/or mentors. In the absence of living figures able to help the youngster to cross the gap between a dimly perceived talent and a definite vocation, a would-be creative person is forced to find some idealized model in historical accounts about the great achievements of the past. In my own field it is extremely common to hear that a person decided to try for a psychoanalytic career, often in adolescence or shortly thereafter, because of the inspiring example of the founder of the discipline, Sigmund Freud. The story of Louis Pasteur has attracted generations of students to biomedical research—and that of Marie

Curie made the physical sciences appear both accessible and glittering for an increasing number of women. And so on. The unfavorable side of this same coin is the seductive pull exerted by the idealized predecessor's specific interests and activities, which may deflect the youngster from his optimal field of endeavor into following that of the person idealized in too literal a manner.

The way in which the specific interests of particular mentors may pull talented students into the discipline of the older person is illustrated with special clarity in the case of Sigmund Freud.[7] As he was finishing secondary school, this brilliant student was toying with the idea of a career in public affairs. At the last minute, so to speak, upon hearing a presentation of an essay "On Nature" (then attributed to Goethe), Freud was flooded with enthusiasm for natural science and enrolled in the relevant faculty at the University of Vienna. The most inspiring professor he encountered there was the philosopher Franz von Brentano, with whom he was able to arrange a private tutorial; at that time Freud expressed the wish to obtain dual qualifications in science and philosophy. Nothing could illustrate better the importance of an idealized model in determining a talented youngster's choice of vocation. Although he did not persist in pursuing his overambitious plan, Freud's ultimate intellectual domain, psychoanalysis, combines within itself aspects of both natural science and speculative philosophy.

As he pursued his biological studies, Freud began to work in the laboratory of the great physiologist, Ernst Brücke. He immersed himself in the research conducted there and spent more time with Brücke than the minimum required to obtain his medical degree. It was only the pressure of having to earn a living, once he decided to get married, that pushed Freud to commit himself to clinical medicine. (He had no realistic hope of academic advancement because of the growing anti-Semitism of the educational establishment.) As he separated himself from Brücke, Freud adopted the clinician and researcher Josef Breuer as his model and, under his influence, gravitated toward clinical neurology. Eventually he obtained a travel grant to study with the eminent French neurologist Jean Martin Charcot. As his letters from Paris reveal, the young provincial from Vienna was dazzled by Charcot as a man, as a scientist, and as a pioneer in the study of psychological phenomena.[8] On his return from Paris, Freud began his own neuropsychiatric investigations, which led, within a decade, to his development of psychoanalysis. Clearly, inspiring mentors were like a series of magnets pulling the young Freud in the direction of their own specific activities.

In many instances the crucial intervention on behalf of a talented child takes place much earlier in life than the foregoing events did in the case of Freud. Such transactions tend to be overlooked in the biographies of historical figures, and the people who made a decisive difference for their future creativity generally remain anonymous. I can provide a prototypical example of such a decisive intervention from the history of one of my analysands, the young woman of great promise who became a millionaire by thirty after attending an Eastern university on a scholarship. The relevant events took place when this girl was in the fifth grade of public school.

The child was the younger of two daughters of a shady business-man and his socially well-connected, bridge-playing, frivolous wife. The older sister was an extremely disturbed, difficult, and cruel girl whom the parents tried to avoid as much as possible. Because in age the children were less than two years apart and my future patient was precocious and responsible, the parents pretended that the sisters were twins and insisted that they do everything together. In this way, the younger child gradually became her sister's keeper. Although this enforced, fictive twinship stimulated her intellectual development, it also caused her to share the sister's chronic unhappiness: the children became more and more alike.

In fifth grade, her teacher was an unmarried young woman who showed real enthusiasm for her work and soon noted this child's unusual intellectual precocity. She began to guide the student's extracurricular reading, lent her books, and arranged to discuss these with her, so that almost every day they spent some time together. These tutorial sessions soon shifted to the teacher's home; the child began to do some of her reading there, in comfortable silence. In this benign setting, the ten-year-old grasped the unfairness of her assigned role at home; her underlying depression surfaced, and she frequently found herself in tears. The teacher never made any explicit inquiry about what was wrong—I believe she must have discerned the truth without that—and she never made any pseudotherapeutic comment. She indicated concern, tolerance, understanding, sympathy—largely without using words.

The girl's parents soon noticed a difference in the child's attitude about the onerous burden they had thrust upon her, and they tried very hard to break up her relationship to the teacher, whom they accused of sexual improprieties with their daughter. Ultimately they effected the separation they wanted by sending the child to a private school. However, they could never regain their daughter's loyalty; she permanently repudiated her mother's shallowness and her

father's dishonesty. What the teacher had given her was a value system espousing Truth, Honor, Justice, Freedom, and Dignity. This woman's later successes in life were founded on these values, but her identification with the teacher did not involve the latter's *vocation*. Incidentally, it is worth noting that this childhood experience of disinterested succor from a relative stranger served as preparation for this young woman's capacity twenty years later to make optimal use of psychoanalysis.

Instead of describing further examples of felicitous guidance provided for talented children by idealizable and idealized adult mentors, let me turn to a different component of a social matrix organized to promote creativity: a cultural ethos that attaches a high valuation to the creative domain for which the individual is best suited. I put this in terms of the standards that prevail in the dominant culture, rather than those of the child's family as such, because it is extremely difficult for children attending school to preserve the cultural attitudes of their parents if these are notably different from those of the great majority of fellow students, not to speak of the teachers.

It is a sociological commonplace that the children of immigrants tend to be ashamed of their parents' lack of acculturation, even if the latter belonged to an elite in their country of origin. Conversely, immigrants who do not want their children to be assimilated into the dominant culture of their new country make great efforts to set up self-contained communities confined to their own cultural subgroup. To retain the younger generation within the orbit of that subculture, it is generally necessary to provide it with separate schooling, even if it has to be conducted bilingually. In American conditions, the melting pot has almost homogenized at least those portions of the population with European ethnic roots. Since the advent of television, the power of the dominant common culture to penetrate every home has been well-nigh irresistible. Nonetheless, some children are still raised in circumstances that cause them to adopt goals and values markedly different from those of the majority around them.

The example I wish to offer concerns someone who was, in fact, descended from a family prominent in his home state for 350 years. He was, however, raised in a small rural town where his father was one of the few persons who had professional status. In this Southern setting, the care of children in such a family was relegated to African-American servants; partly in consequence and partly because of parental limitations, my patient's only sibling, an older

brother, grew up to be something of a cracker, without much connection to the heritage his forebears had succeeded in transmitting over the centuries, from generation to generation. For complex reasons, my analysand did absorb that heritage, largely because he became close to his maternal grandmother, the best living exemplar of that aristocratic tradition. Through her he was stimulated to become interested in high culture. Unfortunately, this elderly lady died when he was still small.

Before the age of ten, this youngster felt himself to be utterly alone in his attitudes and interests within the community. Other children, including his brother, also noted these facts and reacted to the exception in their midst with mistrust and hostility that frequently spilled over into outright persecution.[9] The patient's father also viewed the boy's interests with suspicion—largely because of his hatred of his late mother-in-law, which caused him to look upon any child of his who admired her as a traitor. The mother, caught in the cross fire of a persistent feud between her husband and her family of origin, withdrew into religiosity; the boy was able to share her spiritual fervor, which provided him with the sole unconflicted point of contact with his cultural milieu. Unfortunately for him, his mother also died before he reached adulthood, and without her he was unable to maintain his ecstatic immersion in Christianity—or to conceive of committing himself to a religious vocation.

As it happened, the youngster's greatest talents seemed to lie in the visual-motor sphere; they initially manifested themselves as a skill in drawing—an activity the boy pursued almost in secrecy. Not only was there no art school anywhere nearby, the child never encountered anyone who thought of the visual arts as activities through which one could earn a living. They were universally regarded, instead, as the ladylike avocation of wealthy dilettantes. From the child's point of view, his interest in practicing art was not only without real value—it was a shameful mark of his lack of manliness. Small wonder that the boy did not pursue this depreciated activity and never even considered the possibility of a career in art, despite ending up at an excellent university where, at least with the faculty, the prejudices of the rural backwaters did not prevail. Not the least among the reasons that necessitated this person seeking psychological assistance in middle age was his chronic bitterness about having been diverted from the artistic vocation to which he felt himself best suited. But, unlike Paul Gauguin, who came from a milieu in which Art was highly honored, this man could not contemplate abandoning the practical vocation he had chosen as a youngster.

Perhaps the power of the cultural matrix to determine the fate of a talented person is even better illustrated by circumstances in which, contrary to the above example, the culture outweighs the discouraging effects of familial attitudes. One case of that kind, almost the exact converse of the pathetic story I have just recounted, is that of Paul Cézanne, who triumphed over similar beginnings to become a great painter in the proud tradition of French art. Cézanne's father was of peasant stock but became a successful small entrepreneur and eventually a banker—a shrewd and autocratic man, essentially uneducated and provincial in his outlook, he grew to be the wealthiest citizen of Aix-en-Provence, a small cathedral town not far from the Mediterranean coast. The future artist's mother was a servant girl; she conceived him out of wedlock, although the parents were married a few years later. Needless to say, this family wanted their son to take over their successful business; yet they did want him to be well educated, which meant that Paul was encouraged to study law.[10]

Cézanne attended the public schools in Aix and received the standard classical education of a mid-nineteenth-century French lycée. As an adolescent, he became one member of a clique of boys passionately interested in the arts, especially poetry. One of these companions, and Cézanne's best friend, was Emile Zola, who was to become the most eminent French novelist of the late nineteenth century. These friendships supported Cézanne in transcending the limitations of his family and emboldened him to leave law school. (Be it noted that Aix was no backwater: it had a university, a celebrated municipal library, in addition to its churches crammed with art treasures, and while Cézanne was an adolescent the well-known local painter Granet bequeathed a superb collection of art to the municipal museum!) High culture had been honored in neighboring Marseilles for twenty-five hundred years. Whatever Cézanne's father originally had in mind for his son, he would not have thought of depreciating artistic aspirations as unworthy of a man— if anything, it was more likely that he did not feel that the family had achieved sufficient status to justify his son in pursuing such a bourgeois way of life. (I shall return to the case of Paul Cézanne in chapter 14.)

Contrast the momentum of Cézanne's adolescent evolution in Provence, from the status of the child of uneducated nouveaux riches to that of avant-garde artist, with the roughly contemporaneous case of the pioneering Russian novelist Ivan Turgenev. Turgenev was the younger son of an irresponsible and impoverished aristocrat married to a vulgar, rich woman who was the tyrannical owner of an

immense estate and five thousand serfs in the province of Orel (between Moscow and Kiev). Turgenev's father resigned from the army to spend his life in chasing game and hunting women; he died when Ivan was sixteen. The mother gave her sons a conventional education designed to prepare them for aristocratic careers in military or civil service. She did not mind if Ivan dabbled in poetry and published it at his own expense, but she adamantly opposed his becoming a "scribbler."

Turgenev managed to obtain a command of European culture by spending several years at the University of Berlin, but at the age of twenty-five he seemed ready to sink into the idle life of St. Petersburg society. At that decisive juncture he fell in love with a visiting opera singer, Pauline García Viardot, and managed to befriend her husband and manager, Louis Viardot. This triangular relationship blossomed with the Viardots' successive visits to St. Petersburg, until Turgenev was invited to stay, more or less permanently, at their country house at Courtavenel, not far from Paris. He spent the next seven years there, before trying once again to settle in Russia, an experiment that did not prove to be successful. In the cultivated milieu of serious artistic commitment at Courtavenel, Turgenev was stimulated to begin producing his masterpieces of Russian prose.[11]

There has been a great deal of fruitless speculation about whether or not Pauline Viardot ever reciprocated Turgenev's passion and curiosity about the possibility of a sexual affair between them. (Turgenev was appealing to many women and certainly did not lead a celibate life.) From the viewpoint of Turgenev's creativity, such questions are irrelevant. Whatever Turgenev and his muse may have done in private, the primary role of Pauline in the novelist's life was that of a secret sharer—a veritable alter ego whose example overcame his identification with his father's idleness, lack of discipline, and self-indulgence. Moreover, Louis Viardot, about twenty years older than Pauline or Ivan, was not only a competent business manager; he was a considerable intellectual, able to be a mentor to young people of promise. It was no coincidence that Pauline García had married him on the recommendation of the eminent novelist George Sand, who wanted her young friend to avoid the pitfalls in the path of a female artist in the early nineteenth century—the errors of youth that had made Sand's own career so difficult. From this perspective, the Viardot-García marriage was highly successful: Pauline exploited her talents to the full and became a celebrated artist; moreover, she avoided the personal misadventures that had

ruined her older sister, María Malibrán—a singer of unmatched endowments. Courtavenel was home to what remained of the García clan, for several generations Andalusian musicians of great accomplishment. (There was no place like it in all the Russias.) To be sure, the other giants of nineteenth century Russian letters did not need to go abroad to find their way to a literary career—but neither did they have to overcome the handicaps of Turgenev's childhood exposure to tyranny and degradation.

Let me attempt to underscore my point by asking whether Arshile Gorky could have become a great avant-garde artist if fate had permitted his family to continue their life in Turkish Armenia. We do know that he began to draw and carve by the age of eight— such a village boy in Xhorkom could have become a craftsman of genius or a folk artist. It is conceivable that he might have enrolled at an Armenian educational institution under Russian control and, as a very remote possibility, that he could have made his way from Yerevan to Moscow to study art. We may infer that such is the life he wished he could have lived, judging by his mythical tale of having studied with Kandinsky there. But the Soviet Union utterly crushed the artistic avant-garde within its jurisdiction—only the lucky few who could manage to go abroad, like Kandinsky or Chagall, were able to pursue their own creative aims. Those who were still there in the mid-1920s (when Gorky might have arrived in Moscow in our hypothetical scenario) were not permitted to do so: Malevich, Rodchenko, Tatlin, and others perhaps less well known were all forced to turn their primary attention away from painting.[12] What could a person of Gorky's temperament have done in such an environment? Could he have escaped disappearing into the Gulag?

PART THREE

•

The Struggles of a Creative Life

•

The Price of Commitment

Most academics are thoughtful individuals who concern themselves with the unsolved conceptual and pragmatic problems of their discipline; it is therefore quite striking that relatively few among them pursue creative scholarship or research; steady productivity is demonstrated by a tiny minority. A number of my patients as well as friends in the academic community, knowing that I have the highest respect for their talents, have confided in me their regrets about an inability to put their conclusions, however significant, into written form. I have sometimes responded, with a combination of naïveté and attempted helpfulness, by assuring them that they could accomplish what they wanted to do by systematically training themselves to follow orderly habits of scholarship. The most insightful of my friends finally stopped my provision of thoughtless advice by telling me that these activities might be manageable for certain unusual personality types but that most people would be unwilling voluntarily to condemn themselves to the solitude they require.

Indeed, most creative activities have to be pursued in solitude, and few people agree with the Franciscan motto that this condition is blessed. The great exception to this rule is the case of the performing artist—a matter to be discussed more extensively in chapter 12. Psychoanalysts, who have chosen a profession practiced in condi-

tions of enforced intimacy, are not likely to welcome the isolation necessary for drafting lengthy manuscripts, to give only the most obvious example of a temperamental preference militating against creative endeavors. The employment of ghostwriters is not entirely unknown in scholarly fields. Such surrogates often come cheap, especially in comparison with the rewards of nonscholarly activities such as consulting. Remember, hardly anyone gets paid for attempting to do creative work—at least not much! It is all done "on speculation," as a labor of love, at worst as a requirement of academic tenure.

Three generations ago Sigmund Freud asserted that the creative artist is motivated by fantasies of gaining fame, fortune, and romantic love.[1] To my surprise, in clinical work, I have never found such considerations to be of major significance for the creative persons who have consulted me—not that any sensible person would *object* to any of these desiderata, of course. However, most of my patients learned early in their careers that there are easier and better ways to obtain the good things in life than the pursuit of creative goals. As a matter of fact, in most social settings embarking on a creative career entails sacrificing one's opportunities for such marks of worldly success. It is true, of course, that an occasional artist, scholar, or scientist wins the lottery, so to speak. The Pop artist Andy Warhol, who was such a "winner," is alleged to have made the brilliant sardonic comment, "In the future, *everyone* will be famous for 15 minutes."[2]

Perhaps it is easiest to demonstrate that the creative life generally entails substantial *financial* sacrifices—so much so that one can only sympathize with the bourgeois parents who try to steer their offspring into more "rewarding" endeavors like business or the law. It is true that nowadays great artists are not likely to fall into active destitution, as van Gogh and Gauguin did a hundred years ago: they are generally able to eke out a modest living as instructors of the next cohort of their discipline. Scholars and scientists tend to do even better: in Western societies they belong to a comfortable upper middle-class—like the Mandarins under the Chinese empire. However, even within these more remunerative fields of endeavor, the greatest financial rewards go to those who concentrate on management, rather than directly on creativity. And the talented people who make a go of creative enterprises would, in all likelihood, do just as well in even more remunerative occupations, with a corresponding increase in financial returns.

Whatever changes in the social setting have occurred over the past hundred years, it is still instructive to review the case of Paul

Gauguin in terms of the stark choices that confronted him because of the financial implications of his creative ambitions.[3] Gauguin had attained a comfortable standard of living as an employee in the world of finance, and he had a growing family when, in the mid-1880s, he decided to switch from being a Sunday painter to a full-time commitment to his art. His hope of earning his way by selling his work proved not to be realistic, and (as I have recounted) he was soon forced to take his family to Denmark, where his wife's relatives were in a position to offer some support. These sober burghers had no confidence in Gauguin's future as an artist and tried to push him into commerce. It was in this context that Gauguin decided to return to France, without his wife, and to stop fulfilling his family responsibilities—moreover, he never forgave those who "abandoned" him by failing to support his creative goals. It is worth recalling that, in the eighteen years of life that were left to him, Gauguin never again achieved financial security, except for a brief period when he received a small inheritance from an uncle.

It is scarcely surprising that individuals less ruthless and egocentric than the ferocious Gauguin tend to abandon their creative ambitions in preference to sacrificing opportunities for family life and bourgeois comforts. Even today, without receiving massive family assistance, such choices are scarcely avoidable. In contemporary America assistance is most frequently provided by a supportive spouse. But who can blame a husband or a wife for resenting the necessity to subsidize the creative efforts of someone who does not seem to be achieving obvious success in these endeavors? (This is particularly true whenever it seems probable that the creative partner could better contribute to meeting family needs by doing something immediately feasible that is well remunerated.)

For most individuals the choice for or against the creative career has to be made well before it is possible to think of marriage; the conflict has to be resolved in the context of their family of origin. To illustrate, I can cite the case of a professional woman who originally wanted to become a ballet dancer. This ambition was not in any way unrealistic: she had begun training at an appropriate age and competent judges gave her strong encouragement about her talent. When the time to apply for college was approaching, this person wanted to gain her father's approval for her vocational plans. Although her parent merely indicated that he would be concerned if she undertook any risky venture, such as a career in dancing, this unselfish and conscientious young woman decided that she could not ask him to finance an enterprise that made him uncomfortable.

Although the abandonment of her ambition made her somewhat bitter—when she began analysis with me, she felt that her father had forced her through emotional blackmail to pursue the safer option of college—she simply could not bear to ask her father to carry a burden of discomfort for her sake.

Difficult as the financial sacrifices required of creative people may be, these are by no means the greatest of the obstacles they face. As we may infer from the case of the aspiring dancer, the issue of money often screens underlying emotional concerns, in any case. Many families are in fact able to subsidize their offspring financially without being unduly burdened—some may even be willing to invest in a creative future at considerable cost to themselves. Promising individuals are sometimes able to find a spouse willing to shoulder the burden of supporting them while they prepare for a career. It is probably easier to overcome the financial problems inherent in creative work than it is to brave the unfavorable effects of such endeavors on personal relationships. Never was Freud further from the truth than in his implicit endorsement of the fantastic hopes of those creative people who think that their activities will be rewarded with love.

As it happens, I have had occasion to ascertain why Freud might have been misled on this score: almost thirty years ago his daughter Anna invited me to interview her in her father's last consulting room in London, and I used the opportunity to question her about his work habits. She informed me about his unusual capacity to persevere in his efforts for long periods; when in response I expressed astonishment about the amount of time he was able to devote to scholarship, she agreed that he was unusually energetic in intellectual pursuits. After a pause for reflection, she added, "Of course, my mother and I devoted our lives to making this possible for him." Greater love hath no man.

In contemporary circumstances that kind of good fortune does not seem to be common. Nowadays, women who sacrificed themselves in that manner might be regarded as traitors to their sex and as the lackeys of an illegitimate patriarchy. Certainly, in the bad old days of patriarchal society, despite an occasional exception such as Mary Ann Evans (better known as the novelist George Eliot), no *woman* could count on loving support for any creative ambition; with gender equality the accepted ideal in cultivated circles in our own time, neither men nor women can do so. The feminist critique of the sins of patriarchy is surely valid, but it needs to be supplemented with the realization that *all* creative persons (not only

women) are feared, envied, and hated by large segments of humanity (possibly including their spouses). Alexander Solzhenitsyn, in most ways a relic of a previous era, has managed to find a spouse who abandoned a career in mathematics to become his factotum and amanuensis. Of course, he also happens to be the twentieth-century artist most bitterly attacked for his creativity, which his enemies rightly regarded as capable of undermining the Soviet system.[4]

I can illustrate such attitudes of envy by citing the experiences of an analysand, a budding writer who made many attempts to find a spouse. All too often, otherwise eligible young women expressed surprise and disappointment about the seriousness of his goals; as he once put it, "She expected me to write for *Popular Mechanics!*" Others were morally outraged about his taking advantage of the opportunity to devote himself entirely to his writing, without having to earn a living by holding a job at the same time. For several years he never encountered anyone who could even imagine that, if they had children together, it might make sense to exempt him from the chores of child care to allow for more concentration on his creative work. If, in the 1890s, Sigmund Freud had been expected to share the burden of raising his six young children, would he have been able to produce *The Interpretation of Dreams*? His daughter's testimony implied that this was much to be doubted. If Paul Gauguin had continued working as a salesman of tarpaulins in Denmark, he certainly would not have become the greatest of the Symbolist painters.

It is scarcely surprising, but maximally discouraging, that a person with creative achievements is least likely to receive positive feedback from those most qualified to judge the value of those accomplishments, his peers within the same discipline. The very fact that a person hopes for such feedback is likely to be perceived as peevishness and an arrogant assertion of superiority. Professional rivalries are often as poisonous as the negative advertisements through which political adversaries try to discredit each other. In the arts, where published reviews constitute the initial, often decisive, assessment of the merits of the work, it is not uncommon for critics to assume a depreciatory attitude, as if they were in principle superior to the people whose creations they evaluate. Currently, it is fashionable to deny that there is such a thing as a masterpiece or that those who produce what were once designated as such deserve to be called geniuses. It takes a great deal of personal charisma to overcome these reactions of envy and malice and earn public appreciation for creative work. Ironically, those who do succeed in making

themselves into superstars, like Andy Warhol or Jeff Koons, have to swallow the chagrin of knowing that they have been accepted for a spurious reason, their talent for publicity rather than the merits of their work. The achievement of fame through the simple expedient of becoming famous is, of course, somewhat akin to imposture.

In parallel with the danger of being admired for their personality rather than their accomplishments, creative individuals also run the risk of being exploited by certain associates who wish to share their prestige without caring for their person. The situation is exactly analogous to that of the very rich, who always have to be concerned about being sought out only for their money. The problem is particularly acute in relation to the creative person's parents, who are the persons most likely to derive narcissistic gratification from having spawned a prestigious child.[5] But the issue does not stop with blood relatives: the world is full of celebrity collectors. Witness the amatory career of that femme fatale, Alma Mahler: after the death of her husband, the composer, she was successively involved with the painter Oskar Kokoschka, the architect Walter Gropius, and the novelist Franz Werfel. Speak of "publish or perish."

If creative success does not guarantee the love or money Freud imagined as the artist's desired rewards, it is reasonably likely sooner or later to lead to some measure of "fame," if only in knowledgeable circles within the creative domain concerned. Because the prestige of various fields of endeavor differs widely from one social setting (or one historical period) to another, the attraction of a particular domain for ambitious youngsters will differ, depending on time and place. Although there are some exceptions (rare individuals who are either indifferent to the lures of fame or even aversive to them), most talented people tend to gravitate to disciplines successful practitioners of which are likely to be widely honored. It is no coincidence, therefore, that in most societies persons of upper-class origin devote their creative potentials primarily to public service, business, and philanthropy (rather than to the arts, sciences, or scholarship)—these preferences reflect the ethos of their forebears.

It takes truly unusual personal experiences to override the force of such traditions: for example, Charles d'Orléans (1394–1465), probably the first major European poet of royal blood, turned to literature while he spent twenty-five years as a prisoner of war in England. Several titled noblemen who devoted themselves to the arts, like the painter Henri de Toulouse Lautrec or the poet George Gordon, Lord Byron, suffered from bodily deformities that precluded success in the usual pursuits of the aristocracy. That supreme

novelist, Count Leo Tolstoy, became a double orphan by the age of nine. I hardly need to add that the specific traditions these men abandoned on an individual basis have in the twentieth century all but disappeared as social phenomena. It therefore stands to reason that a successful artist might in this age decide to pass himself off as a Count de Rola, as the Franco-Polish-Jewish painter Balthus has done, unembarrassed by widespread knowledge that he has created a fiction.[6] (Nothing is sacred anymore . . .)

The point I am trying to make through the foregoing examples is that loyalties to class, creed, and nation have been powerful deterrents in terms of potential commitment to particular creative activities. In the fifteenth century a member of the French royal family might dabble in poetry, for this was the age that also produced the first great lyric poet in the French language, François Villon. But the lowly social status of painters and sculptors in fifteenth-century Europe made it impossible for such a prince to engage in one of the visual arts. I can illustrate such inhibitions in contemporary terms through my own clinical experience with a member of the evolving African American bourgeoisie.

During one of our recent wars, I was consulted by a young man who had just withdrawn from medical school, where he found himself unable to study, despite a brilliant academic record in the past. Although his family had recently succeeded in moving out of a Black slum into a prosperous integrated neighborhood, this pioneer of the African American advance into the professional class accepted a job as a mail carrier. It did not take long for us to discover that he was so embarrassed by his acceptance into the majority culture that he would not reveal where he was actually living to his friends from the old Black neighborhood. Not to make this dramatic story too long, it soon became clear that he abandoned his ambition to become a medical researcher when his older brother, who did not attend college and was therefore drafted, was killed in combat. Unaware that the siblings of servicemen who had lost their lives in action were automatically exempted from the draft, this guilty survivor had to drop out of school, thus ending his student deferment, in order to submit to the hazards that had destroyed his brother. In treatment he succeeded in overcoming this irrational guilt, and this man went on to become a faculty member of one of our most prestigious medical schools.

Of course, the average person does not have to struggle with remorse about the death of a sibling rival, but it is difficult for most people to transcend group affiliations and group mores without

experiencing conflict about such a spiritual abandonment of their kin. I have known young artists on the verge of professional success who have succumbed to the pressure of their families to attend medical school, for example—medical traditions persisting through successive generations of the same family are particularly common. (I myself am the product of such an ethos: at the time I entered medical school, I was simply incapable of seriously considering any other alternative. Twenty years later, I was to discover that my first love is scholarship and writing. It has taken me thirty years more to abandon medicine altogether.) Commitment to creative activities alien to one's forebears is a very difficult thing to do.

The would-be writer who had such difficulty in finding a woman who could support his artistic aspirations might have had less trouble persuading prospective brides to back his goals had he had no conflict about them. (Soon after he overcame his own ambivalence, he was able to marry a woman who would support his artistic ambitions. She was not that hard to find: she had the seat next to him at the opera!) He came from a background contemptuous of high art; his father was a successful businessman of dubious ethics whose only criterion for measuring value was financial. My patient's literary ambition echoed his mother's musical interests during his early childhood; however, following a drastic surgical procedure, she gave up playing her instrument and, probably as a matter of sour grapes, became hostile toward the arts. Thus the patient continuously found himself slipping into an identification either with his father's addiction to power or with his mother's caustic attitude toward creative pursuits. For him the internal conflict represented a moral choice: whether to honor his parents or, changing his entire ethos, to follow his muse. In Germany I have encountered colleagues who, in order to become psychoanalysts, had to overcome analogous loyalty conflicts involving their parents' National Socialism.

Important as class, ethnicity, and religion are in determining the consequences of commitment to a vocation, none of these is quite as decisive as is the culture-specific role assigned to each sex. In the past generation the Western world has undergone drastic changes in this regard; certainly it was very difficult and costly, well into the twentieth century, for a woman to violate the expectation that she ought to give priority to marriage and motherhood. The one broad exception to this rule has been the opportunity provided by most creeds to espouse a celibate life devoted to religion. Throughout the Christian era the creativity of women has therefore been channeled in the direction of "faith, hope, and charity."

To cite one prominent example from the modern era, Florence Nightingale, the mid-Victorian founder of professional nursing, began her activities by working in Egypt with the Sisters of St. Vincent de Paul. She then attended an institute for Protestant deaconesses in Germany. At the age of thirty-four, when the Crimean war broke out, she organized a unit of women to set up model hospitals in the theater of military operations. Her legendary devotion to this work thereafter made it possible for her to establish nursing as a respected profession. In late nineteenth-century England, for a married woman such a career would simply have been unthinkable: even if she had managed to get close to the Crimea, the stigma of leaving home and hearth would later have made it impossible for such a person to mobilize massive support for her great enterprise. In 1864 an English novel was entitled *Can You Forgive Her?* because it dealt with the theme of an upper-class girl breaking an engagement![6]

In the contemporary Western world there still exist subcultures that impose upon their young women the same stark choice between family life and creative possibilities that was all but universal in the Victorian era. I heard about one situation of this kind in the context of a psychoanalytic seminar devoted to the discussion of difficult clinical problems: the patient was raised in prosperous suburbia in a family that showed certain middlebrow cultural aspirations, but when in high school she became whole-heartedly involved in theatrical activities, her parents intervened to redirect her into an academic channel. Ultimately, this person did make a serious effort to become a performing artist, although not in the popular genre she would have preferred but in a field her parents held in higher esteem. She still had every reason to feel, however, that in pursuing such a career she was exiling herself from her family of origin and making it all but impossible to establish social relations (not to speak of marriage) with men of their ethnic background and social class.[8]

Even in circles accepting of feminist positions, it continues to be a problem for accomplished women to find men who are wholly comfortable with their achievements. Marriages involving two artists are, of course, fairly common, but they are fraught with the danger of competitive conflicts—witness the wrenching vicissitudes of such couples as Georgia O'Keeffe/Alfred Stieglitz, Frida Kahlo/Diego Rivera, Elaine/Willem de Kooning, or Lee Krasner/Jackson Pollock. Often a woman who is truly creative cannot marry at all or may have to settle for someone whose status does not match her own. Asymmetries of this kind always create some friction; at this junc-

ture, I believe this difficulty tends to be greater when a man feels inferior to his wife than it is when the husband has higher status. (Mutual envy can also be a problem in same-sex unions, although clearly not on the basis of sex roles.)

It remains to be seen whether this legacy of the patriarchal family can be overcome if the ideal of sexual equality eventually pervades our society. For the time being, it remains quite unpleasant to watch the masculine hatred and feminine contempt let loose in some of these ill-starred unions. A fair number of creative women have to pay the price of poisonous harassment by an envious spouse or face the dissolution of their marriage. In analytic practice the destructive spitefulness I have most frequently encountered on the part of men has been sexual depreciation—either through infidelity or by means of increasing loss of interest in marital relations (and/or impotence).

The clearest instance of this kind I have witnessed concerned a couple whose marriage suddenly broke up, after about twenty years, when the wife began to publish extensively in the scholarly literature. She was a historian of culture with a doctorate from an elite university; her husband, a physician, held an administrative job that paid reasonably well but had very little prestige. Although he had always minimized her achievements on the ground that her work was poorly remunerated (so it was, largely because she did not feel free to look for a position anywhere but in the city where he worked), it was only after his desertion that she learned from friends that for some time he had been grossly unfaithful to her. After she began treatment with me (significantly, a physician she knew to be married to a respected historian of culture!), she was able to piece together the history of her husband gradually lapsing into sexual impotence with her. The event that finally disrupted this unstable marital equilibrium was her receipt of a grant to spend several months abroad for research on an ambitious project that would greatly enhance her professional reputation. She left without suspecting that she would return to find her husband living with another woman. It was no coincidence that his paramour came from a social stratum for which this man had always expressed contempt.[9]

It would be misleading to suggest that such attempts to punish a creative person for her success are only possible for envious males: women may also respond to the achievements of their husbands with sexual depreciation, infidelity, or frigidity, and similar behaviors occur within homosexual unions. Perhaps these spiteful behaviors are less likely to achieve their intended effects when they are used by women because accomplished men tend to have a better

chance of finding someone who can tolerate their success than does a middle-aged woman like the scholar I have just described. Nonetheless, the greatest handicap suffered by creative women is not in the sphere of sexual life as such but in that of combining creative work with having children. A man may occasionally choose to remain childless in the interest of forestalling any interference with his work, but such precautions are rarely found to be necessary, even in this day and age of "hands on" fathers. Creative women have always found family life to be more difficult to manage.

Until the modern era the social structure of most families made it so incumbent upon mothers to devote themselves to the care of their children that the great majority of women with notable creative achievements were in fact childless: witness the examples of great literary figures like Jane Austen, George Eliot, and Virginia Woolf—or outstanding painters such as Mary Cassatt and Georgia O'Keeffe. This correlation was so striking that it led to a psychoanalytic hypothesis that creativity must constitute a displacement of the childhood ambition to produce babies to the production of children of one's fancy.[10] As long as the vast majority of creative persons were male, this notion remained plausible: many boys are, indeed, awed by their mothers' reproductive capacity and try to match it through creative efforts. Not infrequently, men of talent are spurred on in their creativity by competitive strivings—the ambition to match their mother's miraculous achievement of producing a younger sibling. One of my patients, a mathematician of great accomplishments, felt he had to create a work of unprecedented magnitude in order to feel worthy to be compared with his awesome mother.

Now that a substantial cohort of women also engage in creative work, it has become clear that having babies does not eliminate creativity, provided the mother receives sufficient assistance with child care to leave her free to do her work without feeling guilty of neglecting her family. During the peak years of reproductive life few young families are prosperous enough to be able to make fully satisfactory arrangements in this regard: it should be recalled that the creative life is not confined to a "thirty-five-hour week," as are ordinary jobs. Thus the exceptions proving the rule are mostly to be found in the upper classes. The nineteenth-century French painter Berthe Morisot exemplifies the conditions that facilitate combining having children and creative work: Morisot was descended from a well-to-do cultivated family, and she married a man from a similar background, the younger brother of her fellow painter and some-

time mentor, Edouard Manet. Be it noted that Morisot took pains to have her studio in her home, that she had only one child, and that her family responsibilities did sometimes interfere with her work, despite the availability of hired help.[11]

Morisot's biography stands in sharp contrast to those of many artists who give their creative work priority over all other considerations. One recent example of such dedication was that of the American sculptress Louise Nevelson. When she was scarcely out of high school, this daughter of highly successful Russian-Jewish immigrants married a wealthy man many years her senior. She gave birth to a son when she was twenty-two. Her husband discouraged her interest in a creative career, and she did not begin seriously to study art until her child reached school age. When she was past thirty years of age, Nevelson for all intents and purposes abandoned her husband, gave over the care of her son to her own parents, and left for Munich to study with the celebrated teacher of painting Hans Hoffman. A couple of years later she formalized this separation from her family. Although her success as a sculptress was twenty-five years away, as Laurie Wilson tactfully puts it, Nevelson "would never again intentionally allow her personal life to impede her career as an artist." It is hard to imagine, however, that she did not have to pay some emotional price for her refusal to subordinate herself to the welfare of her son.[12]

We have no way of knowing whether Nevelson's husband opposed her ambition to become an artist because he did not wish to have a "liberated" wife, for some idiosyncratic reason, or simply out of prejudice against such a creative pursuit. It is much easier to discern the influence of philistine attitudes when they determine family opposition to the creative career of a young man of acknowledged talent. As I have already mentioned, such a situation prevailed in the case of Claude Monet, the younger son of a prosperous Le Havre merchant. The future painter's mother died when he was an adolescent, but a paternal aunt generally supported the youngster against the rigid and inconsistent rule of his authoritarian father.

Monet's talent was already manifest while he was still a schoolboy, when he produced a sparkling series of saleable caricatures. With his aunt's assistance, Claude managed to overcome his father's pressure to devote himself to business and moved to Paris to get artistic training. Because his pioneering work pointing toward Impressionism was at first commercially unsuccessful, necessitating continuing family subsidies, Monet's father periodically revived his opposition to Claude's vocation. When he learned that Monet had

fathered a child out of wedlock, the benign pretensions behind this policy disappeared: Monet was repudiated by the entire family. The fact that the father's moral outrage was sheer hypocrisy is evident from the fact that not long before he also had an illegitimate child from a liaison with a servant girl.[13] To say the least, Monet certainly did not have greatness thrust upon him, to paraphrase Shakespeare's sardonic wit about these matters.[14]

CHAPTER SEVEN

•

Creativity and Self-Healing

In his *Autobiography*, the eminent nineteenth-century English novelist Anthony Trollope characterized the first twenty-six years of his life as "years of suffering, disgrace, and inward remorse."[1] Biographers have confessed bafflement about the mystery of Trollope's transformation into the author of seventy books, an effective civil servant, a country gentleman, a clubman, and a paterfamilias. There can be no question that this broadly based success was founded on a great talent and prodigious energy: it is well known that Trollope fulfilled with distinction all the requirements of a high administrative position in the Postal Service until he retired at the age of fifty-two, and before that he did all of his writing in his spare time—in effect, from dawn until he had to leave for work. Despite this cruel schedule, he produced every day several pages of prose that required practically no revision. Trollope did not regard this toilsome regimen as an undue burden: when he was sixty-one, he wrote, "As to that leisure evening of life, I must say that I do not want it. I can conceive of no contentment of which toil is not to be the immediate parent."[2]

It seems that Trollope was alluding to the supreme pleasure of enhanced self-esteem as a consequence of a job well done—whether the work involved administering the mails, writing novels, journalism, editing a literary magazine, negotiating the international copy-

right convention, or any of his other weighty enterprises. This pref-
erence is not to be confused with the satisfaction of inflicting suf-
fering on oneself: far from being an ascetic or a masochist, Trollope
was a man who allowed himself to indulge his passions—a congenial
companion and an enthusiastic devotee of riding to hounds! I con-
clude that, after his troubled youth, the budding author, through his
own efforts, underwent a change of character. The extent of this
change through self-creation may be gauged from an entry in a pri-
vate journal of his young manhood on the importance of order and
method: "I am myself in all pursuits (God help them) & practices of
my life most disorderly & unmethodical." This from a man who was
to write three-volume novels entirely preorganized in his head![3]

But the young Trollope was not merely disorganized; he was
seriously disturbed in a number of ways. Raised with considerable
cruelty by a rageful father and largely neglected by his improvident
mother, as a schoolboy at Harrow Anthony was the continual vic-
tim of hazing and harassment, and he developed severe difficulties
in learning. As an adolescent he was friendless, ostracized, and
ridiculed in school, and his inevitable resentment about these griev-
ances turned him into a fierce fighter. By this time his father was
not merely irritable; he had become overtly paranoid. Anthony was
also rude and uncouth, perhaps in identification with his father's
behavior, so that nobody could discern either his longing for accep-
tance or his promise. One schoolmate later recalled that Trollope
"was regarded by masters and by boys as an incorrigible dunce."[4]
When he was nineteen, his bankrupt family fled to Belgium to
escape their creditors, and Anthony was sent by himself to London
to enter the civil service as a lowly clerk. Only his progressively
deeper immersion in reading literature of the highest standard
indicated that Trollope was not destined to remain mired in misery
and destitution.

In 1841, when he was twenty-six, Trollope applied for and
received an assignment as a surveyor of postal services in rural
Ireland. Although in administrative terms this was merely a lateral
move within the civil service, for the future artist it meant a radical
break with his unhappy past and unpromising present. In this new,
quasi-colonial environment, he became a new man—as the Trollope
scholar N. J. Hall puts it, "flawed certainly, and idiosyncratic in his
extraordinary forcefulness and combativeness."[5] He threw himself
into his work with great energy and imposed order and method on
his activities. He took up foxhunting, which became his ruling pas-
sion and seemingly directed his aggression into socially sanctioned

channels. It also gave him opportunities for social intercourse with the upper class; as a result, in 1842 he became engaged to a suitable woman. He started his first novel in September 1843, married in June 1844, and completed the book by July 1845.

Another great artist who did not find his true vocation until the age of twenty-seven, Vincent van Gogh, called the period of personal reorganization that precedes such a metamorphosis a "molting time."[6] In the case of Trollope, the work of the first years he spent in Ireland consisted of inventing the first (and perhaps the most original!) of his characters—that of the novelist Anthony Trollope. This was a creative feat of considerable magnitude: Hall calls the emergence of the artist from the chaos of the disordered youth "miraculous"; I would point out that it comes close to imposture of the kind practiced by Arshile Gorky or Balthus. Such self-creation is no more of a miracle than is the invention of vast fictional realms such as the Barsetshire of Trollope's six-novel sequence (from *The Warden* of 1855 to *The Last Chronicle of Barset* of 1867) or the world of his six Palliser books (from *Can You Forgive Her?* of 1865 to *The Duke's Children* of 1880).

Trollope succeeded in constructing an effective personality by remaining true to various aspects of his old self and never lapsing into actual imposture. For instance, his *ambition* to become a writer had already surfaced in adolescence, when his mother, just returned from a three-year misadventure seeking her fortune in America, wrote a highly successful book on *Domestic Manners of the Americans*.

The elder Mrs. Trollope thereafter supported the family as a commercial author, setting her son an admirable example of determination and diligence. Anthony always knew that he could do better than his mother; with excellent critical judgment, he understood that her fiction was mere pulp. For many years before he attempted to write anything, he practiced the craft of storytelling by creating narrative daydreams—"castles in the air," as he called them. Yet his assumption of the role of the writer amounted to identification with the best his mother had to offer. Similarly, joining the upper class involved an identification with his paternal forebears, who belonged to the gentry, and taking up foxhunting amounted to finding an acceptable alternative for his ferocious behavior. In other words, the reorganization of his personality meant reordering the old ingredients in a manner permitting their optimal employment for adaptive ends.[7]

Trollope's early novels, published through his mother's literary connections, received favorable reviews; these explicitly acknowl-

edged that his talent was superior to hers. It was immediately rec-
ognized that his work was lively, clever, amusing, and remarkably
easy to read. He gained self-confidence, not only as an author but
also as a public official: by 1849, when he was called as a witness at
an important trial, he more than held his own under hostile cross-
examination by the leading barrister in Ireland. He was able to take
in stride the failure of his third book, a historical novel set in France,
a milieu he did not know at first hand; from this setback Trollope was
able to learn the lesson that his proper fictional genre was to focus
on the contemporary scene among the upper classes in Britain. Yet
he affirmed his identification with his mother's best qualities in
writing a number of successful accounts of travels to distant lands as
well.

By 1851 Trollope's superior administrative work earned him pro-
motion and a transfer to Southwest England, a scene he thoroughly
assimilated and used to create his fictional Barsetshire. This is not
the place to go into detail about the progress of the mature artist—
his rising success over the next three decades in manifold enter-
prises; suffice it to say that he throve on creative achievements and
mastered most of the legacies of his unhappy upbringing. Perhaps
the most visible scar of the old wounds was Trollope's gruff manner
and a certain dishevelment in his dress—but the boy who had been
ostracized by all became in maturity a literary lion sought after by
the most eminent Victorians.

A generation ago the psychoanalyst Phyllis Greenacre proposed
that creative persons are protected from the expectable pathogenic
effects of childhood traumata because they are already engaged at
the time of these vicissitudes in what Greenacre called a "love affair
with the world."[8] The implication of this notion is that such children
are less vulnerable to inadequate nurture than we might predict
because, as a result of early involvement with some aspect of the
external world that they experience with admiration or even awe,
they are already relatively independent of their parents. My own
clinical observations confirm Greenacre's claim that individuals des-
tined to become creative are *relatively* less vulnerable to the vicissi-
tudes of their upbringing than are other children. However, I am not
satisfied with Greenacre's causal explanation for this correlation: as
the case of Trollope demonstrates, the love affair with the world (in
his case, that of the imagination) may not supervene until adoles-
cence—that is, long after the transactions that would cause difficul-
ties for ordinary persons have taken place.

I believe that it better fits the evidence to postulate that such a

"love affair" exercises a healing effect, no matter when it unfolds. In my judgment it does so not because it renders the individual immune to family disappointments, as Greenacre would have it. In my clinical experience analysands who are already creative employ the same defenses against disillusionment with their childhood caretakers as does anyone else—most frequently, either denial of the bitter truth or disavowal of its emotional significance. These defenses were prominent in the case of Trollope: he looked back upon his father's life as a tragedy and blamed his own unhappiness in childhood on the cruelty and snobbism of his schoolmates—a gross denial of his parents' responsibility and disavowal of his anger toward them. Instead of invoking a "love affair with the world," I attribute the protective function of creativity to the enormous boost in self-esteem provided by any sense of unusual competence. Whenever such effectance (its technical designation in psychology) supervenes relatively early in life, that development is likely to tilt the child's priorities in the direction of gaining satisfaction from exercising the special skills that make outstanding performance feasible.

Children who possess such capacities achieve some degree of independence from their parents by sharpening their skills. In other words, the love affair is not with some aspect of the external world but with the child's own talents—in Trollope's case, presumably with his ability to invent narratives. Clearly, the resultant boost in self-esteem may compensate the child for any kind of narcissistic injury, even that of a physical handicap. Hence psychoanalytic hypotheses that attribute the genesis of creativity to a need to repair damage to self-esteem (see chapter 1, note 18) reverse the actual sequence of events: the creative potential has been available all along and *protects* the individual from injuries to self-esteem.

Be that as it may, the example of Trollope cannot by itself convince about the healing power of creativity because it is conceivable that the novelist may not have been seriously damaged by his seemingly dreadful childhood. It is entirely possible that his *Autobiography*, although obviously sincere and relatively candid, may unintentionally present a distorted, mythic picture, exaggerating his psychopathology—either through self-pity or (more plausibly) simply by focusing on his school years, arguably the most stressful period of his life, when the adolescent witnessed his father's deterioration. Earlier, Anthony might have been a sturdy child—father to the robust man he was to become.

The reverse of the same coin is that there is no need to attribute magical properties to the healing power of creativity—it is already

sufficiently significant if it is capable of *restoring* a person to his or her best previous level of functional integrity. From this perspective it is perfectly reasonable to expect that such restoration should be most feasible if the basic personality is more or less sound—or, if you will, whenever the psychopathology is confined to a limited sector of the personality. If an individual suffers from a more serious disorder, creative achievements may be extremely helpful in holding off disaster for varying periods of time without effecting any fundamental repair of the underlying defect. Such was the effect of making art on the illness of Vincent van Gogh, whose depressive character was unaffected by creative achievements the magnitude of which he well understood.[9]

Van Gogh committed suicide at the age of thirty-seven, at the zenith of a decade of astonishing productivity as an artist and on the threshold of notable public recognition. This seeming paradox has fascinated students of his life ever since, leading to a variety of more or less plausible speculative explanations for the timing of his suicide. A dozen years ago, one of my own conjectures about the proximate cause for van Gogh's despair was that he might have felt hopeless about his intractable neurological illness, diagnosed (probably correctly) as an unusual form of epilepsy. In the interval, we have learned that, by the time Vincent killed himself, his brother Theo was showing unmistakable symptoms of the fatal illness that was to end his life within half a year, as I have already mentioned in chapter 2. Despite the family's continuing efforts to suppress the facts, the recent rediscovery of Theo's hospital records has revealed that he suffered from general paresis—brain deterioration as a result of syphilis. The fateful prognosis of such conditions was well understood in the late nineteenth century. I now assume, therefore, that Vincent knew that his brother was shortly to become completely incapacitated, and that it was this realization that brought on his despair.

As I reconstruct the unfolding of van Gogh's inner life, he fell into suicidal hopelessness for the first time at the age of twenty-seven, as the culmination of a series of vocational and romantic failures. In this emergency, his younger brother Theo (toward whom Vincent had been very protective in their childhood) came to the rescue, urging van Gogh to devote himself to a career in art. Vincent, who already demonstrated unusual artistic talent as a youngster, had (when given a choice) dedicated himself to the service of the underprivileged, in a specifically religious context. He was so committed to altruism that he was willing to become an artist only on condition that this plan

would be undertaken *for his brother's sake*. (In return, Vincent was, with real distaste, reluctantly willing to accept Theo's financial support.)[10] Although we are not fully informed about the brothers' celebrated compact to produce a serious body of work in collaboration—some of the details are unmentioned in their correspondence because they were worked out during a face-to-face meeting—it seems entirely likely that Vincent merely undertook to postpone suicide so long as he could remain "of service" to his brother. Theo's irreversible illness brought this compact to its natural expiration.

In childhood, Vincent had no "love affair with the world"—on the contrary, he was so vulnerable to traumatization through the actions of his parents that he ragefully abandoned his early, promising efforts to make art because the grown-ups seemed more interested in these works than he felt they were in Vincent. Thereafter, the only sphere in which van Gogh allowed himself to demonstrate competence was the private realm of mystical experience.[11] Whatever self-esteem he might have gained from such spiritual exercises was eventually lost, because all the religious authorities van Gogh was to encounter, including his own father (a Calvinist minister), disapproved of Vincent's (essentially idiosyncratic) religious attitudes and sometimes even showed contempt for them. Vincent ultimately turned against contemporary Christianity, although he never abandoned his religious vocation or his identification with Jesus. Thus, when in the St. Rémy asylum he painted a "copy" of a lithograph after a *Pietà* by Delacroix (figure 7.1), he gave Christ his own red hair and beard. The message of his art was also that of his private religion.

At any rate, until he began to create art, Vincent's life was an unbroken succession of failures. He persevered in his creative efforts for ten years, despite further disasters in his personal relationships. These continuing misfortunes were caused by his insistence on choosing companions unwilling to provide him with the kind of relationship he demanded—witness his attempt to force a person he knew to be ruthless and egocentric, Paul Gauguin, to join him in an artists' collaborative. This persistent pattern of pathological human relations is sufficient by itself to show that the flowering of van Gogh's creativity did not overcome his deepest emotional problems. Nonetheless, Vincent's superb *Letters*—works of genius in their own right!—permit us to witness the steady increase of his self-esteem as he gained confidence in the value of his work. Thus, after eight years as an artist, toward the end of his period of residence in Arles, he was able to assure an acquaintance who had posed for him that her portrait (which she received as his gift) would one day hang in the Louvre. He knew his own worth: the five versions of *La Berceuse: Mme.*

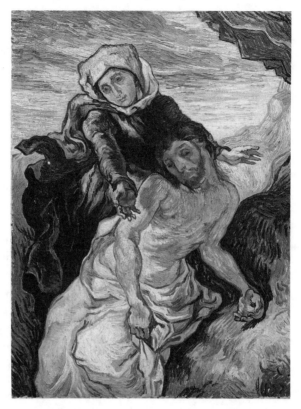

FIGURE 7.1.
Vincent van Gogh,
*Pietà (After
Delacroix)*, 1889.
Oil on canvas.
*Vincent van Gogh
Foundation/
Van Gogh
Museum,
Amsterdam.*

Augustine Roulin are prized in the great collections of Amsterdam,
Boston, Chicago, New York—the Louvre, for once, missed out.[12]

The conclusion is inescapable that the increment of self- esteem
resulting from his creative activities did not save van Gogh from sui-
cidal depression; rather, it was his brother's willingness to affirm that
they needed each other equally that postponed the catastrophe. With
regard to certain other problems, however, creativity did probably
exert a healing effect upon Vincent. He became so passionate about
making art that he was able to work until he reached the limits of his
physical endurance, seemingly totally absorbed in the exercise of his
craft. We might say that, as long as he was able to work creatively, his
emotional problems were not in focus. This state of tolerable equilib-
rium presented a marked contrast to the chronic depression that
beset van Gogh earlier in his life. Even during his decade-long cre-
ative period, whenever he turned away from work to interact with
people, emotionally, Vincent was extremely labile: in meaningful
relationships, he was easily overwrought, leading to unfortunate
outbursts, tense arguments, or strange enactments (like deliberately
burning his hand to prove his passion for a widowed relative).

Perhaps the examples I have thus far provided, the sturdy Trollope on the one hand and the flamelike van Gogh on the other, represent the two extremes on a continuum from the optimal effects of creative activities on personal integration to the minimum to be expected in that regard. To illustrate an outcome closer to the expectable average, we might consider an instance such as that of Sigmund Freud—whose extensive writings include copious records about the vicissitudes of his psychological integration.[13] Although Freud was always reasonably well adapted, there is no question about the beneficial changes in his character that took place around the time of his first truly major achievements, in the late 1890s. Because Freud's creativity was in large measure based on his capacity for introspection, these favorable changes have generally been attributed to his success in conducting a "self-analysis." However, Freud himself stated that this procedure merely consisted in applying to himself the clinical discoveries he had made with his patients. Hence it would be safer to claim only that his growth was a product of the beneficial effects of his creative activities in general.

Probably the most favorable change in Freud's personality was his mastery of a propensity to idealize and overestimate a succession of men in whom he would later be bitterly disappointed, a change that always led to an unforgiving estrangement. The most unrealistic and potentially troublesome of these incidents began when Freud reached the age of forty and was at the very threshold of his most important discoveries. At this time he formed a strange bond with Wilhelm Fliess, a slightly younger physician from Berlin who was engaged in pseudoscientific speculations about biological rhythms, loosely based on numerological assumptions. Freud and Fliess became "secret sharers" (see chapter 2), and in this sense the relationship probably lent Freud courage to embark on his intellectual quest to develop a scientific psychology. However, the price to be paid for Fliess's support was to lend credence to the latter's baseless "biological" assertions. Freud went so far as to allow Fliess to perform a dangerous surgical operation, putatively necessary on the basis of these crackpot theories, on one of Freud's patients. Not only was this procedure irrational; on top of that, through Fliess's negligence, the operation was severely botched. When Freud first learned that Fliess had been guilty of malpractice, he was unable to face the truth and made lame excuses for his bizarre associate.

Not long after this crisis, while working on his greatest treatise, *The Interpretation of Dreams*, Freud gradually emancipated himself from Fliess's influence. On this occasion the gradual estrangement

did not lead Freud to feel much rancor toward the person he had misperceived, and thenceforth he never fell victim to the temptation to ally himself with messianic figures. That is not to say that he was never again tempted: about a decade after these events Freud tried to draw Carl Gustav Jung into his orbit, probably because the latter's personality, like that of Fliess, lent itself to an illusion Freud unconsciously wished to believe, that the other man possessed magical powers.[14] When his follower insisted on performing an experiment in parapsychology in Freud's consulting room, the latter was momentarily swayed by Jung's charisma. But this temptation was overcome within hours, and a skeptical Freud was then able to remain friendly with Jung for several years longer. Their eventual estrangement was not to be caused by Freud's disillusionment about Jung's putative magic—on the contrary, it was a result of Freud's insistence on a rationalism Jung held in contempt.

The change I have described in Freud's behavior undoubtedly constituted mastery of an important personality problem, although it is not possible to state with certainty whether and to what extent it was brought about by Freud's continuing creativity. We do know, however, that in later life Freud looked upon his scientific productivity as the guarantor of his equilibrium in the most difficult of circumstances. For instance, when in rapid succession he lost his daughter Sophie and one of his grandchildren, he stated that creative activity "stiffened his neck" in his bereavement.[15]

The reason for my readiness to attribute Freud's improvement to his creative efforts is largely personal: my own adaptation changed, for the better, in parallel with my establishing a steady level of productivity in scholarly work. It so happened that I hit my stride in this respect shortly before I reached forty, and I noticed the firming up of my personal integration shortly thereafter. My subjective experience became less volatile, so that I can truly endorse Trollope's statement claiming that real satisfaction flows from hard work. I might add that I was totally surprised by this midlife commitment to laborious moonlighting, but I found the subjective rewards to be well worth the effort. Others began to treat me with added respect; this, in turn, encouraged me to try to assist younger colleagues with their scholarly activities. I am inclined to believe that these are fairly common responses to a modicum of success in such pursuits.

Common as such benefits may be, it would be misleading to suggest that they are universal. Certain personalities are unable to profit from experiences that are beneficial for almost everyone else; others may have paradoxical reactions, actually becoming ill in cir-

cumstances that help most people to improve. Some of these issues will be dealt with in greater detail in the next chapter; here it may suffice to offer a few brief illustrations of such exceptional responses. Among the many possibilities, one common reason for failing to benefit from creative success is an unfavorable affective reaction produced by the expectation that external change for the better might jeopardize an essential emotional bond to some important person.

For example, every time she improved with renewed treatment, one highly talented woman (whom I have followed professionally for several decades) would embark on new creative enterprises, only to abandon the effort after interrupting our work, each time because she thought her private goals jeopardized the welfare of some member of her family. The first time this happened, she had begun to pursue a long-held ambition to enter public service; she gave up this attempt because she felt it interfered with her responsibilities toward her young children. I was unable to form my own judgment about this contention before our work reached a natural termination. About five years later this person returned with a moderately severe depression; on this occasion I recommended that she enter psychoanalysis in order to deal with the basic personality problem.

During the analytic treatment she discovered that her dysphoria was in large measure attributable to her failure to make full use of her intellectual capacities. We were able to reconstruct that she had jeopardized her opportunities for the kind of education she needed to develop those capacities fully because she felt constrained not to leave home to attend college. In her view, she had the responsibility to protect a young brother from the consequences of their mother's incompetence and their father's hostility and negligence and could not pursue her own aims in preference to this duty. The issue came to the fore for a third time when the analysis mobilized her to make creative efforts in the paramedical field in which she had been trained before her marriage: her independent activities made her husband so uncomfortable that she compromised, once again, on doing less satisfying work in his business. When she was past the age of sixty, both she and her husband retired, and this person undertook graduate work in a demanding intellectual discipline.

Paradoxical negative reactions to success can actually occur for a variety of reasons. Some people simply find creative achievements to be more stimulating than they can stand; consequently, they shy away from the activities that produce excessive excitement. I have

had one analysand who literally became dizzy from success, another who got so tense when he was doing well that he found himself exploding into senseless rages. Others show an allergy to success, so to speak, because of profoundly masochistic propensities—or, alternatively, in order to deprive their close associates of the satisfaction of being related to someone in whom they can take pride. As one of my analysands complained when success stared her in the face, "But then who is going to punish them?!" (she meant her parents).

To return to the issue of the healing power of creativity, in many instances this has to deal with an acute and temporary impairment in adaptation rather than lifelong issues of personality integration. Such possibilities seem to be particularly available to creative artists, who may try to master a specific problem by making it the focus of their work, often in a repetitive manner. The best example of such a sequence to have come to my attention was the response of the Spanish painter Francisco Goya to a severe neurological illness—a rare choice of artistic subject matter correlated with the vicissitudes of bodily integrity.[16] By all accounts, Goya was a robust, aggressive, well-adapted person, with an uninterrupted record of creative accomplishments of greater and greater value; by the age of forty he was appointed "Painter to the King," having by then produced for the court numerous distinguished designs for tapestries (figure 7.2).

Goya suffered the first attack of an illness involving the nervous system at the age of thirty-one. There were at least two recurrences over the next fifteen years, culminating in 1792–1793 in a life-threatening episode that left him permanently deaf and suffering from severe ringing in the ears (tinnitus). There is no certainty about the precise diagnosis, nor even about the assumption that each attack was in fact a repetition of the same condition—it is possible that a variety of diseases affecting the brain had a cumulative impact in causing the damage. Leaving aside these doubts about the nature of the underlying illness, there can be no question about the historical consensus that his chronic ill-health and the severe impairment it finally produced changed Goya from a pleasure-loving, extroverted man, whose art aimed only to please his patrons, into the first great introspective painter who plumbed man's inner depths (see figures 7.3 and 7.4).

Only recently has it been noted that, following Goya's initial attack, he began to paint a number of pictures the narrative content of which refers directly to the bodily sensations produced by the ill-

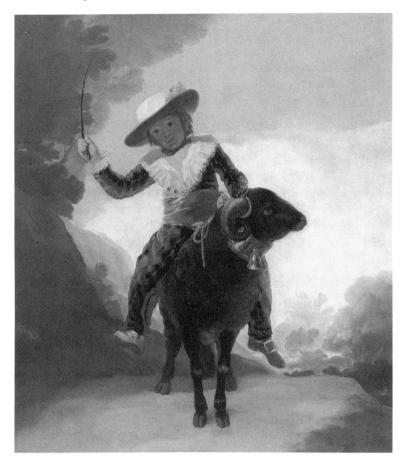

FIGURE 7.2. Francisco Goya, *Boy on a Ram*, 1786–1787. Oil on canvas.
Art Institute of Chicago. Gift of Mr. and Mrs. Brooks McCormick, 1979.479.

ness, with particular reference to dizziness, loss of equilibrium, and sensory disturbances. Goya introduced these themes whenever his assignments gave him some latitude with regard to subject matter; after the near-fatal attack of 1792, he also created an unprecedented sequence of fourteen small paintings, produced entirely for his private purposes, in which the focus on his bodily state was especially clear.

In the earliest paintings that depict scenes of precarious equilibrium, done after his first bout of illness, Goya used children at play as his protagonists; this focus on playfulness may have been a defensive attempt to minimize the gravity of his own situation. A decade later some of the scenes Goya invented implicitly acknowledge the reality of imminent danger, and now the adult protagonists are occa-

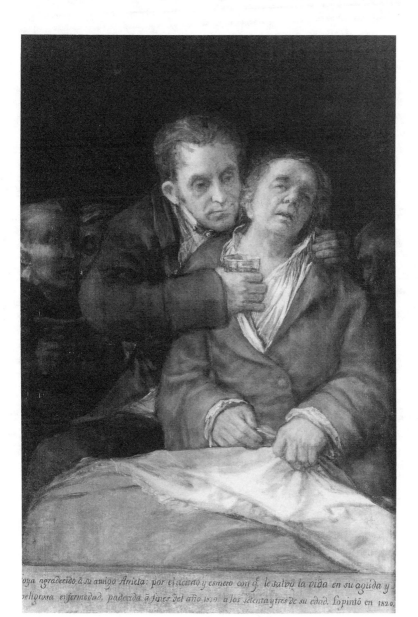

oya agradecido, á su amigo Arrieta: por el acierto y esmero con q. le salvó la vida en su aguda y peligrosa enfermedad, padecida á fines del año 1819. a los setenta y tres de su edad. Lo pintó en 1820.

FIGURE 7.3. Francisco Goya, *Goya and His Doctor Arrieta*, 1820. Oil on canvas. *Minneapolis Institute of Art.*

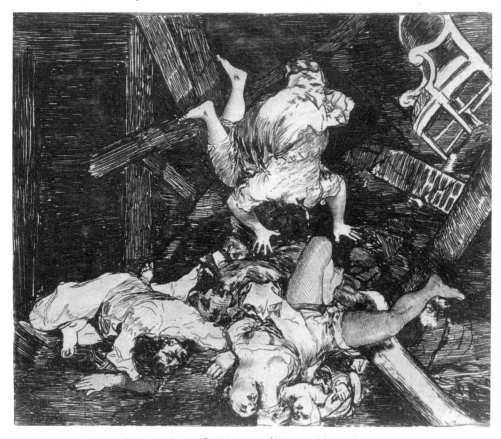

FIGURE 7.4. Francisco Goya, *The Disasters of War, no. 30*, ca. 1810.
Etching and aquatint.

sionally shown as injured or even killed. In these narratives bulls are
sometimes represented as the victims; the fact that these animals
stood for the artist himself is suggested by his occasional use of the
signature "Francisco de los Toros." In the series of fourteen paint-
ings from 1793, the first eight represent the capture, torment, and
destruction of a young black bull. Moreover, the corrida is located in
the bullring at Seville, the city where the illness of 1792 overtook
the artist. The bullfight series has been interpreted as a depiction of
Goya's initial depressive reaction to this overwhelming trauma;
these images are analogous to the recurrent dreams of victims of
traumatic neuroses. By repetition what has been overwhelming may
gradually be mastered.

The second half of the sequence depicts scenes of human help-
lessness, such as being murdered by a gang of highwaymen or con-
finement in an insane asylum among assaultive "lunatics" (figure

7.5). However, the last two pictures in the series, *The Shipwreck* and *The Fire at Night*, portray disasters in which some of the potential victims are rescued through the availability of human assistance. These narratives reiterate "the artist's belief in man's triumph over the malign forces of human existence, a conquest which also constitutes a triumph of human selflessness."[17] Goya emerged from his ordeals with renewed faith in his fellow men and increased concern for human suffering. Thus his creativity not only helped him to master the trauma of illness and permanent disability; it actually

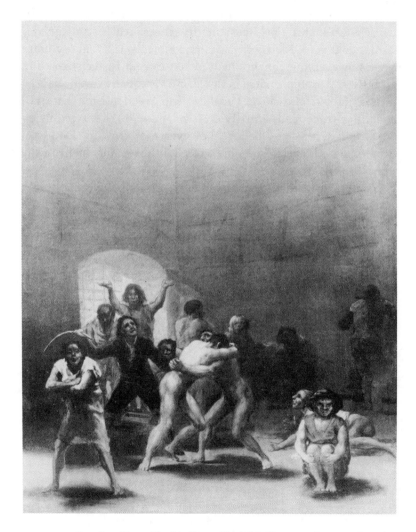

FIGURE 7.5. Francisco Goya, *The Madhouse Yard (Madhouse at Saragossa)*, 1794. Oil on tinplate. *Meadows Museum and Gallery, Dallas.*

transformed him from "a painter of pretty Rococo pictures into an artist of dark expressionist powers."[18]

If I am unable to report from my clinical practice similar instances of improved adaptation as a result of creative success, the reason for this lack is that I find it impossible to differentiate the effects of newfound creativity from those of other consequences of the analytic work. However, I do feel confident in asserting that the positive results of successful analyses are most likely to endure in cases that lead analysands into creative endeavors for which they are well equipped. The psychoanalyst Melanie Klein attributes such outcomes to the probability that the act of creation serves as appropriate reparation for one's past malfeasances, real or imagined.[19] Insofar as it goes, Klein's thesis is undoubtedly valid; in my judgment, however, the enhancement of self-esteem I have stressed in the historical examples cited in this chapter is equally cogent, at least in those individuals who seek analytic help. Freud insisted that emotional health depends equally on love and work; he urged us *zu lieben und arbeiten*—I believe, however, that growing success in either sphere makes it possible to sustain disappointment in the other.

Clinicians who care for the mentally ill in need of hospitalization have discovered that certain "creative" activities, especially in the realm of the visual arts, have a beneficial effect on the course of these disturbances. Because of the complexity of these special circumstances, this aspect of the topic will be dealt with in chapter 10, following consideration of the general question of a relationship between creativity and psychopathology.

●

Creativity and Psychopathology

For the past two hundred years the arts of the West have been increasingly focused on the inner world of their practitioners—"the artist's journey into the interior," as the critic Erich Heller put this— so much so that the predominant subject matter of the modern era might be characterized as the psychopathology of Western man, what the French Romantics called the *mal du siècle* (the illness of this century) and Sigmund Freud labeled the discontents of civilization.[1] Because of this tilt in the direction of psychologically disturbed content, it has been natural to assume that the modern artist is more likely to suffer from psychopathology than are his contemporaries. Many prefer to believe that every artist shares the inner turmoil of a Franz Kafka or an Edvard Munch. Such arbitrary assumptions have remained popular despite the protests of many students of creativity—from T. S. Eliot to the psychoanalyst Ernst Kris and the novelist Vladimir Nabokov[2]—that major artists are distinguished precisely by their capacity to transcend the boundaries of autobiography in their productions.

The tendency to see creativity as a by-product of pathology extends even into the domains of science, scholarship, and other nonartistic realms because the very ambition to accomplish valuable goals is widely regarded as a sign of maladaptation. In prosperous democratic societies, creative achievements are often viewed, with

considerable hidden malice, as egocentric efforts to capture the spot-light—in exact parallel with the pseudomoral condemnation of "profiteering" in societies recently released from Marxist ideology. In this regard, even the traditional Freudian view of the psychology of "the artist," already cited in chapter 1, that creative ambition is aimed at gaining fame, fortune, and the love of the opposite sex, caters to the prejudice that associates creativity with the canker of illness. I elaborated the objections to this point of view in some detail in *Portraits of the Artist*, much of which is devoted to lengthy accounts, both historical and excerpted from clinical experience, that demonstrate motives for creativity quite different from the hope for rewards of the kind Freud postulated in this regard.

It is true, as we saw in the preceding chapter, that in the presence of certain kinds of psychopathology (particularly if that disturbance tends to undermine self-esteem) successful creative accomplishments are likely to restore some measure of equilibrium. The clearest instance of this I have witnessed occurred when a young potter of my acquaintance was deserted by his wife and became agitated and depressed. He obtained a fair measure of relief when he could induce someone to visit his studio, where he would give amazing demonstrations of his virtuosity at the potter's wheel. It was both fascinating and pathetic to watch this need to impress one with his creative power. His agitation disappeared as he took solace from the spectator's admiration.

Whenever creativity has such a self-healing effect, the continuing predisposition for psychopathology will of course perpetually spur the individual on, to attempt to recover adaptive balance by means of further creative efforts. In such instances performing the work acquires the qualities of an addiction. The existence of cases of this kind does not mean, however, that only the need for self-healing can motivate a person to engage in these difficult enterprises—after all, there are always fame, fortune, and sexual prizes to be gained at the other end of that rainbow, not to speak of many other potential rewards inherent in the exercise of intellectual capacities.

In my experience as a clinician, current psychopathology is very likely to *interfere* with creativity, in contrast to the stimulating potential of pathology that has been transcended or the effect of pre-dispositions that may only create problems at some future time. This interference is almost absolute in acute crises of confusion, altered states of consciousness, or severe affective disturbances (whether of depression or elation). As one illustration, we may take the instance of the Florentine mannerist painter Jacopo da Pontormo

(whose career will be discussed in greater detail in chapter 13). This great artist had a melancholic tendency throughout life; in late middle age he became increasingly withdrawn, self-preoccupied, and anhedonic. In this period he was working on a commission to fresco the principal chapel of the church of S. Lorenzo in Florence, but he was exceedingly slow in performing this important and prestigious task. The historian Vasari, relying on the accounts of eye-witnesses, reports that, while working in the chapel, Pontormo was often lost in private cogitation, so that through an entire day he might fail to make a single mark on the painting. We cannot be certain, on the basis of the information Vasari provides, about the precise nature of Pontormo's mental status during these episodes of psychological paralysis, but it is clear that he was unable to produce in his customary manner because of some unfavorable alteration of his subjective state.[3]

Even the inability to modulate excitement (and/or tension) may block the creative process, sometimes as a result of the decision to avoid the risk of overstimulation by giving up the activity that is experienced as excessively exciting. This dynamic accounted, in the architect/painter mentioned in chapter 2, for the initial choice of a creative domain he found relatively less stimulating than certain others: as a student, he intended to be a painter, but he abandoned this plan because he found himself so absorbed in his art that he sometimes lost track of his surroundings. Although he continued to be productive during these dissociative episodes, he was so frightened by such loss of conscious control that he decided to switch entirely to architecture. For many years he had outstanding success in that field; he found that the creative process in architecture was necessarily so slow and involved so many collaborators that he never experienced the overexcitement and altered state of consciousness he had found unbearable while he tried to paint.

The foregoing example also shows that a person may be creative enough to find a practical solution for psychological problems that would stifle creativity in most people. (In other words, self-creation need not in every instance involve imposture!) It also illustrates the fact that the actual interference with a person's creative work may not be the direct consequence of the primary psychological difficulty: the maladaptive outcome very often comes about as a by-product of the defensive measures used to cope with the basic problem, defenses which, from a purely psychological viewpoint, may be quite successful. The kind of avoidant maneuver that carried my analysand from one creative domain into another is not at all

uncommon. Witness, for instance, the manner in which on several occasions during his lengthy career Picasso for significant periods became unable to paint. He chose at these times of crisis to engage in creative activities of various other sorts. In 1934, during the most persistent of these crises, following the birth of the artist's illegitimate daughter Maia, Picasso turned to producing literature; on a later occasion (connected with the infancy of his second daughter, Paloma, also born out of wedlock) he engaged in the decoration of Vallauris ceramics. We have recently learned that at the age of fourteen Picasso vowed to give up painting if God would preserve the life of his youngest sister, who was ill with diphtheria; it was the child's death that released him from this vow. It would seem that Picasso had a magical belief in being capable of destroying others through his wishes or fantasies. Apparently he tried to safeguard his infant daughters from his own potential destructiveness by avoiding his primary artistic domain, in effect replicating his adolescent vow.[4]

Similar vicissitudes of the creative process may follow when a variety of other defenses come to be employed on a continuing basis— whenever they go beyond purely intrapsychic consequences into the realm of behavioral change. I am trying to make a distinction between psychological operations that merely alter the manner in which the person *thinks* (such as the repression of disturbing content or the disavowal of its significance) and those defensive patterns, of greater complexity, that involve actual deeds (as they do in avoidances). One pattern of this second kind is "reaction formation," the reinforcement of some attitude that negates an unacceptable feature of the personality. The lives of numerous saintly figures give evidence that an unusual degree of commitment to virtue may supervene after a period of youthful self-indulgence: this was the sequence of events in the case of St. Francis of Assisi, for example. His creativity in the moral sphere took the form of an identification with Christ thoroughgoing enough eventually to cause death through physical deprivation, if not outright martyrdom. Needless to say, it was the willingness of St. Francis to pursue his ideals in this uncompromising manner that inspired a devoted following and permitted him to found a great religious order. I do not mean to imply that the religious vocation of a St. Francis can be reduced to a form of psychopathology; on the contrary—in his case it was a creative solution to a difficult conflict through which that incipient pathology was overcome. In similar circumstances lesser individuals tend to become incapacitated.

I can offer as one illustration of such an unfortunate outcome the

case of an analysand raised in a large family by a chronically schiz-
ophrenic mother, a severely impaired woman who was, however,
never hospitalized. My patient was the mother's favorite and the
only member of the family she never attacked physically; as a result,
his older siblings turned against him and subjected him to various
kinds of harassment. Needless to say, he accumulated many angry
grievances as he grew up. Because his only refuge from this literal
madhouse was at church, he adopted the moral teachings of his creed
in a fervent and literal manner. Not only did he suppress all expres-
sions of his hostility; he became an ascetic who strove to sacrifice all
"selfish pleasures." In adolescence he decided against pursuing a
musical career, although he seemed to have considerable talent as a
singer; in college he abandoned the study of philosophy, in which he
excelled, to become a fundamentalist clergyman. He needed assis-
tance as an adult because he was depressed: he knew very well that
he was not suited for pastoral work, and he had increasing difficulty
in keeping his resentments in check. His apparent saintliness was
paper-thin, the reaction formation barely screening his ruthless
vengefulness. Although his sins were not of the flesh, his character
approximated that of Sinclair Lewis's corrupt evangelist, Elmer
Gantry.

The example of this unfortunate clergyman is, however, not typ-
ical for persons who seem unable to make proper use of their talents.
My clinical experience suggests that the type of psychopathology
that most frequently inhibits potential creativity revolves around
issues of self-esteem. This impression is based on many cases in
which clinical improvement in self-esteem regulation is followed by
creative activities and achievements previously absent from the
patient's life. Perhaps the most common form of the psychopathol-
ogy of self-esteem to interfere with creativity is the persistence of
infantile notions of grandiosity. Such megalomanic ideas are seldom
fully conscious—if they emerge into awareness at all, they tend to
be quickly disavowed. Grandiose attitudes generally manifest them-
selves in the guise of unrealistic expectations of flawless perfor-
mance, leading to an inability to tolerate the unavoidable limitations
of a beginner.[5]

The most instructive example of such a problem I have personally
encountered was the case of an academician at the threshold of mid-
dle age who had spent more than a dozen years indulging his pas-
sion for playing bridge. He was a man of great talent, particularly in
quantitative fields, and he discovered that he could become a bridge
champion while he was still in college. He was not a gambler, and

during his glory days on the championship circuit he was barely able to eke out a living, but he could not resist the lure of being confirmed as the very best in a select company. In the meantime, he got married, and it was the prospect of having to support a family that sobered him sufficiently to lead him to seek an academic career. He found it extremely humiliating and burdensome to write a dissertation, and it was this difficulty that led him to consult me professionally. We succeeded in dealing with the problem in a relatively simple psychotherapy, whereupon he launched certain highly original investigations that were to earn him renown in his academic specialty. It was only the lack of recognition during the stage of apprenticeship that this wunderkind had experienced as unbearable. Fortunately he did not need to resort to imposture to console himself—neither did he possess Trollope's ability to remake his personality without assistance.

This story is echoed by the career of the great Spanish writer Miguel de Cervantes, who began his literary activity as a late adolescent by attempting to create works for the stage. Unable to compete successfully with the mature playwright Lope de Vega, Cervantes left for Italy (actually, he fled after illegally fighting a duel) and soon enlisted as a common soldier in the 1571 campaign that broke Turkish naval power at the battle of Lepanto. In this engagement Cervantes conducted himself with conspicuous heroism and sustained wounds that cost him the use of one arm. Shortly after his recovery, he was captured by the Turks while trying to return to Spain and for a number of years was held prisoner in North Africa. His conduct as a captive was once again so exemplary that he became the leader among the prisoners of war held by the Turks.

These glorious years were followed by penury and misfortune, experiences that seem to have curbed the artist's grandiose quest for instant success. When, in late middle age, Cervantes returned to literature and produced a series of masterpieces, his work was characterized by recognition of the futility of quixotic enterprises: obviously, this very designation stems from the eponymous hero of his greatest book. In his autobiographical allegory, "The Man of Glass," Cervantes ascribes the artist's need for immediate recognition to his sense of having something of great value to offer, and he makes it clear that it is much easier to get acknowledgment for feats of arms than it is to be valued as an artist. In *Don Quixote* Cervantes makes explicit that the greatest of victories is the rare feat of curbing one's own presumption.[6]

The psychopathology of self-esteem is by no means confined to cases of untamed grandiosity. As the examples I have cited suggest, such a survival of irrational attitudes may be overcome either through professional assistance or, perhaps less frequently, as a result of life experiences that boost legitimate self-esteem while, at the same time, they teach a person to accept her limits. I suspect it is even less likely that an individual could transcend a problem of unrealistically low self-esteem whenever such a view is perpetuated by an inability to accept the good opinion of others. This syndrome is well summarized by the celebrated bon mot of Groucho Marx, who claimed he was unwilling to join any club that would admit the likes of him as a member! Because such attitudes cannot be corrected in the course of expectable experiences in everyday life, I do not know of any historical figures whose creativity was unleashed by overcoming this kind of self-contempt.

In clinical practice psychoanalysts encounter many persons with this problem, and successful treatment will enable a certain number of these to make use of their potentials in creative activities. To give only one illustration of such a sequence of events, I had the opportunity to analyze a young woman of great promise, trained as a mental health professional, whose career was in jeopardy because, in a masochistic manner, she only involved herself in fruitless enterprises. The unfortunate results of these endeavors confirmed her poor opinion of herself, and she was convinced that those who held her in high esteem were merely foolishly taken in by her friendliness and charm. Whenever I provided her with positive feedback, she promptly concluded that I was merely giving her false reassurance or—even worse!—that she had succeeded in turning the head of still another old sucker susceptible to female blandishments. It was only through painstaking reconstruction of the childhood circumstances that had convinced her of her own worthlessness that she ultimately succeeded in freeing herself from this vicious circle of self-hatred. (Her self-esteem was undermined in early childhood by her relegation to hired caretakers who, in turn, abandoned her when it suited them to change jobs.) Among other benefits, the improvement of her self-esteem as one outcome of the treatment brought her the ability to achieve professionally, producing scientific work of real merit.

Moral masochism of the kind illustrated by the foregoing example is actually difficult to distinguish from a different syndrome wherein success is out of bounds because it arouses unbearable guilt. For every Robert Oppenheimer, who, once he saw the consequences

of having created atomic weapons, accused himself (after the fact, so to speak) of having embodied destructiveness itself (as a veritable Shiva, as he is reported to have put it), there are large numbers of talented people whose conscience forestalls guilt-provoking activities by forbidding creative efforts in the first place. President Truman is said to have pointed out that Oppenheimer's self-castigation was irrational; Truman allegedly called him a fool, because the responsibility for dropping atomic bombs was the president's alone. Persons prevented by guilt from engaging in creative endeavors are the victims of irrational thinking analogous to that of Oppenheimer.

In my analytic practice the clearest instance of the operation of irrational guilt in blocking a considerable creative talent was that of a young woman whose self-restrictions applied to work as well as to the realm of human relationships. When she began treatment, this brilliant student was even having difficulty in persevering with the requirements for a graduate degree in literature, and the greatest satisfaction she permitted herself was in taking care of certain animals, more usually used in laboratory experiments, as beloved pets. What changed this pervasive policy of self-deprivation was insight gained through treatment about the source of this person's irrational guilt about any form of success.

This analysand was the first grandchild of her paternal grandparents and remained her grandfather's favorite because of her intelligence and charm. Her father, who had always been frustrated in his desire to please his parents, became extremely jealous about this unusual intimacy; he acted out this hostility by accusing his daughter of vaguely defined malfeasances whenever she dared to attempt earning her grandfather's approval. As the adult patient's affection and pity for laboratory animals suggested, she was ever likely to identify with the sufferings of others; she had keen empathy for her father's depressive state about the manifold deprivations of his existence. As her upbringing gradually taught her to take responsibility for the moods of her associates, this woman ultimately came to believe that she could only be a good person if she joined her father (later, other intimates as well) in misery.

In the course of treatment this analysand accepted more rational views about virtue, the mutual responsibilities of family members, and the causation of human unhappiness. Relieved of irrational guilt, she wrote a distinguished dissertation that earned her a faculty position at an excellent university. Contrary to her own expectations and much to my surprise, instead of becoming a literary scholar, as her previous course suggested she might do, she began to write

poetry and novels of recognized merit. She is widely acknowledged as a major artist, and her creativity has now been maintained for some twenty-five years, through a variety of vicissitudes in living that most people would find exceedingly stressful.

I have had other clinical experiences that involved interference with creativity through the potential activation of irrational guilt in which the issue was not focused on fantasies of destructiveness as a result of rivalry, as it was in the case of the writer I have just described. The alternative source of such guilt I have most often encountered is a sense of obligation to safeguard some vulnerable person by maintaining a symbiotically shared existence with him. Incidentally, such "separation guilt"[7] is not *always* irrational: when I was a young therapist, I once assured one of my patients that his fear concerning his mother's inability to live without him did not make sense; within a few weeks of his first assertion of a right to an autonomous existence, his mother died as a result of a self-induced accident. I have never since dared to maintain that the rupture of a symbiosis will do no permanent damage to either partner. In such situations, what patients have to weigh is the risk to the person who has depended upon them versus the certainty that surrendering the right to lead their own lives independently will have damaging consequences for them. Does the canary have the right to starve the cat by taking to flight?

To illustrate how separation guilt may interfere with creativity, I can cite the case of a middle-aged businessman married to a bizarre woman who insisted that she and her husband had only "one heart and one mind." Needless to say, when push came to shove, it was always her heart and her mind that made decisions for these putative Siamese twins, and her preferences dictated exclusive concentration on accumulating a large fortune. When he saw that even tens of millions of dollars failed to satisfy her greed, the husband sought professional assistance, but he was utterly unable to contemplate abandoning his wife, who manifested alarming psychological symptoms if ever he threatened their symbiosis. The dilemma was eventually transcended, after several years of analytic effort; he was then able to delegate her care to a psychiatrist. Be it noted that she did become depressed as a result of his withdrawal from her.

What I wish to focus on here is the outcome of this transaction in terms of this man's creativity, once he was released from the bondage of producing wealth—being a "cash cow," as he put it. The ingenuity he had previously devoted to making profits was now turned in the direction of using his wealth for socially constructive

ends: he became a thoughtful philanthropist who devoted his bene-
factions to the causes that fulfilled his lifelong ideals, both in the
domain of social welfare and in that of cultural activities. In addition,
he created for himself a home environment celebrated for its aes-
thetic merit; this was accomplished partly by hiring the best profes-
sionals but was also due, in part, to his newly found ability to put
together a specialized collection of art and artifacts in an area he had
studied for many years. These and the other worthwhile activities to
which he was now able to commit himself may not have transcended
the boundaries of the creativity of everyday life (see chapter 1), but
for someone at the threshold of his seventh decade who had experi-
ence only in hoarding money, nothing better was conceivable.

Analogous stories of liberation from separation guilt leading to
creative success can sometimes be inferred concerning major histor-
ical figures who could not become productive in the lifetime of a par-
ent, one with whom they seem to have had a symbiotic bond. This
seems to have been the case in the instance of Marcel Proust, that
dazzling conversationalist and notorious dilettante who, after the
death of his mother, underwent metamorphosis into the greatest
French novelist of this century. Proust's dependence on his mother
was impregnated with hostility, and, while it lasted, he seems to have
used his creativity in the service of guerrilla warfare against her. As
we might predict, after losing her, he continued to form relation-
ships modeled on the one to his mother (usually in the form of
homosexual liaisons in which he mothered a rebellious youngster),
but these inverse repetitions of the past, in which Proust was the
dominant partner, permitted him to define himself in whatever
manner he chose, whereas with his mother he was apparently con-
strained to be exactly what she required and/or to rebel against
everything she stood for—including her passionate devotion to
great literature.[8]

I have been surprised to find that among my patients the most
common cause of inhibitions in other spheres of life, that of anxiety
about potential retaliation for one's competitiveness, does not seem
to be a frequent determinant of difficulties in creativity. Perhaps this
clinical impression means nothing more than to say that creativity
is only likely to stir up infantile anxieties if the motivations for cre-
ating are competitive and therefore tendentious, like the ones Freud
highlighted—gaining fame, fortune, and romance. Tendentious
motives are not likely to predominate with individuals who have
real creative potentials, those who are pulled into the requisite activ-
ities principally by the sheer pleasure of exercising their talents. The

anxieties that I did occasionally encounter in the course of analyz-
ing people who later made creative contributions tended to be pro-
duced by fantasies of losing love as a consequence of gaining public
prominence.

As one would expect, attitudes of this unusual (not to say para-
doxical) kind are only learned as a result of being brought up in
exceptional circumstances. The patient I can describe to illustrate
this scenario was relatively ill-educated and constrained by eco-
nomic factors to devote her energies to the struggle for achieving
middle-class status, so that her creative accomplishments remained
relatively modest; because she was trained in a service occupation,
she devoted herself to the development of concepts and materials of
practical value in that field. I must therefore ask the reader to take it
on faith that, given these inescapable handicaps, this young woman
demonstrated creative abilities of a high order: her ultimate success
in the domain of her work was nothing short of amazing. She began
to show her imaginativeness and enterprise quite early in life but
was severely censured for these initiatives by her beloved father. By
late adolescence she had learned to channel her talents into clown-
ing or disruptive behavior that called attention to herself and, at the
same time, brought upon her punitive disapproval almost as severe
as her father's strictures had been.

In the course of a useful analysis, it gradually became apparent to
us that the patient's father tried to suppress her activities if they
could bring her public recognition (or even notice), because he
became intolerably anxious if any member of his family emerged
from anonymity. As best we could judge, he looked upon any noto-
riety as extremely dangerous as a result of lengthy concentration
camp experiences as a victim of Nazi persecution. His survival at
Auschwitz, despite being among the earliest arrivals at the death
camp, was apparently aided by his fanatical caution and prudence: he
became a master of fading into the background. It is also relevant
that my analysand's mother was also a survivor of the Holocaust; it
seems probable that she managed to get by through her sexual
appeal to a series of guards who "protected" her. She was openly
contemptuous of her relatively unattractive daughter's intellectual
propensities, so that she never bothered to dissent from her hus-
band's disapproval of the patient's efforts to develop her talents in
some intellectual sphere.[9]

The example I have just offered also serves to show that the spe-
cific psychopathology that may obstruct individual creativity may
be almost unique—the particular consequence of the sum of a per-

son's learned patterns of behavior, more or less optimal for the child-hood environment but grossly maladaptive in the circumstances expectable in adult life.[10] Because the variety of characterological attributes that may interfere with creativity is therefore potentially infinite, I shall forego describing further types of relevant psychopathology, except to note that once again the consequences of the major psychoses for organized work of any sort are so drastic that the relation between creativity and psychosis requires separate discussion (see chapters 10 and 11).

Although some of the analysands whose difficulties I have recounted in this chapter have had very distinguished creative careers, it would be appropriate to add a historical example here, to demonstrate that psychopathology is just as devastating for the productivity of artists of worldwide reputation. I have selected an illustrative case in which the problem was that of a general deterioration of the personality—a contingency I have not discussed thus far. The artist who suffered this fate was the eminent Bolognese painter Guido Reni. Although biographical data about seventeenth century figures is never altogether satisfactory, in Reni's instance we possess an account of his life written during the lifetime of direct witnesses of his behavior, by a historian who had known him personally.[11]

Reni (1575–1642) was always vulnerable to real or imagined depreciation and prone to form paranoid misconstructions in his dealings with people; repeatedly, he literally fled from situations of stress when he quarreled with the powerful. He broke with his teachers, his friends, and some close relatives, and he was unable to keep his servants. While insisting on the excellence of his work, he was unable to accept personal praise. Extraordinarily attached to his widowed mother, Reni never married; there is no indication that he had sexual interests of any kind: his biographer, Malvasia, actually noted that the artist was believed to be a virgin when he died. After the death of his mother, he could not tolerate to be touched by a woman, apparently because of his fear of witchcraft. Reni's fervent piety was accompanied by equally intense magical beliefs. Finally, the artist was a passionate cardplayer who gradually slipped into more and more reckless gambling.[12]

After the death of his mother, Reni began to lose enormous sums playing dice. Although he demanded the highest prices for his works, he "would spend a month in his studios, two in the card rooms, which always took away more than he brought."[13] He gambled away such vast sums that he could not possibly earn enough in a lifetime to pay them, and his financial needs became so pressing that he hired him-

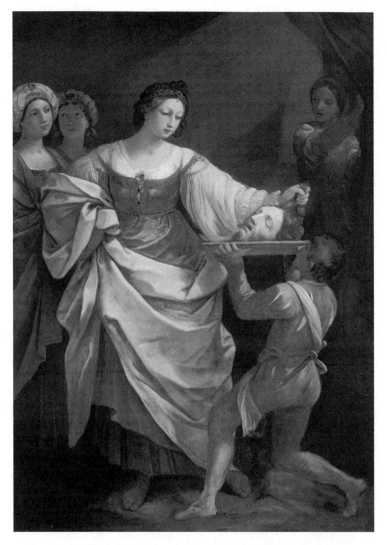

FIGURE 8.1. Guido Reni, *Salome with the Head of Saint John the Baptist*, 1639–1640. Oil on canvas. *Art Institute of Chicago, Louise B. and Frank H. Woods Purchase Fund, 1960.3.*

self out to do hack work for set wages. Most contemporaries believed that in these circumstances the quality of his work suffered because of his haste to produce. He certainly undertook to paint pictures of lesser scope and ambition than previously. As Richard Spear puts it, "Reni's recently discovered death inventory confirms Malvasia's vivid description of a beehive of studio activity during the final years as countless works were blocked out, copied, or retouched."[14]

Autograph works from Reni's late period (figure 8.1) demon-

strate that the artist did not lose his skills—he lost the great fresco commissions that had previously elicited his best efforts, he lost the incentive not to replicate his inventions, and he lost his integrity by signing inferior works by assistants, canvases he had barely touched. His enormous studio became the source of innumerable forgeries. This flood of inferior material was destined to impair his reputation until recent scholarship eliminated these spurious works from his oeuvre. Even today it is difficult to grasp that the young Reni's contemporaries, who generally saw him as the equal of Raphael, did not overestimate his talent.

•

The Frustration of Lying Fallow

In the preceding chapter I attempted to survey the ways in which various types of psychopathology may interfere with the performance of creative work. In contrast, here I wish to examine the psychological consequences that may ensue whenever creativity is blocked, for whatever reason—through psychopathology, physical impairment, inescapable external events, or a loss of creative impetus as a result of a variety of possible internal changes. These potential consequences vary from the most triumphant responses to this adaptive challenge, through a whole range of aggravated maladaptation, to utter collapse, even suicide. Obviously, the impact of any loss in creative power depends on the adequacy of other aspects of the individual's adaptation, those that do not involve the vocational sphere. Among these, the quality of the person's human relationships is perhaps most important. Another way to put this is that the reaction to a loss of creativity is a function of the degree to which the person's self-esteem hinges on continuing evidence of this specific functional capacity.

Perhaps the most tragic story about the devastating effects of the termination of a creative career known to me is that of Arshile Gorky (briefly discussed in chapter 1). Following a lengthy apprenticeship, in the early 1940s, as he was entering his fifth decade, this superb artist reached maturity with a unique personal style (see figure 9.1). In

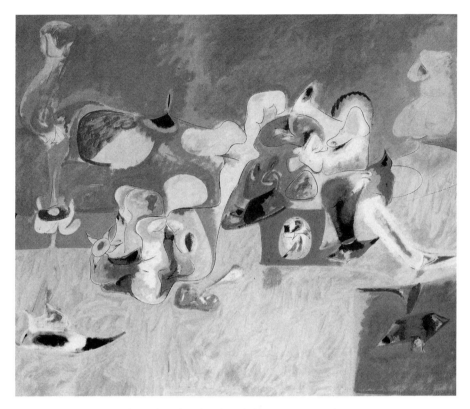

FIGURE 9.1. Arshile Gorky, *The Plough and the Song*, 1946. Oil on canvas.
Art Institute of Chicago, Mr. and Mrs. Lewis Larned Coburn Fund, 1963.208.
© *Estate of Arshile Gorky/ARS, New York.*

February 1946, shortly after he achieved recognition and could look forward to some financial security, he suffered the first of a series of personal disasters, surgery for cancer of the colon, leaving him with a colostomy. He responded with an unprecedented outpouring of work, the excellence of which he was able to affirm in a letter to his sister. A fire in his studio then destroyed part of his oeuvre. In a June 1948 accident, while a passenger in a friend's automobile, he suffered a broken neck; this injury resulted in the paralysis of his painting arm. Some weeks later Gorky's wife abandoned him; at the end of July the artist committed suicide by hanging. His marriage had been troubled for some time; it has been reported that Gorky became sexually impotent after his colostomy. It is not possible to determine the exact impact on Gorky of this marital failure; at the least, it meant that he was deprived of sustaining human bonds when he became incapacitated for work, so that this blow threw him into utter despair.[1]

If I am inclined to give greater weight to Gorky's paralysis than to the desertion by his wife in precipitating his suicide, this bias developed on the basis of my accumulated clinical experience. To relate only one striking case parallel to that of Gorky, I have worked with a professional person who always avoided human entanglements in favor of promoting his career. As a result of several years of difficult analytic treatment, he became an elected official, in a position to make creative contributions in public affairs. His success in these endeavors resulted in a period of unprecedented well-being; this, in turn, led us to terminate the analysis with a sense of significant accomplishment.

Several years later, in a state of severe agitation, this patient returned for further assistance. He explained that his hopes for higher office were blocked by the electoral defeat of his political sponsors and that he found his current position unbearable because a certain faction of influential people had turned against him and, through their public criticisms, caused him severe humiliation. He knew that he was about to sacrifice something of great value, but he was determined to make a lateral move into teaching at the graduate level. Despite my efforts to get him to consider this plan more carefully, he promptly put it into effect by resigning from office. In his new job he had no immediate prospect of exercising his particular creative talents; in actuality, the change threw him into further agitation and depression. He resumed analysis, but my efforts were insufficient to prevent the emergence of suicidal ideation and of a frantic need to save himself by attempts to prove that he possessed magical powers: he lapsed into ever-riskier financial ventures and fantasies of winning the lottery.

These alarming developments persisted as long as he continued in his teaching post. Fortunately, soon an opportunity in public administration again became available, albeit one with less scope and prestige than his elective position. As the patient took hold of this chance to resume work that called on his creative abilities, his depression and agitation gradually lifted, and he was able to relinquish the resort to gambling. The further course of this analysis is largely irrelevant for the point I wish to illustrate here; suffice it to say that when more favorable political circumstances supervened, this man was slated for and elected to the higher office he had always hoped for and there was able to attain a higher level of creativity than ever before. In these circumstances, it even became possible to explore analytically (and partly to overcome) his need to withdraw from meaningful human relationships.

Of course, individuals with stable and satisfying human ties are often able to relinquish creative activities without untoward consequences. One of the most celebrated instances of this kind is that of Gioacchino Rossini, the outstanding operatic composer of the early nineteenth century. Having created a highly successful series of thirty-eight operas, at the age of thirty-seven Rossini retired from composing for the stage. It is true that he was later able to produce a major piece of religious music, the *Stabat Mater*, and a number of shorter compositions, but he did not seem to miss the hectic pace of his earlier creative life. On the contrary, he became a famous bon vivant and gourmet, with a wide circle of friends and a serene domestic life. Reflecting the good humor of this carefree existence, in later life Rossini created a set of piano pieces he named *Sins of Old Age!*[2]

Other creative persons whose inspiration or capacity wanes are not content with sporadic demonstrations of continuing potential, as Rossini seemed to be. As I have already mentioned (chapter 8), when he was unable to create within the visual arts, Pablo Picasso produced a considerable body of literary work. I suspect that the art historian Francis O'Connor is right in his conjecture that Arnold Schoenberg's activity as an Expressionist painter, mostly of self-portraits, was an effort to continue creating during periods when his composing encountered particular difficulties—especially around 1910, when, by inventing the atonal vocabulary of music, he was abandoning the time-honored traditions of his creative domain.[3] Practitioners of disciplines wherein the greatest of creative accomplishments almost invariably seem to be produced during the early years of activity, such as mathematics or lyric poetry, often shift their endeavors to other domains as they begin to experience a diminution of effectiveness within their original field. As an example, one might cite the case of the greatest of Russian poets, Alexander Pushkin, whose production tilted in the direction of prose when he reached the age of thirty. What verse he did create thereafter was not primarily in a lyric vein: he wrote several plays in verse as well as narrative poems. And Pushkin was barely thirty-seven when he was killed in a duel—too young for his lyric flame to have been extinguished altogether.[4]

Such shifts in the focus of creative activity are the consequences of vectors of some complexity. As he entered middle age, one of my analysands transferred his principal allegiance from mathematics to music; however, this change was only made possible by the success of the analysis in helping this very talented person to live his life in

accord with his own preferences rather than those of his parents. It is quite probable that, had he been free of this character pathology in adolescence, he might have chosen a musical career in the first place. In other words, it may be most cogent to look upon his belated espousal of the domain of music as an indication that he was free at last to make better use of his creative potentials—albeit his achievements as a mathematician were by no means negligible. Nonetheless, for this man it was probably the detour into mathematics that constituted a compensatory effort to overcome the damage caused by an inability to pursue his preferred vocation.

Another analysand who followed a roughly similar course was deflected from an artistic vocation by the contempt in which this was held by his entire family and much of their provincial community. Although he had no real love of learning or much inclination for research, he attempted a vocational compromise by devoting himself to scholarship in the history of cultures. Because of his lack of enthusiasm for the work, he was unable to complete his academic projects. His creative aspirations were directed, instead, into the realm of picaresque homosexual adventures. He sought psychological assistance at the threshold of middle age, when the imminent fading of his outstanding good looks threatened to deprive him of the support for his fragile self-esteem that being the hero of these romances provided.

In the analysis this man changed on two parallel fronts: he was able to refocus his career by becoming the curator of a succession of historical houses; responsibility for restoring, refurnishing, and arranging these environments satisfied his need for artistic opportunities. As his self-esteem was buttressed by widely recognized success in these endeavors, the most compelling of his motivations for promiscuity was dissipated, and he abandoned his sexual adventurism. In this instance, commitment to an artistic career made it possible for a vulnerable individual to accept the limitations of an "ordinary" existence. (The adjective is Montaigne's designation for a good life.)

In my clinical experience a resort to sexual excesses is not an unusual response to the frustration of being unable to make use of putative creative potentials. The would-be writer to whom I have already referred (in chapter 2) as too frightened of possible failure to risk any creative effort, discovered in mid-adolescence that numerous disturbed women were eager to be consoled for life's miseries by his sexual ministrations. He became an expert seducer of these pitiful creatures and prided himself on his ability to please them—albeit

on a short-term basis. Once he had proved to himself that a woman was responsive to his services, he rapidly lost interest, only to start the restless search for the next person with whom to repeat the experiment. Like Don Giovanni in the Mozart opera, he literally kept a list of his "conquests," although he knew that it was somehow fraudulent to boost his self-esteem on the basis of such easy pickings.

This frantic Don Juanism gradually evaporated in the course of the analysis, much as the promiscuous activities of the historian disappeared when creative achievements began to satisfy him. In the case of the analysand who found skirt chasing less risky than literature, in order to mitigate his promiscuity it was sufficient for the patient to diminish his pervasive humiliation by overcoming financial dependence on his wealthy family. However, the propensity to involve himself with disturbed, emotionally needy women whom he found it easy to patronize persisted beyond his achievement of economic self-sufficiency. In the analysis we were able to discern the roots of this pattern in his childhood ambition emotionally to assist his dysfunctional mother. Although he had never succeeded in such an endeavor, the discovery in adolescence that many women regard physical love itself as a home remedy for their psychological difficulties became his "secret," patented therapeutic method—a skill the exercise of which replenished his chronically deficient self-esteem. It was only when he actually began to produce serious writing that he was finally able to dispense with this "ace in the hole"—to echo the obscene punning that characterized our analytic dialogue.

Of course, it is sheer prejudice to look upon skirt chasing as a sign of maladaptation and on chasing butterflies, let us say, as an interesting and constructive hobby with scientific overtones. Who is to say that my patient will be less capable of classifying the creatures he once pinned in bed than was Vladimir Nabokov, the Russo-American author, in describing his beloved specimens of *Lepidoptera*? It is worth noting, in this connection, that during his early years in America, before receiving a secure appointment to teach literature at Cornell University, Nabokov supplemented his income and enriched his life by holding a part-time position at Harvard's Museum of Comparative Zoology, working with the butterfly collection. Nabokov never suffered a true hiatus in his productivity as a writer, but even before he reached the United States he decided to change his medium from the Russian language to English. Hence, between the completion of his last (and greatest) novel in Russian, *The Gift*, and the creation of *Lolita*, roughly from 1938 to 1948, his literary output diminished both in quantity and in quality. It would seem that

Nabokov's capacity to transform his passion for capturing butterflies into an avocation that still gave him scope for creativity may have been stimulated by these difficulties.[5]

It should also be noted that compensating for creative paralysis by means of sexual exploits usually amounts to more than a simple displacement of ambition from one sphere of activity to another, although it generally does constitute a substitution of that kind. In most instances, however, this kind of assertion of sexual prowess is perpetuated by the fact that, in addition to boosting self-esteem, promiscuous activity is almost always motivated by chronic rage: for the most part, the Don Juan is actually venting his anger and contempt on women. Moreover, in my judgment, this generalization is equally applicable to the erotic exploits of both men and women, heterosexuals and homosexuals.

The clearest illustration I have seen of these circumstances in the case of a woman is that of an aspiring painter whose Orthodox Jewish family was opposed to educating girls for any role outside the home. In contrast, the patient's older brother was supported to achieve a distinguished professional career. Raised in the multicultural environment of a mid-twentieth-century American metropolis, this victim of sexual bias grew up to hate and envy males, and she' was filled with rebellious anger against her parents. Thus it was an act of revenge on her part to deflect her "creative" activities onto the stage in the form of striptease dancing; she was keenly aware of feeling triumphant whenever she perceived men in the audience masturbating in response to her provocativeness. Fortunately, she was sufficiently goal-directed to use her resources to obtain the education she needed, and her spitefulness diminished as opportunities for an artistic career supervened. By the time she sought treatment, she was working as a high school art teacher; she needed help to overcome her deficient self-esteem so that she would have the courage to display her art—and to value herself as a woman.

I have already alluded to the example of the novelist Marcel Proust, scion of a wealthy Parisian family, who did not begin to write *Remembrance of Things Past* until 1908, some two-and-a-half years after the death of his mother. It is true that in earlier years Proust produced some criticism, translations, and occasional pieces for newspapers, and around 1895 he even tried unsuccessfully to write fiction, but nothing he had done before was remotely comparable in scope or quality to his immense masterpiece.

Proust had a very complex relationship to his mother, pathologi-

cally dependent and hostile at the same time. Without presuming to specify exactly how this chronic guerrilla war prevented the son from becoming the artist he was capable of being (was he resisting her implicit demand for performance? was he punishing himself for his acts of aggression against her? was he deflecting her unconscious envy?—the possibilities are manifold!), we may conclude that her presence robbed him of the opportunity to use his talents optimally. In his case, as in those I have witnessed in my practice, the impasse led to provocative sexual misconduct—homosexual promiscuity of the kind Proust was to describe so acutely in his great novel. After his mother's death and the release of his creativity, Proust continued to be exclusively homosexual, but his behavior became notably more discreet; in seeming identification with the mother he had lost, the middle-aged author fell in love with a promiscuous youth who provocatively abused his trust.[6]

Angry self-assertion may, of course, also find nonsexual modes of expression, as was the case with the analysand whose case I compared to the tragedy of Arshile Gorky—the public servant who insisted on proving that he is the possessor of magical powers. I have encountered unrealistic ambitions of this kind in analyzing a fair number of mental health professionals. In a medical domain succumbing to irrationality of this particular kind may entail endangering the lives of other people. What I wish to stress in this context is the fact that regression to unrealistic magical ambitions is an ever-present danger in the health professions. It is especially likely to occur whenever a practitioner is thwarted in the performance of "the healing art." Although one would hope that health care activities would be based on scientific foundations, praxis inevitably consists in the creative application of natural science in circumstances of considerable ambiguity. When we are more often defeated in such enterprises than we are able to tolerate, it is all too easy to lapse into the role of a shaman.

A third area of compensatory activity in case of creative paralysis is the accumulation of money, sometimes carried to the extent of senseless greed or avarice. Many years ago I treated a young professional man who was in perplexity about a marital crisis; in due time the acute issues were resolved. When we terminated our work, he also changed the direction of his career and began to give scope to his imagination in starting a collection of unusual artifacts that subsequently became greatly sought after. About twenty-five years later, now a person in late middle age, this patient returned for assistance, even more perplexed than he had been at the earlier turning

point in his life. He recounted that he had remarried and fathered several children; with his wife's encouragement he abandoned his profession, started a highly successful business, and made a considerable fortune. He was working very hard, but his activities had become routine, and he was terribly bored. He was scarcely spending more money than he used to do as a younger person, for every available dollar was reinvested in order to expand the business. The reader will now have recognized that this is the patient I have already described, from a different vantage point, in the preceding chapter.

Because the patient's dysphoria was difficult to understand, I recommended a trial of psychoanalysis, a course of action eagerly embraced by this confused person. What we then discovered was that the analysand was committed to the accumulation of money as the activity for which he and his wife had an equal amount of enthusiasm. Aside from this shared passion, they had little in common—for example, she was so uninterested in his collection that his artifacts (which were by then exceedingly valuable) were relegated to storage in the garage! Without going into the details of a complex process, let me state that the treatment culminated in a rupture of this mercantile alliance in the guise of marriage. As I have already mentioned, the patient then began to improve his standard of living, resumed his collecting, and started to use his fortune for philanthropic purposes, in highly ingenious ways. I think we may infer that he had lost interest in the business when it no longer called upon his creative abilities, but he was rightly afraid that to change course at that point would have disrupted his family life. He fell into miserliness because he had no creative outlets available; once the dreaded family rupture had occurred, he found new channels of creativity and was no longer greedy for money per se.

Another analysand (briefly mentioned in chapter 2) also substituted financial goals for creative ambitions; she consulted me when she achieved her target of becoming a self-made millionaire by the age of thirty. In the process of achieving success in business, she made quite a mess of other aspects of her life, and it was to straighten out those matters that she sought help. The manner in which the analysis accomplished that task is not relevant for my point here; suffice it to say that we learned, en passant, that as a student at an elite university, she had been avidly interested in history and social theory. Her problematic upbringing in a family of businessmen did not prepare her to venture on an academic career; she

felt constrained to earn her own living and to accept her family's verdict that it would be impractical to try to compete in the arena of scholarship. She then determined to prove herself as a competitor of the men in her family—a task she managed to accomplish at considerable cost to herself. She was able to master this problem in the treatment, so that she could entrust her profitable business to hired executives while she resumed the abandoned intellectual activities of her college years.

Compared with the suicide of Arshile Gorky, the substitution of sexual, monetary, and power-seeking goals, or oscillation between one realm of creativity and another, are relatively healthy coping mechanisms, even if they lead at times to behaviors many of us find unattractive. It is more difficult to take a position of neutrality about still another adaptive device used by some to deal with creative frustrations, that of resort to alcohol or other drugs that alter subjective experience. Because self-medication of this kind often results in addiction, with extremely damaging consequences for overall health, these home remedies are truly worse than the dis-ease they are intended to alleviate.

Perhaps the best known artist to have destroyed himself through alcohol abuse was the American culture hero Jackson Pollock. (His actual death occurred as a result of a one-car automobile accident that most biographers judge to have been a suicide.) Francis O'Connor asserts that what best served to hold Pollock's chronic alcoholism in check was his own creative activity: it is probable that the artist's longest period of total abstinence, from late 1948 to the end of 1950, was attributable to the fact that, starting in 1947, he reached the apogee of his creativity. His drinking bouts recommenced when the vein of his most famous works, the multicolored pourings, was exhausted, and Pollock was confronted by the challenge of surpassing his greatest achievement. As the painter put it, he then "hit an all-time low—with depression and drinking." Pollock continued to produce creditable work for the remaining six years of his life, but he could not content himself with a standard of performance less exalted than his best. Pollock's paintings of 1951–1952, the so-called Black Pourings, have been characterized as representing "a fire extinguished"—I read them as mournful records of the lowering of his creative fire (figure 9.2).[7]

Stephen Spender was the first to point out the parallel between the life of Jackson Pollock and that of the English novelist Malcolm Lowry.[8] The latter was also a chronic alcoholic, and his masterwork,

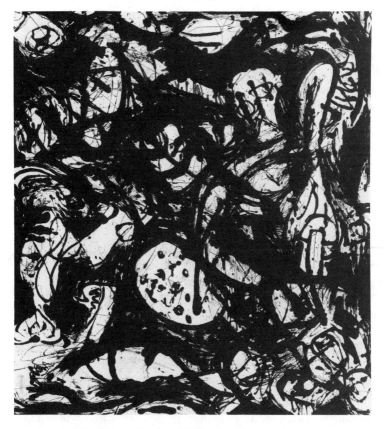

FIGURE 9.2. Jackson Pollock, *Black and White, Number 20*, 1951. Duco on canvas. *Los Angeles Museum of Art, Estate of David E. Bright. © 1996 Pollock-Krasner Foundation/ARS, New York.*

Under the Volcano, is arguably (among its other merits) the finest depiction of that syndrome. Lowry created this book in its definitive form during the early 1940s, when with his second wife he lived in British Columbia; the novel was finally published in 1947. Apparently the years spent rewriting this modern classic were the happiest of Lowry's life—and, clearly, the most effective. For a decade after the book appeared, and before he died, Lowry was unable to finish his projects; we might attribute this failure to his worsening alcoholism, except for the consensus that his later writings (posthumously published by his widow) simply do not measure up to *Under the Volcano*. In my judgment, Lowry drank himself to death because he experienced the pain of lying fallow.

Because individuals in the throes of acute alcoholism or drug abuse cannot be assisted by verbal means alone (often they must undergo a process of detoxification in an in-patient setting), as a

psychoanalyst I have had almost no firsthand experience with these conditions, so that I am unable to cite comparable cases from my analytic practice. I have, however, analyzed one person who dealt with the frustration of her creative ambitions by lapsing into bulimia—a condition analogous to drug or alcohol abuse, albeit one cannot literally become "habituated" to food. (A different aspect of this analysis was presented in chapter 8.)

My patient acquired her eating disorder in adolescence, when she lost hope of being able to compete with her sisters for the esteem of her mother. The latter, a survivor of the Holocaust despite several years of captivity, an accomplishment attributable in some measure to her sexual attractiveness, was only able to value her daughters' physical merits. The patient was large, clumsy, and epileptic; in her mother's scheme of things, she was utterly useless as a woman. The fact that the girl was intellectually brilliant counted for nothing; the mother kept badgering her to concentrate on covering up her physical limitations. It was in response to these infuriating inanities that the outraged adolescent found herself engaging in eating binges, although she managed to hide from herself that this behavior represented a repudiation of her mother's value system. When she started analysis, about a dozen years later, she was repeating this pattern in relation to a lover who was losing sexual interest in her, probably because he was envious of her intellectual superiority. It should be understood that, despite her underlying anger, this woman consciously accepted her mother's views and failed to use her outstanding talent in creative endeavors until her separation guilt was brought fully to light in the analysis.

I believe I have now given a sufficient number of examples illustrating a broad range of reactions to the frustration of creative ambitions to make it possible to state certain conclusions. First, it is clear that, viewed in isolation, both well-adapted and pathological coping mechanisms in reaction to such frustrations are completely indistinguishable from behaviors motivated by other problems in living. In other words, it is never legitimate to infer from its phenomena what the dynamics of any behavior might be. Second, the specific coping mechanisms utilized are always functions of the opportunities available in the milieu: in Cambridge it is often possible to engage in serious scientific work about butterflies, but this is seldom feasible in Siberian exile. (Have great novelists ever been exiled to Siberia? Certainly: it was such an experience that Dostoievsky recorded in *The House of the Dead*, written upon his release).[9] Finally, the manner in which any individual responds to creative paralysis is most likely to follow paths already trodden in previous difficulties.

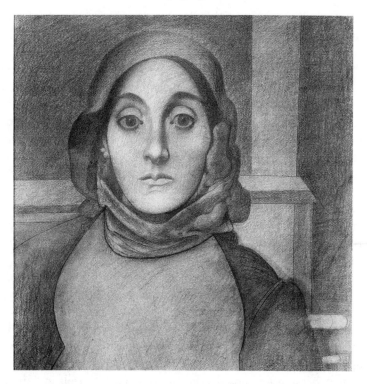

FIGURE 9.3. Arshile Gorky, *The Artist's Mother*, 1926 or 1936. Charcoal on ivory laid paper. *Art Institute of Chicago, Worcester Sketch Fund, 1965.510.* © *1995 Estate of Arshile Gorky/ARS, New York.*

To buttress this contention, let me return to the fate of Arshile Gorky. He was born in Turkish Armenia, into a family of farmers and priests of the Armenian church, the only son and middle child of three. His early life was just as full of catastrophes as were the last several years of his tragic existence: the Adoians' family life, which the artist was to remember in ideal terms, was utterly disrupted by the communal warfare between Armenians and Turks that was to culminate in massive genocide. Gorky's father emigrated to the United States in 1904, when the boy was only four, to escape conscription into the Turkish army. Gorky was extremely close to his mother, as shown by a series of works he created in later years that were based on a photograph taken when he was eight; the most poignant of these is an elegiac charcoal drawing, *The Artist's Mother* (figure 9.3). Early in World War I, with the advent of hostilities on the Russo-Turkish frontier, the Armenian population in that area was besieged by the Turkish army and driven into exile behind the Russian lines. After terrible hardships, Gorky, his mother, his two sisters (and a half sister) reached Yerevan.

Details of the Adoians' mode of existence as refugees are not available, but it is known that Gorky's older sister and half sister made their way to America late in 1916. By doing whatever work he could obtain, the twelve-year-old boy helped to support his mother and younger sister while he continued to attend school. In the spring of 1918 (Russian) Armenia declared its independence, and there was a threat of civil war. In August the Adoians decided to flee abroad, but the mother was so ill from malnutrition that they were forced to return to Yerevan, where in March 1919 she died. Shortly thereafter the surviving children, fifteen and thirteen, left for Georgia with a family friend. Thence they followed a stream of Armenian refugees to Istanbul, where they were taken in by a family who paid their passage to the United States. They reached Providence, Rhode Island, where the father was living, early in 1920.[10]

It is truly astonishing that, following such a series of traumata, within less than five years Gorky was able to recreate himself as an artist. No doubt he chose a pseudonym that expressed his unresolved feelings of bitterness; admittedly, to be reborn as a member of the New York avant-garde, he had to engage in some measure of imposture. By all reports, he put aside the experiences of war, ethnic cleansing, starvation, and death, and immersed himself in "memories" of a paradisiac childhood. He was a self-consciously *Armenian* artist, proud of the medieval artifacts produced and preserved by his people, albeit he took Cézanne and Picasso as his models and idealized mentors.

Many commentators have noted that, for an artist of Gorky's enormous talent, an apprenticeship of more than a dozen years, in the course of which he humbly followed in the footsteps not only of Cézanne and Picasso but also of Miró, Léger, and even Matta, was extraordinary. I understand this slow but well-founded progress as one consequence of the artist's need to find substitutes for the father who had deserted him. In that sense, Gorky's European-modernist works, such as *Three Forms* (figure 9.4), constituted a mythic recreation of an idealized version of the childhood he longed for. Clearly, portrayals of his mother, alone or with his boyhood self, had a similar significance.

Starting in the mid-1930s, Gorky began to entitle some of his quasi-abstract works after places and events of his Armenian past.[11] He fell in love with the landscape around the property of his wife's parents in Virginia, stating that it reminded him of his native Armenia. Thus, when he entitled numerous works *Virginia*

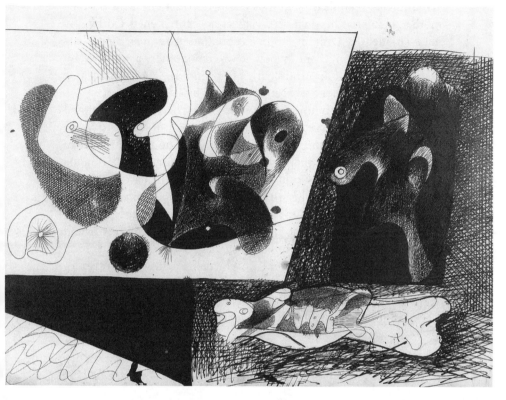

FIGURE 9.4. Arshile Gorky, *Three Forms*, 1937. Pen and brush with black ink over pencil, with touches of oil paint on paper. *Art Institute of Chicago, Grant S. Pick Memorial Fund, 1968.35.* © *1995 Estate of Arshile Gorky/ARS, New York.*

Landscape, he was using metonyms alluding to a perfected past. *Apple Orchard* and *The Plough and the Song* (see figure 9.1) refer to his father's property in Xhorkom. Through such symbolic substitutes for what he had lost, Gorky kept alive his connection to his childhood paradise and warded off the unbearable memories of his expulsion from Eden.

Gorky responded to his mother's death, the rigors of exile, the need to acculturate to his adopted country, and the economic hardships faced by every artist during the Great Depression with courage, stoicism, and resourcefulness. He accepted the failure of a first marriage in the mid-1930s without undue difficulty. After his operation for cancer, his productivity was, if anything, greater than ever, but his work took on a tragic air, reflected in titles such as *Charred Beloved* and *Agony*. We do not know whether the former refers to his own body, to his paintings lost in the studio fire, or to both—but we may infer that allusions to these recent events also

stand for his rekindled memories of the destruction of his beloved mother. Insofar as his own survival was now threatened, Gorky was bound to identify with his mother's situation in Yerevan. This identification was strengthened when he was emotionally abandoned by his wife (who had an affair with his friend, the Chilean painter Matta), as his mother had been abandoned by her spouse.

It was in these circumstances that Gorky became preoccupied with Chekhov's story "The Black Monk" and based on it what turned out to be his unfinished *Last Painting*. The title of the story refers to a vision of death, personified as a black-clad monk. What is most significant about Gorky's interest in this narrative is the fact that the protagonist of the story is a despairing genius who knows he will be unable to fulfill his artistic aspirations, because his body is failing him. It is unclear to me whether Gorky was merely afraid that his cancer would recur or had been diagnosed with a recurrence. At any rate, after the accident in which his arm was paralyzed, Gorky asked visitors to read "The Black Monk" aloud, over and over again. A genius with a broken body must be ready for death. And Gorky's mother had taught him how to die heroically.

Psychosis and the Art of Inner Necessity

In the past 250 years the care of the insane has been revolutionized as a result of the triumphant spread of the moral views of the Enlightenment. As psychosis became the subject of scientific study, a shift that simultaneously freed its victims from religiously inspired moral sanctions, mental hospitals were transformed from places of detention for the demoniacally possessed into shelters for unfortunates deserving of humane treatment. These developments gained impetus toward the end of the eighteenth century, led by such pioneers as Philippe Pinel in France, William Tuke in England, and Benjamin Rush in newly independent America.

Psychiatric efforts to ameliorate psychotic illness were perforce confined to what was then called "moral treatment"—essentially, the provision of a safe and empathic hospital environment that encouraged patients to make use of their residual capacities to perform useful or at least harmless activities. It was something of a surprise that patients frequently preferred to focus on producing "art," most often in the form of drawn or painted images. Although individuals without prior artistic training could only create works in the manner art professionals have labeled naive, the occasional trained artist who became psychotic, such as the mid-nineteenth-century British painter Richard Dadd, produced work of undoubted formal sophistication while confined in an asylum.[1]

At first, these creations were only taken seriously within the psychiatric community, and only in the hope that patients' artistic products might serve as a source of insight into the mental universe of the psychoses, previously impenetrable in large part precisely because the illness greatly interferes with the victim's capacity to communicate by means of consensual language. Gradually, the mental health professionals who studied the art produced by hospitalized psychotics began to realize that some of these works possess aesthetic value as well. As a result, a number of hospital-based collections of psychotic art were established; among these the best known are the one made by Cesare Lombroso, professor of psychiatry in Turin and—even more celebrated—the Prinzhorn Collection at the University of Heidelberg.

The scientific literature reporting on the creative accomplishments of the insane was, early in the twentieth century, complemented by scholarly attention to these phenomena from the side of art history and criticism. Hans Prinzhorn, who organized the Heidelberg archive, was an art historian who obtained psychiatric qualifications in order to be able to study the creativity of psychotics. His 1922 book, *Bildnerei der Geisteskranken*, presenting the cream of the Heidelberg collection as art of the highest significance and merit, became enormously influential.[2]

Professional artists were quick to respond with avid interest to these early reports about the raw power of the art of the insane. This was particularly true in Germany, where, during the first third of the century, the Expressionist movement was seeking to create a novel art depicting man's inner world. Artists destined to achieve major reputations, such as Max Ernst, Paul Klee, and Richard Lindner, studied the Prinzhorn materials at first hand and were strongly influenced by the "schizophrenic masters" featured in the collection (figures 10.1 and 10.2). After the Second World War Jean Dubuffet was the most prominent among artists interested in the work of psychotics. At the same time, critical opinion began to single out several psychotic artists as creators of outstanding bodies of work. By general consensus, the Swiss painter Adolf Wölfli, much of whose output is now in the Bern Museum, is considered to be the greatest of psychotic artists; the Swedish painter Ernst Josephson and Aloïse Corbaz, another artist from Switzerland, are also highly regarded. Recently, the Argentine schizophrenic, Luis, has been added to this roster.[3]

In the past sixty years, in large measure because of the direct influence of such psychotic masters, the subject matter once unique

FIGURE 10.1. Moog, *Destruction Jerusalem*, 1919. Pencil, color pen, and tempera on cardboard. *Prinzhorn Collection, Ruperto Carola University, Heidelberg.*

for the art of the insane—imagery expressing megalomania, delusions of persecution and of sexual power, or bizarre religious ideas—has entered the mainstream of contemporary art. Although the Surrealists, in particular, claimed to be tapping the same unconscious wellsprings in their work as did the psychotic artists they admired, their volitional manipulation of form and/or content for artistic ends is not strictly comparable to the spontaneous and apparently aimless image making of the mentally ill. In my judgment, Ernst, Klee, and Dubuffet used such artistic means to convey humor, for example (see figure 10.3); Lindner's work is filled with a spirit of irony (figure 10.4).[4]

Of course, no human behavior is literally unmotivated, and the image making of psychotics cannot be the exception to this rule. But

FIGURE 10.2. Neter, *Witch's Head*. After 1911. Gouache on cardboard. *Prinzhorn Collection, Ruperto Carola University, Heidelberg.*

it must be kept in mind that the insane engage in these activities even if there is no prospect of sharing their product with anyone else—in other words, they do not necessarily attempt to *communicate*, as do other artists. John MacGregor has called attention to a 1735 engraving by William Hogarth, *In Bedlam*, showing (among the manifold activities of a crowded ward of the Royal Bethlem Hospital) an inmate drawing graffiti on the wall. The work of *that* psychotic artist appears to deal with a cosmological fantasy of the kind commonly found in any collection of the art of the insane. At any rate, through his depiction Hogarth makes it entirely clear that the man drawing on the wall of the asylum is lost in a private world.[5]

The mysterious need of many psychotics to produce art may be illuminated by focusing on the histories of the rare professional artists who produced both work that fit the cultural tradition to which they belonged and a separate oeuvre that shared the characteristics of the art of the insane, in subject matter, in terms of certain formal elements, or both. The most instructive instance of this kind may be that of the Anglo-Belgian pioneer of fantastic art, James Ensor. Well-trained in the academic tradition and abreast of French avant-garde developments, Ensor produced work of the greatest emotional power when he abandoned sophisticated techniques in

favor of formal means redolent of the naïveté of the art of the insane. His great achievements took place in the late 1880s, before appearance of the reports that made public the characteristics of psychotic art, so that Ensor certainly found the raw style needed to communicate his message on his own.[6]

Ensor was raised in the rancorous atmosphere of a perpetual family civil war, but he was unable to emancipate himself from that environment and settled in the parental home after leaving art school at the age of twenty. He lived for several decades as a despised dependent, thus following in the footsteps of his hapless, alcoholic father. The latter's deterioration culminated in dying of exposure while in an alcoholic stupor; James Ensor was twenty-seven years old at the time. The artist reacted by becoming obsessively preoccupied with the prospect of his own death—an ominous sign of extreme psychological stress. As a result of his bereavement, Ensor was incapacitated for several months, but he was able to maintain a measure of equilibrium by identifying with certain aspects of his father's customary behavior. For example, he was delighted if he was able to provoke townspeople into jeering him, as his drunken parent had been jeered. He also felt abused by his erstwhile artistic friends—a paranoid reaction without a trace of justification in actu-

FIGURE 10.3. Jean Dubuffet, *Genuflection of the Bishop*, 1963. Oil on canvas. *Art Institute of Chicago, Joseph Winterbotham Collection, 1964.1807.* © 1995 ARS, New York/ADAGP, Paris.

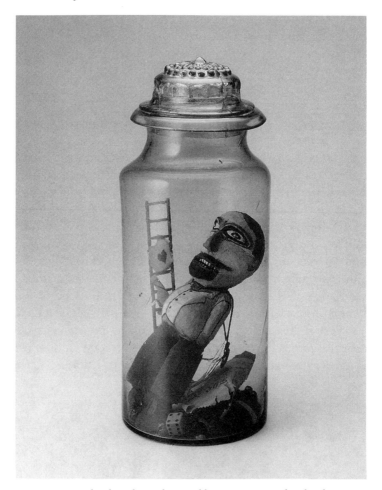

FIGURE 10.4 Richard Lindner, *The Gambler*, 1952. Green glass bottle containing a carved and painted figure, dice, chips, paper, string, plastic ladder collage elements. *Lindy and Edwin Bergman Collection, on loan to the Art Institute of Chicago, 141.1991.* © *1995 ARS, New York/ADAGP, Paris.*

ality. A year later Ensor formed a liaison with a socially inferior woman whom he allowed to direct his everyday activities as if he had been a small child; the lovers maintained their mutually hostile symbiosis for the rest of their lives.

The crisis of depression and paranoia precipitated by these events led to the creation of the artist's most original and powerful works. In the process, Ensor's disorganization was halted barely short of an overt psychosis; the understanding of supportive friends assisted him to pursue his art in relative isolation until his personal storm blew over. Thus the case of James Ensor illustrates both the contin-

uing development of a major professional artist and the self-referential image making of the mentally ill. As his emotional crisis receded, Ensor's work lost aesthetic power; his artistic self-confidence diminished just when the artist started to gain public acclaim. Ensor began to replicate his successful works from the past, and he devoted the rest of his long life to self-promotion and the impersonation of a great man.

The most bizarre content to enter Ensor's repertory during his crisis was his repeated depiction of himself as a creature in decay or as a skeleton. He also reworked a number of his earlier paintings at this time, transforming them from conventional genre scenes into weird images of ectoplasmic apparitions or other hallucinated entities. This subject matter is strikingly similar to that of many works in the Prinzhorn collection. In both cases, the artist seems to be setting down an actual perception about the reality of which he cannot quite decide. Critics have called even Ensor's townscapes of this period images of a foundering world; a similar sense of cosmic anxiety fills the landscapes produced by psychotics, and these results are produced by means of comparable stylistic expedients: *horror vacui*, the flattening of objects, violent color contrasts, a caricatural rendering of the human figure. Yet it must not be forgotten that, in parallel with these celebrated expressionist works, Ensor continued to paint glowing pictures of tranquil beauty. In other words, he suited his formal devices to the specific subject matter of the work in question (figures 10.5 and 10.6).

Ensor's best work is sadistic and scatological; it is often viewed as a metaphysical inquiry into the ubiquity of evil. Such images gain their power to convince because, at the same time, they express the artist's paranoid resolution of his potentially disorganizing emotional crisis. A work in which this idea is concretized is an 1888 drawing (later reworked as an etching), showing a swarm of demons teasing Ensor (figure 10.7). Ten years later, the artist reused this image for a poster of an exhibit of his works in Paris; by that time the portrayal of terrifying persecution had been transformed into the representation of a game. This gradual taming of raw emotion through repetition demonstrates the manner in which image making may exercise its healing power. The example also suggests it is not a coincidence that when nonpsychotic professionals such as Ernst or Dubuffet use these formal devices, the results tend to produce a comic effect.

In summary, Ensor's art proved to be an effective antidote for his incipient psychosis, in part by encapsulating his illness within the subject matter of his work, in part by gaining him recognition as one

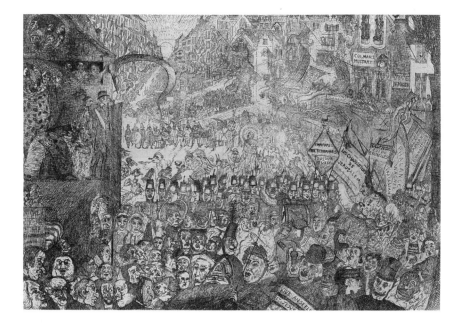

FIGURE 10.5. James Ensor, *Entry of Christ Into Brussels*, 1898. Etching.

of the great men in the glorious artistic tradition of Flanders. Thus the artist was able to substitute for his disappointing father powerful creative progenitors like Rubens, Breughel, and Bosch. By the age of forty Ensor had become a Flemish classic, and this status stabilized his equilibrium. Obviously, the vast majority of psychotic artists cannot heal themselves to the same extent, but we may infer that their spontaneous efforts to make images have an identical aim, that of regaining equilibrium. Perhaps the success of such an enterprise depends in part on the unexpected but appreciative response of a significant public. According to Michel Thévoz, the peaks of psychotic art reached by Wölfli, Aloïse, and their peers were achieved when the work had its sources in an active dialogue with psychiatrists, caretakers who truly valued it.[7]

Thus far, positive responses to the production of psychotics have occurred mostly in the visual arts—so much so, that Hans Prinzhorn believed that mental illness enhances creativity in this realm but no others. This was, of course, a debatable value judgment, because psychotic patients certainly make frequent attempts to create literary products. It is true that the illness may so impair their capacity to use language for communicative purposes that one might not expect the resultant writings to have the power to evoke

positive responses. Surprisingly, in German avant-garde circles of the past generation, certain psychotic poets including Adolf Wölfli have been appreciated despite the impossibility of apprehending the intended meaning of their words: the poems must be judged on their merits as abstract compositions—from a psychiatric vantage point, their technical designation is word salads: they communicate nothing beyond the sonic properties of the phonemes ("words") they employ.

In less severe instances psychotic illness does not impair the patient's capacity to use language in a consensual manner, so that a meaningful written production might only betray its psychopathological sources because of its bizarre subject matter. The plays of August Strindberg written at the nadir of his mental illness, or such a retrospective description of a highly disturbed childhood as the one given by Rainer Maria Rilke in *The Notebooks of Malte Laurids Brigge*, are representative examples of productions of this kind. The reader's capacity to respond to such literature from an appropriate aesthetic distance depends on a large measure of tolerance for delusional views of the world.[8]

Perhaps the most explicit yet widely known psychotic literary effort is the *Memoir of My Nervous Illness*, published in 1909 by

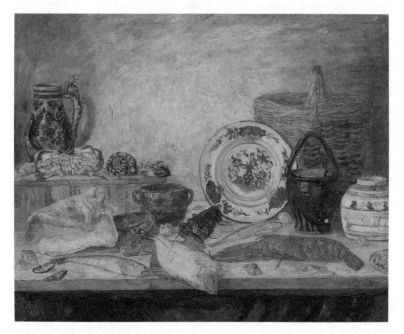

FIGURE 10.6. James Ensor, *Still Life with Fish and Shells*, 1898. Oil on canvas. *Art Institute of Chicago. Gift of Mary and Leigh Block, 1978.96.*

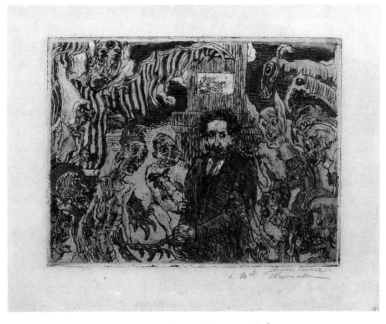

FIGURE 10.7. James Ensor, *Demons Teasing Me*, 1895. Etching.

the Saxon jurist Daniel Paul Schreber. Impressed by its revelatory quality, Carl Jung brought this book to the attention of Sigmund Freud, who then used it as a vehicle for articulating his views about psychosis. In his celebrated "case report" on Schreber, Freud interpreted the *Memoir* as a retrospective effort on the part of a victim of personal catastrophe to make some sense of the incomprehensible experience of a loss of personal integration. In this work Schreber transformed the banal consequences of his disordered mentation into events of portentous, even cosmic, significance. The *Memoir* is replete with the same kind of imagery expressing megalomania, delusions of persecution, and bizarre sexual or religious ideas that characterize the works of art in the Prinzhorn Collection. Through this lamentable panoply of unreason, however, a modicum of pseudorational sense is wrought out of the senseless experience produced by a psychotic breakdown.[9]

It is noteworthy that Schreber made this effort to understand his psychotic experiences after many years of hospitalization and at a juncture when he had recovered sufficiently to maintain an acceptable social facade, at least much of the time. During the initial phase of an acute psychosis, patients are in no condition to make art. Their panic often renders them incapable even of basic self-care. *Spontaneous* ini-

tiatives to make art (as opposed to the therapeutically motivated promotion of such activities by the hospital staff) only take place when the episode of disorganization has run its course and islands of integrated functioning have reemerged. In that context it is natural that patients should make great intellectual efforts to understand what has befallen them.[10]

In this connection, it is noteworthy that mental health professionals, to whom the idiosyncratic notions of the mentally ill about their being-in-the-world seem wearisomely repetitious, tend not to appreciate delusional recitals and/or imagery, even in instances where these might possess aesthetic merit. For the most part, those with wide exposure to psychosis are impressed with the relatively narrow range of such bizarre ideation—the stereotypy of paranoid, or messianic, or sadomasochistic sexual ideas. Of course, they are familiar with unselected samples of such material; once the shocking novelty of delusional views of the world has worn off, one tends to focus on the monotonous predictability of their content and style.

It takes talent of a very high order to transcend the constraints of such poverty of ideation in works of art, especially whenever they attempt to convey a narrative. It is precisely because Prinzhorn chose to present the production of the most talented artists represented in the Heidelberg archive that he succeeded in persuading a wide public that psychotic art is particularly meritorious. Subsequent exhibitions of selections from the Prinzhorn Collection have employed sampling biased in the same direction. Maria Cristina Melgar and Eugenio López de Gomara have made clear that the work of Luis selected for public exhibition also constitutes the best of his production, much of which is chaotic, disorganized, and (in their judgment) lacking in aesthetic merit.[11]

What is more, as a result of the popular success of "fantastic art," Dada, and Surrealism, the Western public for high art has become accustomed to subject matter that subverts the actualities of everyday reality. In this sense, the art of psychotics, even at its most bizarre, is now smoothly accepted as if it were but a curious variant of works depicting the world of dreams. Indeed, how does a delusional production differ from a narrative such as Günter Grass's novel *The Tin Drum*, recounting the adventures of a boy who volitionally stops growing at the age of three and has the magical power to carve glass with his voice? In terms of the manifest content of the plot, the difference is probably undetectable; it is only in terms of the overall impact of the novel that we are enabled to discern Grass's intention to create an allegory.[12]

The imagery of private fantasy was first employed in high art at the end of the eighteenth century in the work of Francisco Goya and Henry Fuseli. However, these pioneers used the most refined of formal devices to convey this unusual subject matter; it was Ensor and his twentieth-century successors who, for the first time, combined fantastic subject matter with a deliberately primitivized style. The post–World War II work of Dubuffet—contemporaneous with *The Tin Drum*—marks the full acceptance by a sophisticated public of what he called raw art—*l'art brut*. Hence, in our generation, the art of psychotic masters tends to be received without prior prejudice.

Because of the increasing success of the work of psychotics and of those antitraditionalists who borrowed style and/or subject matter from the mentally ill, a tendency has arisen within the art world to idealize the creativity of psychotics. This preference is in part the result of the widespread commitment at this time, in the visual arts in particular, to anticlassical aesthetics—attitudes derived from the Dada movement, which started out as a serious assault on the artistic institutions of the bourgeoisie. Second, those who have revived Cesare Lombroso's scientifically discredited theory that creative genius is closely correlated to psychosis are impressed by the undoubted *productivity* of individuals who are motivated to make art by a personal need to heal themselves[13]. Psychotic artists are often obsessively preoccupied by the ideas they try to express in their work, and this tends to lend their devotion to this task the quality of a monomania—an impression often underscored by a similarly obsessional technique. Finally, the idealization finds some justification in the high valuation, throughout the twentieth century, of *originality* as such. Precisely because they are unconcerned about commonly accepted norms, psychotics initially give an appearance of originality—from a different point of view, of course, their eccentricities and idiosyncrasies merely constitute crippling handicaps.

However one might feel about the aesthetic value of psychotic art, from the viewpoint of studying creativity it is important to keep in mind that artistic production occurs only in the process of recovery from the acute phase of the illness. In this regard, it is worth recalling the testimony of Joanne Greenberg, who went through a lengthy psychotic illness before she wrote her highly praised book, *I Never Promised You a Rosegarden*. Greenberg insists that mental illness makes creativity impossible: she was able to write only during periods of recovery. When she was in crisis, she was altogether unable to put her experience into words.[14]

It probably is true that image making is sometimes possible when the capacity to verbalize psychotic experience is unavailable or is so impaired as to render the would-be writer's productions unintelligible. Certainly, in childhood development the acquisition of syntax is normally a later and more complex achievement than that of summoning up visual imagery, as in dreaming. This developmental consideration probably led Prinzhorn to conclude that the creativity of psychotics tilts in the direction of the visual arts.

In any case, I believe that Greenberg's claim that being entrapped in psychosis prevented her from being creative is also valid for nonverbal productions. She reported that in her psychotic state she was immeasurably more frightened than on any occasion when she was faced with realistic dangers. This testimony suggests that when a psychotic makes art, that effort is part of the attempt to recover from the illness, using whatever capacities have been spared by the pathological process. And the very success of art making as an activity tends to accelerate the amelioration of behavioral integration.

Of course, it is also perfectly possible for a psychotic person to produce works entirely devoid of references to his illness—for example, to carry out a commission within precise parameters defined by the buyer. Thus, much of the production of Richard Dadd, after he resumed painting in the mental hospital, constituted an extension of his previous "normal" work. MacGregor, for one, considers these paintings, untouched by Dadd's schizophrenia, to be unexceptional—by implication, of no particular consequence. It is precisely the occasional works showing "schizophrenic characteristics" that MacGregor calls "the masterpieces of Dadd's *oeuvre* in terms of twentieth-century criticism."[15]

In other words, for practical purposes, the modern art establishment values only that portion of "the art of the insane" that deals with the emotionally powerful subject matter of the psychotic experience itself. This preference is clearly justified because, for the psychotic artist, these private productions are not vehicles for achieving vocational success but attempted solutions for problems of vital significance. Such an art of internal necessity often manifests a degree of urgency about making its point that is seldom attained in the creative activities of mere professionals.

Why is the art world so interested in subject matter that is seldom acceptable when communicated in words? The explanation of this seeming paradox may have to do with the fact that it is precisely the mastery of consensual language that puts an end to the acceptability of irrational messages. Most of us find it intolerable to hear

repeated assertions that $2 + 2 = 5$. (It is even worse to be told that the correct sum is 3.9!) In the phase of our life that precedes the primacy of verbal communication (albeit not necessarily the acquisition of some degree of linguistic competence), we are still free of the constraints of rationality. In other words, as long as a message is primarily encoded in images, as are dreams, we remain reasonably comfortable with unreason: it is only possible to be rational by manipulating *abstract* symbols. Some of us enjoy the opportunity to regress to the realm that antedates reason by viewing imagery that encodes the irrational in a concrete manner.

The romanticization of psychosis—insistence that it not so much a horrible illness but an understandable rejection of a dung heap world—is based on a confusion of the mental states of the insane with those of young children. The mad scene from *Lucia de Lammermoor* does not possess clinical verisimilitude, alas! The most powerful artistic portrayal of psychotic experience with which I am familiar is contained in Alain Resnais's film *Last Year in Marienbad*, which conveys (by means of Alain Robbe-Grillet's narrative) the frightful confusion the illness induces in the victim. At the same time, by means of the formal devices of its cinematography, the film simulates the unbearable perceptual distortions of true psychosis. The pleasing aesthetic qualities of the art of "the insane" depict only the narrative content of their delusional ideation—but through formal means that are not in themselves pathological, however "primitive" or "naive" they might be.

Finally, it is worth mentioning that, for the past generation, influential voices—especially those of the New Left formed in the 1960s—have tried to discredit the concept of psychotic illness altogether. This movement gained the support of a number of psychiatric mavericks who then became widely popular, and it was fueled by the speculative sociology of intellectual figures such as Michel Foucault. These controversialists put forward the claim that the so-called mentally ill were unjustly held in snake pit like prisons and that their "psychotic" behavior was an inevitable response to the conditions of their confinement. These fantastic contentions found enough public response to lead to a drastic decrease in the number of hospitalized mentally ill—and the corresponding growth in the problem of homelessness.

Perhaps this plague of irrationality has now run its course—the current psychiatric fashion is to attribute psychoses to constitutional factors exclusively, so that the mentally ill can now be seen as victims, and happily not the victims of a wicked psychiatric estab-

lishment. This change in the climate among advocacy groups for the mentally ill has not as yet permeated our culture as a whole, so that psychosis continues to retain some of the aura of spiritual glamour it was given when it was classified as a civil rights issue. Remember the appealing schizophrenic hero (and pathetic psychiatrist) of Peter Schaffer's hit play, *Equus*? That whole era will be recalled as one in which the fate of millions was decided by science fiction criteria, appealing to governments because they happened to be very easy on taxpayers. A shameful business. At any rate, mental health professionals continue to be suspicious of anything that smacks of minimizing the gravity of the psychoses.

•

When the Wind Is Southerly

However fascinating the "psychotic art" produced in the course of recovery from a mental breakdown may be, from the vantage point of creativity studies this relatively narrow domain is probably less significant than are the major creative achievements of individuals who through much of their life wear certain stigmata of psychosis but produce works of merit that are often free of overt traces of pathology. Because most of these cultural figures are widely admired, the general public (and sometimes even specialist scholars) may be very reluctant to acknowledge that a diagnosis of psychosis can be applied to persons who have accomplished so much.[1] Admittedly, the usage of the label *psychosis* is somewhat arbitrary, for psychoanalytic investigation of apparently well-adapted persons has revealed that, in special circumstances, a hidden core of madness may come to light in almost everyone.[2]

Thus it is entirely possible to be mad only "north-northwest," as Hamlet puts it about himself, and therefore to insulate the "southerly" domain of creative work from one's psychopathology. I have previously tried to demonstrate as much in the case of Caravaggio (Michelangelo Merisi), probably the greatest artist to have committed murder and arguably a person chronically at the edge of paranoia.[3] What is truly remarkable about his career is the progressive deterioration of his behavioral integration in the last

decade of his short life, while his art focused with ever increasing depth and passion on spirituality and religious fervor. Insofar as Caravaggio referred to his own existence in his works, he did so by portraying himself as a repentant sinner or a heedless pagan who brings on his own destruction—for example, by giving his own features to a decapitated head of Goliath. Meanwhile, in his personal life, he continued to erupt into homicidal rages; through his ceaseless quarreling, he managed to provoke the persecution (in large measure by agents of the law) that fueled his anxiety and murderous hostility.[4]

If Caravaggio's art and life appear to have been guided by contrasting mental dispositions, seemingly kept apart through a chronic split in the mind,[5] in other instances the separation between creative works and the psychotic process has to be effected through deliberate efforts. In chapter 12 I shall discuss such a planned change in the focus of his art in the case of Paul Cézanne. Here, I wish to stress that it is also quite possible for an established artist to experience a psychotic illness that may transform his professional activities into desperate attempts to cope with disintegration. One clear instance of this is that of the Belgian surrealist painter René Magritte, whose artistic responses to the threat of both depressive and manic episodes provide convincing illustrations of this point.[6] Magritte's mother committed suicide (probably as a result of untreated manic-depressive psychosis) when he was an adolescent. The future artist came close to an emotional breakdown in response to her death but managed gradually to recover and, after making a felicitous marriage at a relatively early age, he became a major contributor to the surrealist movement.

In 1940, after more than fifteen years of stability and creativity of a high order (see figure 11.1), a rift in the relationship to his wife caused Magritte to flee Belgium without her when the country was invaded by Nazi Germany. He was separated from his wife for several months; when conditions allowed Magritte to return to Brussels, they were reconciled, but thenceforth the artist was chronically depressed. He attempted to overcome this problem by adopting the sunny style of Impressionism, in an effort to depict determinedly cheerful subject matter. This volitional effort to cover over a mood disorder was, as one might predict, emotionally unsuccessful. Moreover, the works Magritte created in this uncharacteristic style have never been well received (figure 11.2).

In his vulnerable state, Magritte was thrown into disorganization by the challenge of his first exhibition in Paris. He responded with a

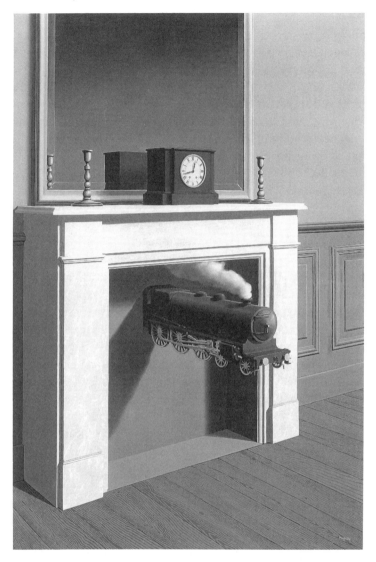

FIGURE 11.1. René Magritte, *Time Transfixed*, 1938. Oil on canvas. *Art Institute of Chicago, Joseph Winterbotham Collection, 1970.426.* © 1996, C. Herscovici, Brussels/ARS, New York.

brief episode of hypomanic excitement that he tried to control by means of feverish productivity. His working methods switched from his customary meticulousness to slapdash spontaneity, and he exercised no autocritical judgment about producing and planning to exhibit work that would obviously be unacceptable to the Parisian art world in both form and content (figure 11.3). Needless to say, in the mid-1940s the reception of this sample of "psychotic art" was

entirely unfavorable—a circumstance that led Magritte to lapse once more into chronic depression. Although the works of Magritte's hypomanic phase were initially rejected by the public, it is interesting to note that, with the ever-increasing acceptance of psychotic art, they have recently begun to find some critical favor.[7]

Sobered by the unhappy experience of his rejection in Paris, Magritte allowed his wife to persuade him to encode his work once again through formal devices that had brought him success in the past. Henceforth, his preoccupation with his psychological condition could only be discerned in some of the subject matter of his art, wherein it was ingeniously disguised. To cite only two examples: Mary Gedo interprets Magritte's numerous paintings depicting a world of petrified objects (figure 11.4) as references to his subjective state of deadened emotionality (a common manifestation of chronic depression); she reads the canvases in which a townscape is shown simultaneously in daylight and in darkness (figure 11.5) as metaphors of his alternating elation and melancholy.[8]

Looking back on his production of inappropriate work for the Paris exhibition, Magritte himself interpreted his persistence in that course of action as one manifestation of his self-destructive tendency. In my opinion, the artist's retrospective judgment was almost

FIGURE 11.2. René Magritte, *Oceanus*, 1943. Oil on canvas. *Private collection.* © *1996, C. Herscovici, Brussels/ARS, New York.*

FIGURE 11.3. René Magritte, *Titania,* 1948. Gouache and pencil on paper. *Private collection. © 1996, C. Herscovici, Brussels/ARS, New York.*

certainly wide of the mark, because it attributed damaging inten-tionality to a course of action that was motivated by considerations entirely distinct from its unfortunate outcome. From the viewpoint of the self-healing functions of artistic activity when a person is on the edge of psychosis, Magritte's creativity may have been effective in fending off a full-blown manic episode.

Brittle personalities like Caravaggio, Cézanne, or Magritte may slip into or out of overtly psychotic behavior with relatively minor consequences for their creativity; in parallel with the case of Ensor, organizing their lives around their artistic vocation probably helped these vulnerable individuals to avoid more severe impairment as a result of their pathological potentialities. Unlike Ensor, none of the other painters adopted a primitivized style to depict subject matter

associated with his psychic disturbance; with the exception of a limited segment of Cézanne's early work and those produced during Magritte's brief hypomanic episode, all three artists habitually veiled the psychological distress implicit in their themes by means of aesthetically pleasing formal devices. Magritte's brilliant facture, in a work such as *On the Threshold of Liberty* (figure 11.6) makes it very difficult to focus on the fact that the image represents a desperate need to blast one's way out of a closed space. The cannon, which (in a letter) the artist explicitly equated with his phallus, is pointed at the painted torso of an enormous woman; we are given the subliminal message that Magritte fears entrapment by a seductive female. Shorn of poetic allusion, the title of this work could be "Claustrophobia."[9]

Clearly, it is easier to disguise the pathological content of visual images than that of verbally encoded information; by the same token, similar information transmitted through music is almost impossible to decode unless the composer chooses to incorporate a

FIGURE 11.4. René Magritte, *Memory of a Journey*, 1955. Oil on canvas. *Museum of Modern Art, New York. Gift of D. and J. de Menil, 1959. © 1996, C. Herscovici, Brussels/ARS, New York.*

FIGURE 11.5. René Magritte, *The Empire of Light, II*, 1950. Oil on canvas. *Museum of Modern Art, New York. Gift of D. and J. de Menil.* © 1996, C. *Herscovici, Brussels/ARS, New York.*

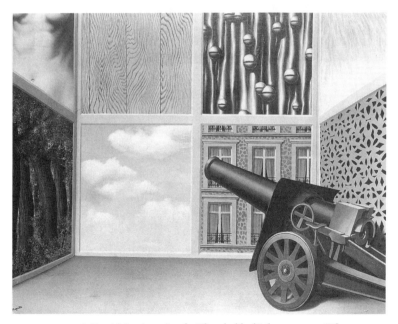

FIGURE 11.6. René Magritte, *On the Threshold of Liberty*, 1930. Oil on canvas. *Museum Boymans-van Beuningen, Rotterdam.* © 1996, C. *Herscovici, Brussels/ARS, New York.*

verbal message within the score. Thus in music psychosis can only be depicted through the verbal content of vocalization, as in the delusional declamations of the protagonist of Alban Berg's opera *Wozzek* or the mad scene in Verdi's *Macbeth*. A composer's own psychotic ideation may barely betray itself through some consistent pattern in her choice of narratives for musical treatment. For instance, without supplementary biographical information, drawn from extramusical sources, it would not be legitimate to reach any particular conclusion from the fact that nine of Richard Wagner's mature operas (from *The Flying Dutchman* through *Parsifal*) deal with the supernatural— more particularly, with magical events lacking even a religious rationale. The sole exception to this preoccupation with personal omnipotence is the libretto of *Die Meistersinger*.[10] Wagner was well aware that he was engaging in mythopoesis, a choice that made it unnecessary to justify this preoccupation with transcending the laws of nature.[11]

In contrast, the intellectual historian Bryan Magee does not hesitate to label Wagner a megalomaniac, with "a sense of persecution that bordered on paranoia"—a judgment based on Wagner's life, not on his work.[12] Peter Gay puts the matter this way: "The Cause was divine, but Wagner himself . . . was only human. But only just: if some indiscreet worshipper blasphemously mistook the prophet for his God, he was forgiven."[13] Wagner's notorious anti-Semitism has often been cited as the core of his paranoid attitude, and it certainly possessed a delusional flavor. As Dieter Borchmeyer states, Wagner argued that "[b]eing racially different . . . the Jews had not been properly assimilated but had continued to exist as a self-contained group, seeking in that way to monopolize every aspect of culture, economics, and politics." Only two years before his death, Wagner wrote his patron, the King of Bavaria, that "the Jewish race [is] the born enemy of pure humanity and all that is noble in man. . . . We Germans especially will be destroyed by them."[14]

In my judgment, however, this anti-Semitic delusional system formed but a superficial part of Wagner's psychotic ideation: he was convinced Jews were persecuting him in revenge for his 1850 broadside decrying what he considered to be the baneful influence of Jews on music—an attack probably motivated by Wagner's envy of Meyerbeer, a German-Jewish composer who dominated the operatic scene in Paris. Rather, Wagner's psychotic core consisted in the megalomanic conviction that his artistic work would accomplish the world's salvation.[15] A left-wing revolutionary who participated in the Dresden insurrection of 1848–1849, an intimate of the anarchist

Mikhail Bakunin, Wagner was in deadly earnest in the conviction that his music dramas would create a social and political revolution. In this sense, the most revealing of Wagner's works may have been his youthful "grand tragic opera," *Rienzi*, which deals with the fate of a would-be tribune of the people. Ironically, when, in 1906, the seventeen-year-old Hitler attended a performance of *Rienzi*, he was inspired to emulate Cola di Rienzo (and Richard Wagner) in the grandiose quest to lead a revolution. But, unlike Wagner, Hitler knew the difference between the power of art and the art of power.[16]

At any rate, if Wagner's megalomania affected his creative output at all, it was in the realm of his work as a dramatist, not as a composer. In this connection, it should be noted that, alone among major operatic composers, Wagner always wrote his own libretti. As Dieter Borchmeyer has pointed out, Wagner's music drama employs its mythopoetic framework in a utopian and mystical manner—among other things, one of its aims was to solve "the Jewish problem" by redeeming the Jews! In this regard, we must recall that the figure of the Flying Dutchman is based on that of the Wandering Jew, and that of Kundry (in *Parsifal*) is derived from the latter's female counterpart. In other words, the redemption of these characters in the first and last of Wagner's mature operas constitutes the mise-en-scène of a megalomanic idea.[17]

In his theoretical writings, in greater or lesser conformity with the idealist philosophers who dominated German intellectual life through much of the nineteenth century, Wagner was explicit about his utopian hopes for the redemption of humankind through art, particularly by means of the new sacred music he believed he was creating. Although such mystical beliefs were clearly socially sanctioned at the time, from a diagnostic viewpoint they constitute the expression of fantasies of omnipotence unchecked by rational considerations—in psychoanalytic terms, a "psychotic core." More often than not, if an author wants public acceptance for irrational ideas of this sort, the most acceptable avenue to follow is to present them in religious terms: in Wagner's lifetime, Mormonism, Christian Science, and theosophy were but some of the creeds initiated in this manner.

Perhaps the clearest illustration of the success of a writer with similar mental dispositions is the career of C. G. Jung, the Swiss psychiatrist who broke away from psychoanalysis to form a school of healing based on principles he ultimately defined in his autobiography as religious.[18] Jung was admirably candid in describing the severe psychological disturbance he suffered as a child (experts on

childhood disorders have not hesitated to diagnose this condition as a psychosis) as well as the drastic disorganization he went through as a consequence of his rupture with Freud.[19] He went on to relate his mastery of this crisis through his conviction that his private fantasies and visions had accurately predicted the horrors of World War I—that is, that he possessed prophetic illumination. Jung's current followers are right to point out that his basic difference with Freud (and psychoanalysis) lay in his inability to accept the latter's strict rationalism, which (as we shall see) he regarded as "shallow."[20]

This is not the place to spell out the nonscientific features of Jung's psychological system; suffice it to say that his status as a creative intellectual and a major voice in the humanities is not in dispute. What I wish to highlight here is the continuing influence of Jung's "healed over" psychotic episodes on his productions, until the end of his long life. This influence is evident in a number of ways in *Memories, Dreams, Reflections*, the beautiful personal memoir he produced as he entered his ninth decade. For instance, in his account of the rupture with Freud and its origins, Jung related that he performed a successful experiment demonstrating his capacity for "precognition" to his older colleague, whose skepticism he attributed to shallow positivism.[21]

Elsewhere, I have given a detailed account of the irrational beliefs Jung communicated to Freud in their correspondence, particularly in 1910 and 1911—his conviction about possessing the highest esoteric wisdom, his endorsement of occultism and astrology, and his equation of psychoanalysis with the Godhead.[22] When the break with Freud deprived him of this faith, Jung felt disoriented; as an octogenarian, he reported that he had been afraid that he was undergoing a "psychic disturbance." By the fall of 1913, he felt that his reaction was a response to some "concrete reality," and he had "an overpowering vision" of a catastrophe drowning Europe in a sea of blood. In June 1914 Jung dreamt that he could heal the survivors of a Europewide disaster by giving them the juices of grapes from his "tree of life." The outbreak of war in August convinced Jung that his personal psychic experiences coincided with the general fate of humanity. He felt possessed of demonic strength and the "unswerving conviction [of] obeying a higher will." A half century later, Jung was still certain that his life consisted of a series of irruptions of the "imperishable world" into this "transitory one."[23] No wonder Henri Ellenberger decided that Jung's crisis after the rupture with Freud should be called a "creative illness."[24]

Jung was keenly aware of the messianic appeal of the modern

mystery cult he was trying to establish. At the climax of his dialogue with Freud about the appropriate qualities a therapeutic movement must possess in order to gain public favor, he wrote the latter, "Religion can be replaced only by religion. . . . Two thousand years of Christianity can only be replaced by something equivalent. An ethical fraternity, with it mythical Nothing, not infused by any archaic-infantile driving force, is a pure vacuum and can never invoke in man the slightest trace of that age-old animal power . . . without which no irresistible mass movement can come into being." Jung wanted psychoanalysis to effect a revolution as radical as the one Wagner thought he could create through music.[25]

Essentially analogous efforts to replace Christianity by means of art have also manifested themselves within the domain of literature. One of the most notable oeuvres of this kind, that of the Prussian writer Heinrich von Kleist, also seems to have been the by-product of an imperfectly compensated psychotic illness. Kleist suffered a major breakdown of this kind at the age of twenty-six; in this crisis of despair he destroyed the manuscript of his most ambitious work, the verse drama *Robert Guiscard*. Kleist had managed to hold off suicidal depression for some years by clinging to the optimistic assumptions of the Enlightenment. When he was twenty-two, he resigned his army commission to study philosophy, mathematics, and physics; he then became an enthusiastic follower of Immanuel Kant. Unfortunately, the latter's skepticism shattered Kleist's defensive optimism and certitude; he wrote his fiancée that "unspeakable emptiness filled [his] innermost being," and to his sister he confessed, "The very pillar totters that I have clung to in this whirling tide of life." Thus for about a decade before his suicide, at age thirty-four, Kleist barely kept himself alive, attempting to master his despair by illuminating through his art a human being's relation to God.[26]

To be more precise, Kleist seems to have reorganized himself around the delusion that he was being persecuted by a malignant deity with whom he thenceforth engaged in single combat. At the same time, he understood the absurdity of such a view and did his best to disavow it: "It cannot be an evil spirit that stands at the world's helm, but merely an uncomprehended one," he wrote a friend. Yet in Kleist's terrifying stories, the arbitrary power of this incomprehensible deity tosses the protagonists about like helpless puppets. Some of his heroes, such as Michael Kohlhaas (in the novella named after him), rebel against their unjust fate—only to be crushed all the more cruelly. The psychological position is stated

most clearly in Kleist's Socratic dialogue, "On the Puppet theater," where the protagonist is continually defeated in a fencing match by a supernatural beast.[27]

Throughout his dramatic oeuvre, Kleist deals with our helplessness against Fate. In his earliest play, *The Schroffenstein Family*, he wrote, "God puzzles me. . . . His very thought hatches disaster." (This from a man of twenty-four!) The next work he completed, *The Broken Jug*, ostensibly a pastoral comedy, deals with the investigation of a sexual crime committed by a man named Adam; despite his clever dodging, the representatives of higher authority prove his guilt. In addition to echoing Genesis, this is a burlesque variant of *Oedipus Rex*, the tragedy of a person unjustly persecuted by the god Apollo. In his neoclassical *Penthesilea*—an astonishing return to the art of Euripides—Kleist portrays the disintegration of the heroine's control over her behavior as a consequence of attempting to adopt the religion of the man she is destined to love, Achilles. The capstone of Kleist's work as a dramatist, *The Prince of Homburg*, again traces the hopelessness of man's wish to revolt against whatever destiny God assigns him.[28] The author's personal tragedy was compounded by his inability to accept the role of God's marionette; his ultimate effort to escape the fate of submitting to divine authority took the form of a defiant and ecstatic suicide.

Before going on to draw conclusions about the vicissitudes of creativity in persons with a psychotic core, I wish to offer an additional example relevant for the visual arts, that of Michelangelo Buonarroti, sculptor, architect, painter, and poet of genius. The artist lived for almost ninety years (1475–1564); we know about four episodes during this long career that can most plausibly be understood as psychotic.[29] The first of these occurred in 1494, shortly before his original patrons, the Medici, were overthrown as rulers of Florence as a result of their disastrous policies in face of a French invasion. Michelangelo unaccountably fled to Venice in a panic; he tried to explain this flight by claiming that someone shared with him a prophetic dream foretelling the doom of the Medici. This sounds like a thin rationalization for a delusional experience, particularly in view of the nature of the artist's subsequent psychotic attacks.

About a year later, Michelangelo suffered a second episode of panic; he fled from Bologna to Florence. On this occasion, his explanation was more openly paranoid: he said he was afraid of bodily harm at the hands of certain artistic rivals. The third episode occurred in 1506, on the eve of ceremonies for laying the new cor-

nerstone of St. Peter's Basilica, as designed by Bramante, a rival Michelangelo appears to have hated. Once again, the artist gave a paranoid rationale for his flight—in all probability, the harm he dreaded involved his own hostility toward his rival and Julius II, the patron who had favored Bramante. The last in this series of events took place during the Spanish siege of Florence, in 1529, when Michelangelo was serving the city's republican regime as a military engineer. On that occasion, Michelangelo did not bother to justify his flight; he simply stated that a stranger "arranged" his clandestine departure so that he could avoid danger. He said this helper was either God or the devil, thereby indicating his implicit recognition that the assistance did not come from a merely human agent.

The four incidents are essentially similar: under various kinds of severe stress, Michelangelo's integration threatened to collapse. It was this internal catastrophe he concretized and projected onto external events to form persecutory delusions. Very probably, these temporary lapses into paranoia constituted repetition of infantile states of disorganization and their eventual resolution. Robert Liebert has suggested that Michelangelo's artistic preoccupation with the idealized male nude was an effort to counter a subjective dread concerning his bodily integrity.[30] I see this anxiety as a chronic and manageable form of the ideas explicit in his delusional states. In his late poetry, Michelangelo showed real insight into these matters. In "Madrigal" (1544), he says,

> As in hard stone, a man at times will make
> Everyone else's image his own likeness, I make it pale with weakness
> Frequently, just as I am made by her [stone, *pietra*, is feminine] . . .
> Destroyed and mocked by her,
> I'd know
> Nothing but my own burdened limbs to sculpt.[31]

On the basis of this and similar evidence, Richard and Edita Sterba proposed that Michelangelo restituted himself when sculpting in marble or quarrying by venting his rage on the stone.[32] This insight implies that the very choice of medium may be governed by a need to deal with the threat of psychotic disintegration. A Michelangelo sonnet echoes the Sterbas' contention:

> Whenever a master keeps a slave in prison . . .
> He grows so much accustomed to his anguish

That he would hardly ask again for freedom . . .
And, toiling at his works, the raw artist
By custom and sweat doubles exertion.[33]

An art of internal necessity, indeed! It should be recalled in this connection that, after the death of his greatest patron, Julius II, Michelangelo spent around three years in the mountains quarrying marble, ostensibly for the late pope's tomb. Needless to say, he never used most of the stone he had labored to excavate. This activity has often puzzled historians because of its seeming irrationality; however, it makes very good sense if understood as an adaptation to an emergency, in response to the devastating loss of Julius, Michelangelo's secret sharer in the creation of the Sistine ceiling.

Perhaps a sufficient number of artists with a psychotic core has now been presented to make it possible to arrive at some generalizations. The example of Kleist demonstrates that creative work is possible only as long as the psychopathology is contained in a sector of the personality that does not gain control over behavior as a whole—during his mental collapse, Kleist was unable to continue work and, in his frustration, destroyed the manuscript of his magnum opus. Much the same might be said about Jung's psychological crisis after the rupture with Freud. Wagner never came close to a psychological collapse, and his creativity was never interrupted, although at times he produced only drama or theory and did not compose music. Michelangelo used a variety of emergency behaviors in situations that threatened his psychological integration; some of these defensive operations interfered with his creative activities, once for several years.

Both Wagner and Kleist tended to enact their idiosyncrasies by enmeshing their associates in transactions in the long run unacceptable to the latter (thus the composer once had to leave Bavaria because he tried to give inappropriate political advice to the king, and Kleist was in disgrace at the Prussian court because of his attacks on government policy in the national emergency of defeat at the hands of Napoleon); Jung, by contrast, managed to suffer the slings and arrows of his fortune in the mind alone, so that his career, following his declaration of independence, was without troublesome external vicissitudes. Michelangelo's prestige was so great that, for the last thirty years of his life, all his eccentricities were overlooked by a worshipful public and patrons grateful for his willingness to accommodate them. In other words, there does not seem to be any direct correlation between creativity and the effects of psychopathology on

those aspects of life that are unrelated to work. Thus the crucial factor accounting for the effect of a psychotic core on the performance of creative activities is whether or not this pathological aspect of mentation remains truly split off from the dominant organization of personality.[34]

PART FOUR

•

The Fit Between Talent and Opportunity

•

The Psychology of Performance

Any attempt to differentiate the psychological dispositions of performing artists from those of creative persons who do their work in "blessed solitude," as those devoted to the contemplative life call the absence of intruding witnesses, must start with the admission that relatively few individuals confine their artistic activities exclusively to one of these realms. The solitary poet may emerge from her cocoon to stage charismatic public readings of her work; musical performers may withdraw into isolation to engage in composition; visual artists have to oscillate between the deserted studio and the (please, God!) crowded reception marking that their very life's blood has been put on exhibition. The psychoanalyst is subject to many of the same swings of the pendulum; his clinical work is ever under the scrutiny of those harsh critics, his patients; in his scientific guise, he must work in isolation, but in order to present his concepts to a live audience, he has to acquire all the skills of the preacher and the mountebank.

Not to belabor the point, let us agree that many creative careers fluctuate between public performance and solitary work and many demanding endeavors actually require some measure of both. If the two types of activity call upon differing psychological skills and present the would-be creator with varying pitfalls, it is not surprising that, the question of raw talent aside, at particular points along their

life course individuals may experience greater difficulties in pursuing one of these creative avenues than the other. Clearly, therefore, what one concludes about these psychological differences is not to be understood as characterizations applicable in perpetuity to specific persons but only as generalizations about the immediate, ad hoc adaptations required of anyone who would engage in creative endeavors of particular kinds.

I am sure that a readership familiar with performers need not be reminded that the greatest difference between performance art and other creative endeavors consists in the finality of the performer's deeds. However well rehearsed the performance, however well planned in its minutest aspects, it is at all times a matter of "Now or never, do or die." This is a requirement that puts indecisive, obsessional characters under excessive duress—they are doubtless better suited to creative activities that permit revising, editing, and the consideration of numerous alternatives. As the humorist S. J. Perelman somewhere put it, his best results were obtained when he did thirty-two revisions; he once attempted thirty-seven, but the outcome apparently got a bit lapidary.

The other side of the same coin is that certain character types experience excessive "performance anxiety," even though they have ample opportunity to refine their work without the risk of any public humiliation. For example, a distinguished painter of my acquaintance once told me that when he stood in front of his easel, paintbrush in hand, he felt like a duelist fencing with foils: "One false move, and you are dead!" he explained morosely. It would seem that he always carried an internal critic around with him, one much more severe than the actual reviewers, dealers, and collectors, who prized his work. It is not surprising that, despite a fair measure of public recognition, he was dissatisfied with his progress and increasingly tended to fall into depressive moods.

When the house lights dim, the performance artist is truly under the gun. Perhaps it is an exaggeration to say that one faux pas will kill him, as my painter friend claimed—although dancers, athletes, and other performers who use their bodies for expressive purposes may certainly sustain serious injuries by making false moves. Audiences tend to be both naive and forgiving; they generally identify with the performer who commits a mistake, provided the latter continues without sulking. But, of course, there precisely is the rub; how could a person who is of necessity dedicated to the pursuit of perfection easily tolerate the imperfections of her work, witnessed by multitudes entitled to turn their thumbs down, hiss, and throw

metaphorical rotten eggs? It is only managed with great difficulty, of course. . . . If the artist's self-esteem depends on performing flawlessly, her temperament is better suited to pursuits that allow for thirty-two revisions rather than thirty-two fouettés. Hence certain actors who do excellent work on film are unable to tolerate the potential humiliations of appearing in live theater; musicians may decide to restrict their public performances to the recording studio, etc.

Not that creative persons who do their work in solitude can escape the ravages of *their* untamed narcissism. Flaubert may have been justified by the results in spending some seven years in writing and rewriting *Madame Bovary*,[1] but the ambition to create the perfect masterpiece generally ends in failure and dire psychological consequences. A generation before Flaubert, Balzac—a writer of prodigious fecundity who cared nothing about trivial flaws—invented the mad artist Frenhofer who worked on one canvas for more than seventeen years, only to produce an inchoate mishmash, *The Unknown Masterpiece*.[2] Did Leonardo da Vinci really require twenty-six years to create the *Mona Lisa*? Or, better put, was the picture he left unfinished at his death the very best of his conceptions of the work? Unanswerable questions—but for every Leonardo whose painstaking methods seemingly produce art of supreme merit, there are legions of perfectionists who only defeat themselves by seeking the unattainable. Nonetheless, excessive ambitions may be pursued in private for long periods of time without arriving at the "moment of truth," as the Spaniards call the climax of the bullfight, whereas every performance artist faces the brave bulls with each appearance.

For reasons that go beyond the finality of each performance, the performing arts actually challenge the artist's equilibrium with regard to self-esteem more severely than do other creative activities. In my judgment, the most important of these is the fact that all performers have to display their actual person in doing their stuff. "How can we know the dancer from the dance?" wrote W. B. Yeats, and his great line has rightly been applied to all artists.[3] But we may momentarily forget Yeats as a person while reading his poems, and the poet may not have been attending to his future readers in composing them. By contrast, the dance and dancer are truly indissoluble, for the spectator as well as the performer. At the Calgary Winter Olympics, before the figure skating finals, the favorite, Katherina Witt, was asked whether the judges were biased in her favor because of her physical attractiveness. With admirable aplomb—and emo-

tional self-control—Witt replied that figure skating *is* the expression of feminine grace.

If it is true that performing artists cannot possibly differentiate themselves from their performance, it would follow that audience response has the power to penetrate to the most fundamental determinants of their self-esteem, those formed earliest in life and therefore endowed with the highest valence—issues revolving around the body and its basic functions. The effort to master past deficiencies in that regard has been understood as one of the most powerful motivating forces for a career as a performer; perhaps the earliest recorded instance of this pattern is the case of the Athenian statesman, Demosthenes, whose oratorical skill (as I have already mentioned) represented a hard-won struggle with his childhood stuttering.[4] I do not mean to imply that the desire to perform is always fueled by the need to overcome *defects* in self-esteem; on the contrary, it is much more likely to exploit the ease of reproducing early experiences that affirm the child's positive attributes at the level of physical performance.

[What deserves emphasis is simply that the performing artist, by virtue of invariably having to display physical skills, is likely to be more profoundly affected by his reception than a creator who has fashioned a thing or a concept separate from the physical self.] Needless to say, critical responses to the work of nonperforming artists (as well as scholars and scientists) are also less likely to be living transactions of the kind intended to indicate approval or the lack of it in the concert hall or the theater. It has long been recognized that the performer must be a person of courage; two thousand years ago the Roman poet Horace, in a didactic work addressed to other artists, noted that it is both essential and supremely difficult to maintain one's own standards in the face of popular disaffection. He added an admirable example of artistic independence: "As the actress, the valiant Arbuscula, said, when the rest of the audience started hissing, 'It is enough for me if the orchestra seats applaud.' " Indeed, it does take valor to be a performing artist.[5]

At the same time, because training for a performing career involves a stream of almost continuous critical feedback from expert professionals, the performer's exposure to the risk of narcissistic injury (and, on the other side, to that of intoxication by the heady brew of acclaim) may be outweighed by the lower likelihood of having to suffer the consequences of artistic isolation. By contrast, scholarship, literature, the plastic arts, and musical composition require extraordinary capacities for bearing loneliness, particularly on the

part of innovators. The widespread contemporary phenomenon of literary workshops and artists' collaboratives attests to the hardships of solitude, seldom regarded as "blessed" in nonmonastic circles. Whatever the therapeutic benefits of these efforts at mutual aid may be, the fact remains that they have largely failed to yield noticeable artistic results: from a poet's perspective, there can be no argument with Wordsworth's complaint that "the world is too much with us."[6]

Psychological studies of the creative artist have tended to assume, without much evidence, that while doing her work even the solitary creator has a potential spectator, audience, or reader in mind. In one sense, of course, this statement is merely a truism: the artistic product must be encoded within some symbolic system or tradition that is shared by a community, however small or recherché it may be; the artist can therefore never overlook the requirements of communicability without lapsing into a solipsism that will be unacceptable to any potential public. But statements in the psychological literature about the artist's dialogue with a figure of fantasy, the Other, usually do not refer to these self-evident propositions; more often, these assertions allude not to the requirements of a craft tradition but to the suspicion that in her inner world the artist is never alone—that the people who matter to one are forever present in one's imagination. To put it differently, in this view the muses are merely disguised representations of the original parental authorities who originally gave the child encouragement and approval.[7]

Neither my clinical experience nor my study of the lives of numerous artists supports this widespread psychoanalytic viewpoint. On the contrary, like artists' cooperatives, the muses may be invoked to mitigate the isolation of creative work precisely because such solitary activity cuts the creator off from all human ties. To buttress my point, let me cite the remarkable case of Giuseppe di Lampedusa, author of the great novel of my youth, *The Leopard*. Lampedusa was a Sicilian prince who did not begin to write until his ancestral home in Palermo was largely destroyed by the bombardments of 1943. To be more exact, this middle-aged aristocrat was devastated by the loss of his material ties to the past; his reaction was so severe that his wife (who was one of the pioneers of psychoanalysis in Italy) suggested that he attempt to master it by recapturing his family lore in the form of a written memoir. In other words, the germ of this wonderful recreation of the world of Lampedusa's grandfather began to sprout when the author was given encouragement to turn away from the persons available in the present to engage in a solitary work of mourning.[8]

The genesis of artistic activities in early childhood is often the result of turning away from the sphere of human relationships in an analogous manner. For example, the future architect and painter I have referred to more than once preferred to withdraw to the attic of his family home where, undisturbed by the activities of others, he could endlessly engage in various games involving the solution of spatial problems. Thus the Muse of Architecture was not a substitute for his mother but a symbol of his preference for exercising his intellect in a very specific but deserted arena. A child of comparable talent who finds his métier in the context of childhood activities that do involve another person may always have to depend on the collaboration of a secret sharer, as I have discussed in chapter 2. Incidentally, Joseph Conrad expressed such a need in these terms very much on the basis of his own childhood experience of quasi symbiosis with his father.[9] When exposed to real solitude, people who need such a companion may become paralyzed in their creative endeavors. I have little doubt that personalities who cannot stand solitude would adapt better as performing artists were such a path open to them.

I can offer another example supporting this argument on the basis of my analytic experience: the most talented musician I have worked with had a history similar to that of my architect patient; he, too, played early childhood games, in this instance involving the production of various musical tones, which he found to be extremely comforting. In this case, difficult family circumstances rendered the child too vulnerable to make it possible for him to tolerate even the degree of solitude regularly required to practice his instrument, and, instead of persisting in his ambition to become a pianist, he eventually chose a profession that offered him practically uninterrupted human contact. In the course of his work with me, this man resumed his musical activities and achieved some success on a semiprofessional basis. He turned out to be particularly adept as an accompanist because of his ability to empathize with the state of mind of the singer. In other words, the very qualities that may produce an insurmountable handicap in one context can, in different circumstances, turn out to be special assets.

An issue somewhat related to those of attachment and solitude is that of the creative person's complex relationship to his predecessors. In this regard, performing artists are under greater constraint than their nonperforming counterparts, for the requirements of performance necessarily include the re-creation of another artist's conception. Conductors and instrumentalists must come to terms with

the prior achievement of the composer, whatever their feelings may be about earlier practitioners of their own skills. The recognition of this constraint on performers involves no depreciation of the latter, for the capacity to reinterpret meaningfully the creation of another mind is precious and rare. Among other things, it requires mastery of the unavoidable discomfort of merging oneself into someone else's mental universe. In an unforgettable phrase, the literary critic Harold Bloom has named this problem "the anxiety of influence."[10]

Perhaps the activities that most easily betray the undesirable effects of the artist's unresolved conflicts in this regard are those in the borderland between performance and the other arts—the realms of the stage director in opera or drama. Under the guise of innovation and/or the transposition of the works of another era into versions more acceptable to a contemporary audience, directors may take liberties that no longer re-create the original works but attempt, instead, to patronize or popularize them, to transmute them through irony or the superimposition of ideas foreign to their creators. Of course, such mistranslations may simply reflect excessive competitiveness on the part of their perpetrators; I have the impression that such envious attitudes are also at work among those prejudiced historians and critics who delight in putting down their artistic betters or deny the possibility of greatness, calling it a romantic fallacy. Yet the problem transcends competitive issues, for it is truly a difficult feat to become a faithful mouthpiece for someone else—all the more difficult if the other possesses genius.

Many years ago, I learned about these psychological difficulties from one of my patients, who had been forced to abandon a promising career as an actress because of a psychiatric illness that necessitated hospitalization while she was in rehearsal for her first leading part in New York. This person consulted me a few years later; although she was troubled in many ways, she was by no means sufficiently disturbed to make comprehensible her suicide attempt on the threshold of a professional breakthrough. It took me some time to grasp that the principal dynamic behind the patient's collapse had been a loss of the boundary between her private self and that of the character she was attempting to portray on stage, Ibsen's psychotic heroine, Hedda Gabler. It was a matter of sheer blind luck that, unlike the hapless Hedda, my patient had not succeeded in killing herself.

Dramatic cases of this kind underscore the fact that people are quite right about having *some* fear of excessive influence from the outside. These extreme instances also demonstrate why performing

artists must have mastered any undue anxiety about the inevitable influence the great works they re-create will have upon them. At the same time, we cannot forget that similar conflicts may also interfere with the creativity of nonperforming artists; after all, this is the group to whom Bloom applied his diagnostic label about the "anxiety of influence." Perhaps the most successful creators have less discomfort about being swallowed up by great predecessors than do more ordinary artists; I suspect this is what T. S. Eliot may have had in mind when he reportedly quipped that good artists borrow while great ones steal!

Thus Stravinsky was able cheerfully to cannibalize Pergolesi, as Bach had appropriated material from Vivaldi.[11] We have no better evidence about an artist's attitude toward the great figures within his tradition than in the case of Pablo Picasso, whose dazzling originality in inventing Cubism, collage, assemblage, welded metal sculpture, and a host of other technical processes did not prevent him from mining the work of countless predecessors for more than seventy-five years. It is fascinating to note that Picasso was one of those artists, like Joseph Conrad, who achieved his greatest original works when he had a secret sharer—a living artistic peer who worked in parallel with him. Hence Picasso compared his collaboration with Georges Braque in developing Cubism to the contemporaneous feat of the Wright brothers in promoting aviation. When Braque was drafted into the French army in 1914, Picasso promptly turned for inspiration to one of the dead giants of the French tradition: he appropriated the style of J. D. Ingres for a series of drawings that became one of the summits of twentieth-century culture (figure 12.1). This ease in merging with the individuality of another without losing one's own is the polar opposite of the anxiety of influence; it is also the fundamental requirement that makes possible the re-creation that is the task of every performer.[12]

The psychological tasks I have just outlined are particularly stressful—and consequently easier to discern—whenever the person whose original work is being created anew is still living and therefore may either participate in the interpretive process or at the very least share his reactions to it with potential performers. The producers of *My Fair Lady* were certainly wise not to initiate their adaptation of *Pygmalion* until Bernard Shaw had died! And there cannot be too many composers as willing to bend to the wishes of conductors as was Anton Bruckner—obviously, the shoe is generally on the other foot. I shall never forget the dramatic moment when Elliott Carter stalked out of Orchestra Hall in Chicago, enraged by

FIGURE 12.1. Pablo Picasso, *Portrait of Leonide Massine*, 1919. Pencil on paper. *Art Institute of Chicago, Margaret Day Blake Fund, 1972.970.* © 1996, ARS, New York/SPADEM, Paris.

the flippant manner in which the conductor, Leonard Slatkin, addressed the audience in an effort to mollify us in advance of the premiere of one of Carter's austere and unfriendly pieces! A day of wrath, indeed.

I have had my own dies irae, an experience that persuaded me that I am grossly unsuited to the role of the performer. About twenty years ago, a distinguished senior colleague of Austrian origin was invited to deliver an important address in his native language. Moved by admiration and friendship, I offered to produce an English version of his text as a present for his sixtieth birthday, for he was a creative man whose time ought not to have been taken up

with translations. I enlisted the help of a native German to produce
a literal rendition into English and then proceeded to transform this
into a text worthy of the original and, as I saw it, representative of
the author's voice rather than my own. Needless to say, he was
highly displeased: my English version was probably as fluent as the
original had been in German, but the author did not write that way
in *English*, and he insisted on rewriting the translation in an ugly
Teutonic jargon. That, of course, is when *I* walked out, although I
was more quiet about it than Elliott Carter.

I have often asked myself in the interval what made it impossible
for my erstwhile friend to accept my translation—the accuracy of
which he did not dispute—and why I experienced his inability to let
my interpretation of his work stand as an actual betrayal. I assume
that the answers to these questions go to the heart of the psychol-
ogy of both originators and performers. If I may begin with my own
reaction, I believe my bitterness was caused by the author's failure
to acknowledge that, in the effort to become an interpreter of his
work, I had stretched beyond my customary reserve about allowing
others to become a part of me, or, if you will, to let the spirit of the
author infuse my own. It is the fact that I could not help looking
upon this self-restriction as a *sacrifice* that reconfirmed my unfit-
ness to be a performer.

From the author's perspective, of course, I had probably failed to
be sufficiently self-effacing; to put this into neutral terms, my
English was undoubtedly more latinate than anything a native
German would produce. Thus my translation, however *correct*, was
like a transcription of Baroque music for contemporary instru-
ments. To my ears, when *he* translated his elegant, old-fashioned
German into English, the result was analogous to the rendition of an
opera on a barrel organ. But it was *his* opera to transform as he
pleased, and he was probably justified in rejecting a stage director
who proposed to put it on in modern dress. Yet, of course, he could
have suppressed my version without telling me that it was unsatis-
factory. Why did this ceremoniously polite man find it necessary
openly to repudiate my interpretation?

In answer to such a question, one could simply say that he was
not like successful choreographers who alter their conception in
accord with the physical and artistic capabilities of the dancers who
collaborate on the very creation of a ballet, nor like Brahms, who was
able to accept the expert suggestions of his friend Joachim in revis-
ing his *Violin Concerto*. My colleague's attitude resembled that of
Richard Wagner, who desperately tried to prevent others from stag-

ing his mature works, after unhappy experiences with various pro-
ducers, especially at the Paris Opera. Wagner set up his own operatic
domain at Bayreuth in order to monopolize the presentation of *The
Ring of the Niebelungs* and *Parsifal* as well as to set canonical stan-
dards for productions of his earlier works.[13] My ungracious friend
seemed to suffer very intensely from the "anxiety of influence" pos-
tulated by Harold Bloom. I suspect that such mental dispositions are
more and more characteristic of the creators of original works as the
modern age increasingly encourages "the artist's journey into the
interior," as Erich Heller has put this.[14] In the course of that journey,
great artists may steal, if we can believe T. S. Eliot, but they are
reluctant to borrow too openly.

I have finally come full circle in my argument: while trying to
stake out the psychological boundary between artists who perform
and persons who create de novo, I have had to acknowledge that on
both sides of the fence there is heterogeneity in mental dispositions.
The medieval sculptor whose anonymous work was intended to
form but one small part of the harmonious whole that was to be a
House of God had to be a personality utterly different from his pre-
sent-day counterpart, most likely to be dedicated to the greater
glory of his own self. In other words, one of the principal distinctions
I have postulated between the two groups may well be a phenome-
non confined to our own era.

Not only does this distinction tend to apply to certain restricted
segments in the history of artistic endeavors, it also suffers as a
result of the propensity, quite prominent in the recent past, for var-
ious creative activities to spill over into contiguous fields. As an
example, let us take the emergence of so-called performance art, the
hybrid form that hovers between improvisational theater, ballet,
mime, and the visual arts. In an earlier age, such hybrid genres began
in the form of re-creating famous paintings by enacting them in
tableaux vivants. Nowadays, it is painters dissatisfied with the limi-
tations of artistic illusion on canvas and insistent on starring in their
own creations who tend to encroach on the preserves of drama.

Nonetheless, even these so-called performances may underscore
the fundamental isolation of the artist from the consumers of what-
ever he produces as an original creation. Some years ago, the
Museum of Contemporary Art in Chicago staged a performance by
Chris Burden that consisted of the artist lying down on the bare
floor. The spectators waited for some hours, but as time went on they
began to dribble away, until only museum officials were left on the
scene. The artist did not move throughout the night or the next day;

the newspapers began to take notice; finally, the organizers of the event became alarmed and forcibly removed the body. The artist then declared that his performance was over. He explained that he had succeeded in demonstrating the general public indifference to the welfare of our fellow human beings; he had been prepared to die of dehydration if nobody intervened in time. Indeed, museum officials had rescued him before it came to that—although not before he underwent distressing hunger and thirst—but not on the basis of having empathically grasped the artist's message. On the one hand, they merely suspected that he was crazy; on the other, they were warily afraid of legal complications. Obviously, such a scenario can produce this kind of total bewilderment only once; after its premiere, it enters our collective memory as a satisfying tour de force, at best causing wonderment about the mechanical arrangements for disposal of the performer's excreta.

The foregoing illustration suggests that the modern originator has resurrected the mythical role of the artist as protagonist and victim of a sacred ritual, analogous to the Dionysiac festivals of ancient Athens. It cannot be a coincidence that our greatest cultural heroes, like Vincent van Gogh, Alexander Solzhenitsyn, or Béla Bartók, led lives that suggest persecution by a malign fate. Even the titans of previous eras, such as Michelangelo or Beethoven, appear to us as prototypes of the *artiste maudit*, the artist accursed, prefigured by the musician/hero/martyr of Hellenic myth, Orpheus. In contrast, successful performers may have become the contemporary equivalents of the victors of the Olympiads of antiquity. I do not mean to imply that striving for Olympic laurels is psychologically easier than to accept the role of sacrificial lamb. I am only suggesting that these contrasting destinies are seldom likely to suit persons with the same emotional needs.

Yet there are exceptions. No artist has played the role of Orphic prophet with greater distinction than the Czech playwright Vacláv Havel, who was a prisoner of conscience for the better part of a decade. When the moment of truth arrived, Havel's performance played a vital part in the triumphant overthrow of the tyranny oppressing his community, and he now wears the laurels of president of the republic.

•

The Anticlassical Insurgency: A Personality Type Who Can Seize the Day

It is widely believed that the great style of Italian Renaissance painting that subsequently came to be called classical reached full maturity around the year 1500. This closure was reached in such works as Leonardo da Vinci's *Last Supper* in Milan, and his projected *Battle of Anghiari*, or Michelangelo's cartoon for a *Battle of Cascina*, both commissioned for the Palazzo Vecchio in Florence. The High Renaissance style became dominant in both Rome and Florence, triumphantly carried forward not only by the two great masters who initiated it but also by distinguished recruits such as Andrea del Sarto and Fra Bartolommeo in one city and Raphael and his workshop in the other. The early years of the sixteenth century, characterized by the artistic patronage of Julius II and Leo X, popes committed to the proclamation of the grandeur of their office and persons, saw the birth of such matchless projects in painting as Michelangelo's Sistine ceiling and Raphael's *Stanze* in the Vatican, not to speak of a host of other masterpieces.[1]

There also seems to be historical consensus about a gradual exhaustion of the High Renaissance style toward the end of the century's second decade. Some critics already detect departures from classical equipoise in certain peripheral figures of the Sistine ceiling; such experiments in stylistic freedom are widely attributed to Raphael in his late works, such as the *Transfiguration* now in the

Vatican Museum. Moreover, almost simultaneously, around the close of the reign of Leo X, all leading exponents of High Renaissance painting happened to abandon the field: in 1520, at the age of thirty-seven, Raphael suddenly died; Fra Bartolommeo was only slightly older at his death in 1517. Michelangelo was fully occupied with architectural and sculptural projects for the Medici, and Andrea del Sarto was flirting with the idea of moving to France, where he spent about a year in 1518–1519. Thus the opportunity for innovation in Italian painting was opened for a new generation of aspiring artists.[2]

The spirit of the age was also at odds with the serenity of its recent masterpieces in painting. The disastrous Wars of Italy, periodically revived since 1495, had in the course of twenty-five years demonstrated the political and military helplessness of the small Italian states vis-à-vis powers like Spain and France; among them only Venice was destined to maintain its sovereignty and maritime power throughout the sixteenth century. The abuses of the Church were widespread and widely recognized: within a few years, the Reformation would rupture the ecclesiastical hegemony of Rome over Western Europe. The prevalent spiritual malaise was reflected in Machiavelli's contemporaneous works of political philosophy. The time was "out of joint," and it may have called for something other than an art of classical order.[3]

Italian painters responded to this zeitgeist of social crisis and artistic opportunity in a number of different ways. In Venice Titian extended the precedent set by Giorgione to create a new poetics of color; in Parma Correggio explored a personal style that is often seen as the first manifestation of the tendency that later grew into the painting of the Baroque era. But the broadest response, in Rome, Florence, and elsewhere, was a combination of individual contributions that is often called "the anticlassical insurgency." Through most of the sixteenth century this movement succeeded in influencing the art of painting in much of Europe and, because at its height it was characterized as the "beautiful style," *la bella maniera*, it is now called Mannerism.[4]

Well before the middle of the century, mannerist painting became the accepted style in Central Italy, and after 1550, in the era of Giorgio Vasari, the original historian of these developments, Mannerism became the academic orthodoxy of the day. Frederick Hartt, expressing something of a consensus, has characterized this school in the following terms: the iconography of mannerist painting "exploits strangeness of subject, uncontrolled emotion, or with-

drawal"—in other words, it eschews "the normal." It makes use of "elaborate, involved, abstruse" narrative, within space that is "disjointed, spasmodic" and "often limited to the foreground plane." Its composition is "conflicting, acentral" and tends to seek the picture frame. In their proportions, the figures depicted are "uncanonical, usually attenuated"; they are "tensely posed, confined or overextended." The colors used are contrasting and surprising; the overall effect is artificial.[5]

Artists who adopted many or most features of this *maniera* after it became widely popular were probably no different as a group from those who have joined any other artistic bandwagon. However, for about a dozen years, from 1517 to around 1530, innovations of this kind were decidedly revolutionary, and the painters who pioneered this route appear to have been very unusual personalities. I shall make the attempt to discern the psychological dispositions these pioneers had in common; if such commonalities are found, this would buttress a conclusion I reached elsewhere, that an important new departure in a creative domain may call upon individuals with a very specific set of personality traits.[6]

Biographical information about sixteenth-century figures is always scantier than we would like, and its reliability is often in question, although the reports of Vasari (who knew many of his mannerist predecessors or their close associates in person) have held up surprisingly well to historical scrutiny. Nonetheless, we have to approach any attempt to correlate stylistic features to attributes of an artist's personality with very great caution. We are on safer ground in dealing with the first cohort of anticlassical insurgents as a group—indeed, most commentators on mannerist painting have not hesitated to call the work of its originators neurotic.

Of course, this designation does not pretend to use the technical vocabulary of abnormal psychology in a precise manner, and I suspect that the label is simply intended to mean that these images reflect a world of peculiar psychological states. From a psychoanalytic perspective, these abnormal states go far beyond the boundaries of what is correctly defined as neurosis, into a realm of subjective uncertainty about body boundaries, aliveness, human identity, and the reliability of sense perceptions. I shall return to these specifics shortly; here let me note that none of the originators of Mannerism employed all of the devices the style eventually came to incorporate; hence each aspect of the mature style seemingly had a different set of progenitors.

Because the point I wish to highlight—the importance of the

artist's inner world in shaping creative achievements at times that provide socially sanctioned opportunities to alter a discipline—may be amply illustrated by choosing a limited number of unequivocal examples, I shall make no effort to survey the contribution of every mannerist of note. I shall confine the discussion, instead, to the three artists most frequently mentioned as the foremost representatives of the school: Jacopo Carucci of Pontormo (1494–1557), Giovanni Battista di Jacopo, nicknamed Rosso Fiorentino (1495–1540), and Francesco Mazzola, known as Parmigianino (1503–1540). Each of these men used most of the stylistic devices that were to characterize the mannerist school, but I shall concentrate on those features in the case of each one that had the greatest weight for the work of that individual.

Because it presents the least difficulty, I should like to begin by considering the example of Rosso Fiorentino. This artist probably began his professional career circa 1512 as an employee in the studio of Andrea del Sarto; his independent activity as a painter dates from 1517–1518, the precise moment when the style of the High Renaissance was reaching its culmination. Following the catastrophic siege and sack of Rome in 1527, in reaction to the general political chaos that supervened, Rosso obtained an invitation from the King of France, Francis I, and in 1530 he permanently left Italy. In France he became the principal figure of the School of Fontainebleau, where his work in the sumptuous royal palace constituted the first spread of Mannerism beyond the boundaries of Italy. His decoration of the Gallery of Francis I with an integrated assembly of stucco reliefs framing a dozen large narratives in fresco is the most ambitious of his projects, but one generally considered within the boundaries of French art, not in those of Italian Mannerism. Thus Rosso is the simplest of my illustrative cases only because his corpus of work in Italy is relatively restricted.

Eugene Carroll recently summed up the artistic principle underlying Rosso's work as "contrarian"; i.e., as opposed to the ordered, serene, and rational qualities of the art of the High Renaissance. Carroll uses adjectives such as hysterical, rapt, shrill, blatant, and sexual to describe Rosso's paintings.[7] There is historical consensus about the fact that Rosso Fiorentino—the nickname means the Florentine Redhead, after all!—was a quarrelsome person. His first major commission, for an *Assumption of the Virgin* in the atrium of the church of SS. Annunziata in Florence, led to a falling out with Andrea del Sarto, supposedly because it aroused the latter's jealousy. This atrium is completely covered by a cycle of frescoes, several

among them by Andrea; Rosso's portion was the last to be com-
pleted. While it does not outshine its competitors, it joins a contri-
bution by Pontormo next to it in obtrusively violating the scale
implicitly agreed on by all previous contributors to the schema. To
put this differently, we cannot be certain about the reasons for the
quarrel with the artist who had trained him, but it is likely that
Rosso had not conducted himself prudently, because, despite his
obvious talent, thenceforth he had difficulty in getting work in
Florence. He did complete an altarpiece in 1518, but it was so odd and
strident that its patrons refused to accept it. (Consequently, Rosso
did his best work before his 1523 move to Rome in the decidedly
provincial city of Volterra.)

The most bizarre aspect of the *Assumption of the Virgin* is the
strange facial expression given to the Apostles who witness her
ascent to Heaven. Some have perceived these as shrill or rapt, some
as "almost drunken"—in agreement with S. J. Freedberg, I think the
behatted figure at the extreme left conveys an aura of madness
because of the grimace on his face noted by many observers. The
provocative intent of such a depiction is confirmed by that of the
angel-putti who surround the Virgin, teasingly withholding her gir-
dle, which they are supposed to drop to St. Thomas. Even as the
debut of a precocious twenty-two year old, this performance of
Rosso's was calculated to discourage potential patronage.[8]

Nor did Rosso fare much better in Rome. An autograph letter has
survived that Rosso wrote to Michelangelo in order to deny reports
that he had made depreciating comments about the Sistine ceiling.
But one suspects that Rosso was not above committing such an
impudent indiscretion. The Florentine architect Sangallo arranged a
commission for Rosso to decorate a chapel Sangallo was designing,
but a bitter quarrel between them put an end to this potential col-
laboration. For the most part, because he managed to alienate all
who might have employed him, Rosso was reduced to producing
drawings intended to be reproduced as engravings. In his celebrated
Autobiography, Benvenuto Cellini, who was in Rome at the same
time, described Rosso as an arrogant person with a vile tongue.
(Later, when both were in Fontainebleau, Cellini felt that Rosso
underhandedly tried to get him to leave, lest he become a serious
rival for the king's patronage.)[9]

Between the sack of Rome and his departure for France, Rosso
was active in Arezzo (where he met Vasari) and in Borgo San
Sepolcro, comparative backwaters where, for lack of competition, he
was able to find work. However, another bitter quarrel led him to

abandon one project, although this default obliged a friend who had agreed to be the financial guarantor of Rosso's work to reimburse the patron for expenses. Linda Caron has recently pointed out that in a *Deposition from the Cross* completed in July 1528, Rosso had the nerve to include an ape among those attending this sacred event—a provocation made possible by the relatively inadequate lighting then available, which left Rosso's ape veiled in darkness.[10]

We have less information about the artist's behavior in France, although by 1530—when he was thirty-five—he had obviously gained enough savoir faire to please the king. Perhaps it was royal favor, which enabled him to live in lavish style, that sufficed for a number of years to soothe Rosso's customary prickliness. However, Vasari's account of Rosso's death—never definitively corroborated, but probably accurate in view of the historian's direct contacts with Italians working in Fontainebleau—suggests that the artist's character remained unaltered. Vasari relates that Rosso committed suicide (presumably because he felt humiliated) when it was proved that he had falsely accused a fellow artist of a fictive crime—in the manner of Shakespeare's Iago.[11]

All of the anecdotes we possess about Rosso convey a remarkably coherent account of his character, that of a negativistic and vehement person, a genuine contrarian. As Freedberg notes, for Rosso "authority meant challenge." Little wonder that the most notable feature of his paintings is their *vehemence*. This quality is perhaps most clearly demonstrated in his *Moses and Jethro's Daughters* (figure 13.1), a canvas Rosso probably produced shortly after his arrival in Rome, in 1523. The very choice of this rare subject betrays an unusual degree of interest in violence, but Rosso's insistence on presenting most of the action in a crowded, close-up view (as if pulling the viewer into the middle of combat) greatly heightens the intensity of the emotion conveyed. The tense, contorted, naked bodies of the protagonists, their wild gestures and long, disheveled locks, and the facial expressions conveying extreme psychological states (mostly of rage and terror) typify the "abnormal" subject matter said to characterize mannerist painting.

Moses is one of the most wrathful and impetuous of Biblical characters, probably the most appropriate of alter egos for a quarrelsome man destined for a violent end. What the biographical data available do not prepare us for is the atmosphere of prurience of which this picture is redolent; as Frederick Hartt puts this, "the feminine charms" of "a very provocative daughter of Jethro" are "either entirely unveiled or else covered by filmy drapery which

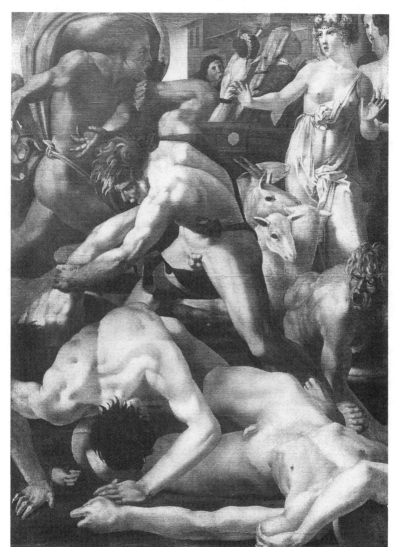

FIGURE 13.1. Rosso Fiorentino, *Moses and Jethro's Daughters*, ca. 1523. Oil on canvas. *Uffizi, Florence. Alinari/Art Resource, New York.*

reveals more than it hides."[12] To the best of my knowledge, such raw suggestiveness had never before been attempted in Italian art. Although there was ample precedent for rendering fighting male figures as nudes, the juxtaposition of such *ignudi* with a partially clothed, nubile girl interprets the motive of Moses in defending the daughters of Jethro as a fight for sexual possession. In these circumstances, Rosso's choice to minimize the size of the penis of Moses lends a note of incongruity to the painting that may be a

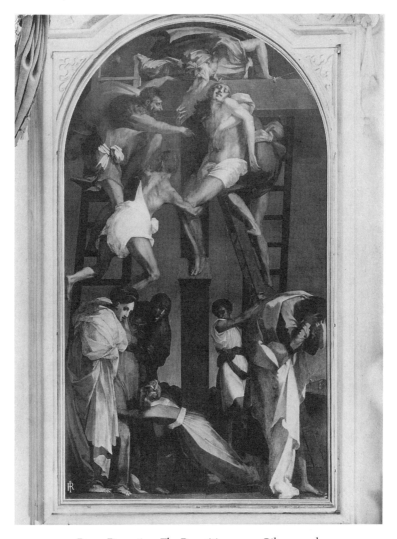

FIGURE 13.2. Rosso Fiorentino, *The Deposition*, 1521. Oil on panel.
Volterra Cathedral. Alinari/Art Resource, New York.

hint of the artist's propensity to distort his representations of the
human body.

But Rosso's preference for altering human proportions is more
clearly manifest in other works, notably in his rejected altarpiece of
1518, with its bizarrely emaciated figures, and in the masterpiece of
his Italian years, the *Descent from the Cross* in Volterra, painted in
1521 (figure 13.2). In the latter most of the actors are robust enough,
but their heads are very small in relation to their massive bodies. In
contrast to classically correct proportions of six to one, Rosso's fig-

ures here have heads no larger than one-tenth of their total height. Moreover, as Hartt points out, bodies are rendered in a deliberately unnatural manner, as if they were not flesh but quasi-abstract shapes carved from wood. The aura of arbitrariness is further heightened by a choice of peculiar colors, ones usually avoided in classical painting. I shall not make explicit the ways in which the qualities of this work echo those of the other Rosso paintings already discussed, nor pause to speculate on the probable psychological correlates of this way of portraying the human body—a matter to be considered after discussing Parmigianino and Pontormo.

The constraints of space compel me to turn, instead, to the Parmesan master, Francesco Mazzola. Like Rosso, Il Parmigianino had a short life, and much of his production as a painter consisted of cycles of frescoes (in and near his native city) in which he restrained his mannerist propensities. Consequently, the works demonstrating his originality to the fullest degree are relatively few in number. In contrast to Rosso, Parmigianino's introduction to the profession was brilliantly managed by the uncles who raised him after the early death of his father—the entire family consisted of professional artists. As early as 1522, when the boy was barely nineteen, he received a commission for work in Parma Cathedral, although this was never executed. Parmigianino was acclaimed as the heir of Raphael, despite having been heavily influenced by Correggio, who was active in Parma through the years of the younger artist's adolescence.

At the age of twenty-one, soon after a great patron of the arts, Clement VII, succeeded to the papacy, Parmigianino was sent to Rome with proper introductions to the court and a dazzling sampler of his youthful masterpieces. The elegant, suave, and beautiful young artist succeeded in gaining Clement's favor; he was destined to obtain patronage easily so long as he lived. Parmigianino's work is almost exclusively focused on the human figure, and he became a portraitist of real distinction, capable of combining psychological penetration with grace and beauty pleasing to his sitters. However, none of his portraits match the originality of his *Self-Portrait in a Convex Mirror* (figure 13.3), one of the works through which the artist managed to capture the attention of the pope.

The twenty-one-year-old painter, still several years away from arriving at his mature style, here represents his reflection in a barber's mirror by painting on a specially prepared convex surface. The result is a harbinger of one of Parmigianino's most important contributions to Mannerism, the distortion of the human figure for expres-

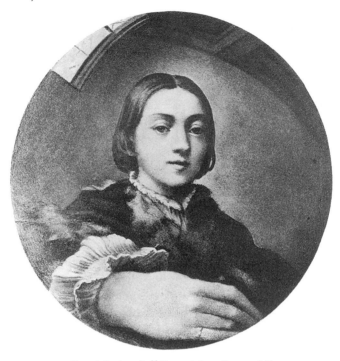

FIGURE 13.3. Parmigianino, *Self-Portrait in a Convex Mirror*, 1524. Oil on panel. *Kunsthistorisches Museum, Vienna. Marburg/Art Resource, New York.*

sive purposes. Here, the artist's intellectual breakthrough consists of the refusal to correct the actual percept visible in the mirror, that is, to present an "undistorted" representation of the figure, as painters had always done in the past. What we see, instead, is the monstrous enlargement of the young man's hand and forearm, raised into a horizontal position in front of his torso. The walls of the room behind him are correspondingly distorted; only Parmigianino's head and shoulders, which occupy the central portion of the convex surface, are reflected in a "natural" guise.

This image is a triumph of rationality over artistic convention; it represents the artist's successful mastery of the manifold problems and anxieties every human being has about maintaining a stable body image. Parmigianino soon extended this mastery by abandoning any constancy in the representation of the human figure; that is, he began to experiment with deliberately *irrational* presentations of the images of living beings. For example, in 1527, just before the sack forced Parmigianino to leave Rome for Bologna, he painted a *Vision of St. Jerome*, the spatial arrangement of which abandons rationality altogether. The position of the sleeping saint is inexplicable, in

view of the enormously greater scale of the virgin and child who *ought* to be represented as being further away from the viewer. Frederick Hartt reminds us that in the sixteenth century mirrors distorting the image along the vertical axis in this manner did not exist: the bizarre elongation of the sacred figures Jerome perceives in his "vision" is strictly the result of the painter's imagination. The unnatural enlargement of the Baptist's right arm, hand, and pointing finger, echo those of Parmigianino's own in the self-portrait already discussed.[13]

Nor did the artist restrict this kind of distortion to his handling of the human figure; he played equally arbitrary games in representing other creatures. Perhaps the most astonishing image he ever painted is that of the rearing horse in *The Conversion of St. Paul* of circa 1527 (figure 13.4), probably one of his first works in Bologna. Oberhuber calls this animal "exquisitely refined," but it looks more like a mythical beast than a real equine: it is even more microcephalic than its fallen rider, whose head measures less than one eighth of his total height.[14]

In their emphasis on verticality, suave grace, on the decorative arrangement of figures in unnatural, serpentine poses, as well as in the ambiguity of their space and lighting, both the *Vision of St. Jerome* and *The Conversion of St. Paul* demonstrate the attainment of Parmigianino's mature style. It is worth noting that he created these works around the age of twenty-four. These characteristics are even more notable in *Saint Roch and Donor* (figure 13.5), painted before 1530 for a chapel in Bologna Cathedral. Oberhuber stresses "the self-conscious twist in the movement of the giant body which fills the whole space," thus "endowing the figure with extraordinary tension." Note the exaggerated enlargement of the hands of both St. Roch and the donor, especially in relation to the figures' small heads.[15]

In 1530 Parmigianino received a great fresco commission in Parma, for which he returned to his native town. For unknown reasons he was quite dilatory in fulfilling his contract, so much so that he was eventually put in debtor's prison and ultimately, in 1540, fled Parma without completing the project. He died of a fever shortly thereafter, at the age of thirty-seven. Parmigianino's late style may be illustrated by two works from the second period in Parma, the celebrated *Madonna of the Long Neck* (figure 13.6) and the *Cupid Carving His Bow* (figure 13.7), both of circa 1534–1535. These paintings show not only the characteristics already mentioned as constants of Parmigianino's style but additional features equally important for the later development of Mannerism.

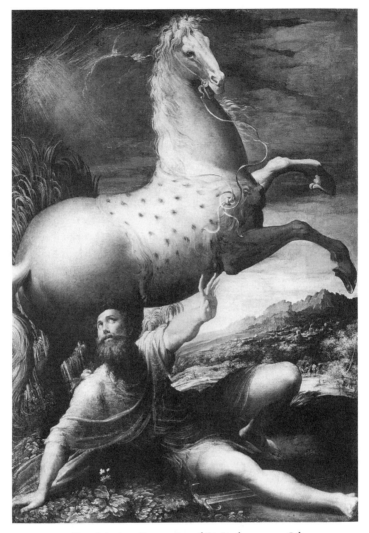

FIGURE 13.4. Parmigianino, *Conversion of St. Paul,* ca. 1527. Oil on canvas. *Kunsthistorisches Museum, Vienna. Marburg/Art Resource, New York.*

Parmigianino was probably assisted in turning away from the example of Correggio, toward his individual version of a mannerist style, through his contact in Rome with several older painters who started on that road before him, such as Raphael's principal assistant, Giulio Romano, and Rosso Fiorentino. From Rosso in particular, he could have learned to experiment with elongating the human figure and reducing the size of its head. However that may be, several other features also became prominent in Parmigianino's work, characteristics without precedent in that of any other painter.

The overt sensuality of *Cupid Carving His Bow* was prefigured by the madonna and child of the *Vision of St. Jerome*, but the very subject matter of the 1535 painting steps up the intensity of the erotic charge. In contrast to some of Rosso's work, however, I do not find Parmigianino ever to be prurient. His detached attitude to eroticism is articulated in the painting of *Cupid*: two putti appear between the legs of the god; one is crying with pain and fear because he has been burned by touching Eros, the other is sadistically trying to force him to repeat the act. The nude Cupid, seen from the back,

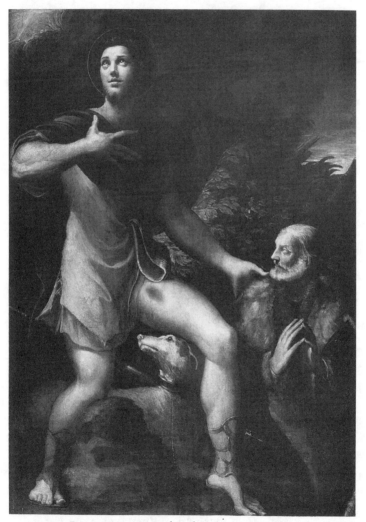

FIGURE 13.5. Parmigianino, *St. Roch and Donor*, ca. 1528. Oil on panel. *S. Petronio, Bologna. Scala/Art Resource, New York.*

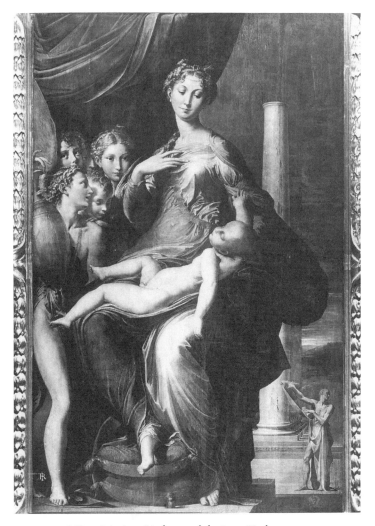

FIGURE 13.6. Parmigianino, *Madonna of the Long Neck,* ca. 1534.
Oil on panel. *Pitti Palace, Florence. Alinari/Art Resource, New York.*

is somewhat effeminate, but (as many observers have noted) he is
not rendered as a creature of human flesh. Rather, this figure is an
excellent example of Parmigianino's characteristic manner of paint-
ing the surfaces of human bodies as smooth hard textures.

Some of the commentators already cited describe the faces of
Parmigianino's protagonists as "masks"; others talk about his han-
dling of flesh as if it were a "vitreous film." His personages appear to
be made of porcelain (in a sixteenth-century Italian context, it might
be more appropriate to say glazed terracotta); sometimes the skin is
therefore unnaturally white, at other times it is as if suffused with

subtle colored glazes. Others compare the flesh of Parmigianino's Cupid to mother-of-pearl. From a psychoanalytic viewpoint, the eroticism of such works is therefore explicitly fetishistic and represents a rejection of ordinary sexuality, focused on human partners, in favor of inanimate objects.

The *Madonna of the Long Neck* is probably the most famous of

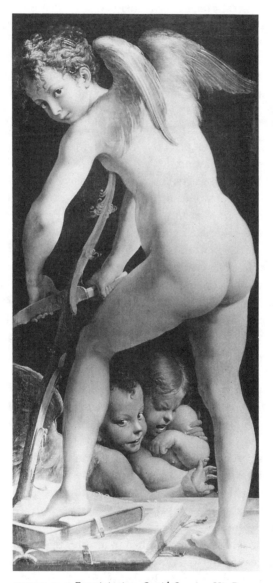

FIGURE 13.7. Parmigianino, *Cupid Carving His Bow*, 1535. Oil on panel. *Kunsthistorisches Museum, Vienna. Marburg/Art Resource, New York.*

Parmigianino's works. Hartt calls it a painting of "chill eroticism," in which the virgin's erect nipples may be seen through her transparent gown.[16] The significance of the tangle of scantily draped adolescent spectators is obscure, except for their stunning grace and beauty. The virgin's posture is physically untenable; her elongated proportions are further exaggerated by the bizarre narrowing and extension of her neck and its lateral curve, as if it were the trunk of a tree. Equally irrational is the inclusion of a single monumental column in a background that is otherwise largely left in an unfinished state.

To recapitulate, once he reached artistic maturity, Parmigianino gave ever-freer rein to his tendency to introduce into his work irrationalities of various kinds—in spatial arrangements, in representations of living figures, in renderings of the externals of human appearance, and in focusing on a very unusual, probably fetishistic form of eroticism. It is scarcely surprising that these subtle signs suggesting some profound inner disturbance are complemented by Vasari's report that the artist became progressively more involved in alchemy, to the detriment of his commitment to artistic projects. Some historians have even wondered whether Parmigianino's premature demise could have been due to chemical poisoning, perhaps caused by mercury, often used in alchemical experiments. In any case, such a preoccupation with nonartistic concerns, albeit with matters then considered legitimate subjects of inquiry, constitutes a sign of a deep personality change. According to Vasari, Parmigianino in his last years "changed from the delicate, amiable and elegant person that he was to a bearded, long-haired, neglected and almost savage or wild man."[17]

We do not have sufficient data to make a precise diagnosis of the artist's condition, but it is clear that it constituted a regressive change in his personality. What we can conclude with some confidence is that Parmigianino's capacity for human relatedness underwent some diminution; the specific characteristics of his late work can therefore probably be correlated with an upsurge of instability in his conception of the human body, some interference with his sense of feeling alive, and, possibly as a restitutive symptom, a resort to fetishistic sexual preoccupations.[18]

The last painter I wish to consider in this study is the Florentine master Jacopo da Pontormo. Trained in a series of studios, including that of Andrea del Sarto, Pontormo, more pliable than his contemporary, Rosso, fully absorbed the discipline of the classical style. His great talent was recognized early and led to independent commis-

sions of increasing importance, culminating in a *Visitation* for the atrium of SS. Annunziata (ca. 1514–1516), a place (it will be recalled) already decorated with several frescoes by Andrea. The outstanding merit of this youthful masterpiece in the High Renaissance style secured Pontormo's reputation. However, even this demonstration of the young artist's mastery of the work of the previous generation contains a harbinger of Pontormo's future oddity: in the right foreground he introduces the inexplicable figure of a naked child of heroic proportions, sitting on the steps in a peculiar posture, displaying his genitals.

Pontormo's career continued for four decades after these auspicious beginnings; by coincidence, however, the three major fresco cycles that constituted the core of his activities after 1535 have all been destroyed, so that we know only a fragment of his late work, mostly a series of austere and sober portraits of the aristocracy of the Medici court. For all practical purposes, therefore, the corpus of Pontormo's surviving oeuvre is contemporaneous with those of Rosso and Parmigianino, both of whom predeceased him by sixteen years. Pontormo was an artist who experimented ceaselessly; as late as 1520 or 1521 he created a bucolic fresco for the Medici villa at Poggio a Caiano that most critics do not look upon as mannerist in style. This unique painting had no precedents and, as far as I know, no sequel; it is relevant here only because the motif of the naked boy exposing his genitals recurs no fewer than four times in this composition. In addition, an adult male sitting with his legs splayed out is shown uncovering his genitals, previously hidden by the loincloth he is holding aloft.

Pontormo's specifically "mannerist" experimentation may be said to have begun in 1518, when (along with Andrea del Sarto) he participated in decorating a room in the Palazzo Borgherini. One of his contributions to this ensemble was a panel of *Joseph in Egypt*— an image of bewildering complexity, filled with compositional irrationalities. The picture is an assembly of separate incidents, presented without regard to spatial coherence or uniformity of scale. Many of the individual figures are attenuated and microcephalic. The oddest touch in this strange potpourri may well be the presence of two gigantic nude statues mounted on plinths and silhouetted against the sky; critics have noted that these figures are rendered so ambiguously that it is difficult to discern whether they are animate or inanimate. "Through the whole picture . . . runs a strange terror resulting in an almost physical tremor, like chills and fever." A plague is about to descend upon the land of Egypt.[19]

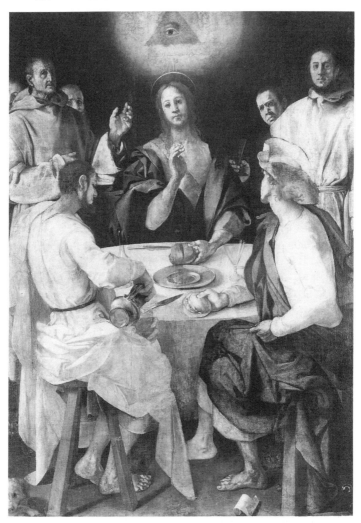

FIGURE 13.8. Jacopo Pontormo, *Supper at Emmaus*, 1525. Oil on canvas.
Uffizi, Florence. Alinari/Art Resource, New York.

During an actual plague that struck Florence in 1523, Pontormo
took refuge in the suburban Charterhouse of Galluzzo, where he exe-
cuted a cycle of paintings that were to shock even that archmannerist,
Vasari, because they are full of stylistic borrowings from the prints of
Albrecht Dürer.[20] Even in the cosmopolitan sixteenth century, such a
departure from national traditions was seen as perverse. The last of
Pontormo's works for Galluzzo was a *Supper in Emmaus* (figure
13.8), completed in 1525, which is noted for the uncompromisingly
down-to-earth presentation of its sacred personages, negating the ide-
alism of the High Renaissance and prefiguring the naturalism of

Caravaggio, Velázquez, or Zurbarán. Neither this naturalism nor the elongated proportions of Pontormo's figures is derived from Dürer.

Between 1525 and 1528 Pontormo decorated the Capponi chapel in the Florentine church of S. Felicità with a superb cycle of paintings, including an *Entombment of Christ* (figure 13.9) that is generally considered to be his supreme achievement. This mystical work presents an image that is the very opposite of naturalism, a point perhaps best illustrated by the astonishingly unusual choice of Pontormo's colors, dominated by oranges, pinks, acrid greens, deep yellows, and pale blues. The compositional grouping of the figures

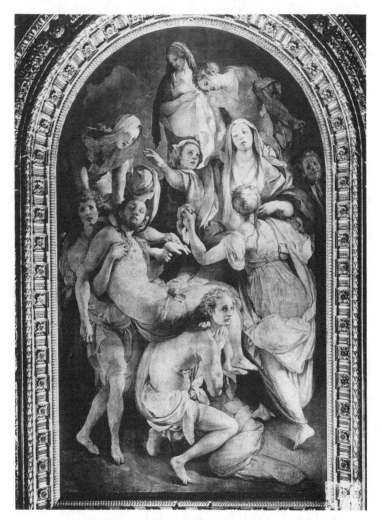

FIGURE 13.9. Jacopo Pontormo, *Descent from the Cross*, ca. 1526–1528. Oil on panel. *S. Felicità, Florence. Alinari/Art Resource, New York.*

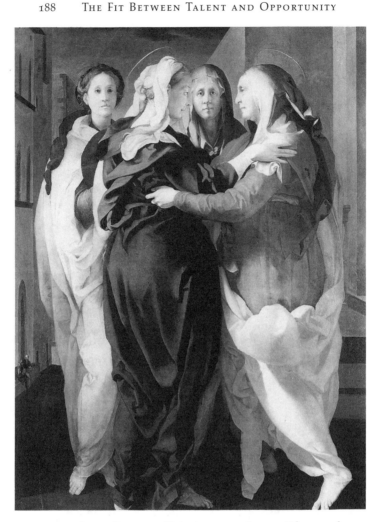

FIGURE 13.10. Jacopo Pontormo, *Visitation*, ca. 1528–1529. Oil on panel.
Pieve di S. Michele, Carmignano. Alinari/Art Resource, New York.

has no regard for spatial plausibility (are the topmost participants
floating in air?). The only other oddity I wish to single out for men-
tion here is the fact that several personages are painted with skin-
tight garments, presumed to be made of leather, that simulate
human flesh rendered in bizarre color: pink for the arms and torso
of the youth supporting Christ's legs, greenish-yellow for the legs
of the one holding the Savior's trunk, avocado green for the whole
costume of St. John, who looks down upon the scene over the
Virgin's right shoulder. These details remind one of Parmigianino's
representation of flesh as ceramic or mother-of-pearl.

A *Visitation* (figure 13.10) Pontormo created for an abbey in

Carmignano ca. 1528–1530 makes use of the same original color scheme. In addition, in this painting the artist introduced a novel kind of distortion of the human figure: although the personages are still microcephalic, instead of being attenuated, their bodies appear inflated, like balloons. The background of this painting represents a townscape, shown with a startling disparity of scale between left and right; Pontormo has returned here to the spatial irrationality that characterized his *Joseph in Egypt* a dozen years before.

Following the fall of the Florentine Republic in 1530, Pontormo seems to have entered the orbit of Michelangelo, who continued to live in the city until 1534. The younger artist executed two paintings, a *Nole mi tangere* and a *Venus and Cupid*, based on Michelangelo cartoons; in these works Pontormo seems to have suppressed his originality in favor of collaborating with a genius he was ever proud to emulate. At the same time, Pontormo's overall mood apparently darkened; those few of his later paintings that have survived are notably somber. Portraits, such as the *Alessandro de' Medici* of 1534–1535 (figure 13.11) show this tendency, although in this painting one does not see Pontormo's continuing preference for expressive distortions of the human figure.

According to Luciano Berti, Pontormo's late work (most of which is familiar to us only in the form of preparatory drawings) was impregnated with anxiety and existential doubt, expressed by means of bold subversion of Michelangelesque forms—Berti calls this "emulation through contradiction."[21] To what extent this turn to ever more bizarre forms was a response to the political disasters of the age is difficult to say; it *is* certain, however, that it paralleled the deterioration of Pontormo's adaptation as a social being. Vasari reports that the artist, who lost both parents by the age of ten and his only surviving grandparent by thirteen, was already "melancholy and lonely" as an adolescent and that, as an adult, he preferred "quiet and solitude." In the 1530s Pontormo's domicile had "rather the appearance of the dwelling of a fantastic and solitary man than a well-considered house. The room where he slept and sometimes worked was approached by a wooden ladder which he drew up after him, so that no one could come up without his knowledge or permission." When Pontormo was decorating the principal chapel of S. Lorenzo, he "kept the place closed for eleven years, so that not a living soul entered it except himself." Vasari confessed that he felt bewildered by Pontormo's S. Lorenzo frescoes, "full of nudes . . . with so much melancholy as to afford little pleasure to the

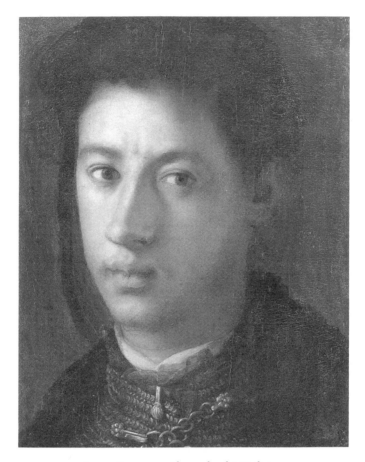

FIGURE 13.11. Jacopo Pontormo, *Alessandro de' Medici,* 1534–1535.
Oil on panel. *Art Institute of Chicago,*
Mr. and Mrs. Martin A. Ryerson Collection, 1933.1002.

observer"; he could not accept these figures in which, according to
him, Pontormo tried to "force Nature."

In Vasari's view, Pontormo was "solitary beyond belief," although
he continued to associate with certain old friends, including his for-
mer student Bronzino, who persisted in behaving toward him with
affection and gratitude. "Jacopo had strange notions, and was so
fearful of death that he never allowed it to be mentioned, and he
avoided dead bodies. He never went to . . . places where crowds col-
lected for fear of being crushed."[22] Vasari's account is confirmed by
the evidence of a "diary" of Pontormo's for the years 1554 to 1556,
which records his preoccupations with eating, elimination, and

numerous hypochondriacal concerns.[23] These are the scribblings of a person whose world has contracted, to a very large degree, to his own bodily functions.

Although the information available to us does not permit any precise diagnosis of Pontormo's psychological state (in exact parallel with the cases of Rosso and Parmigianino), it does point to the progressive aggravation of a lifelong depressive tendency, more and more avoidance of human relationships, and a concomitant increase in peculiar somatic sensations—in sum, a syndrome of profound disequilibrium of an archaic type.[24] In all three cases, throughout the life span a variety of psychological vicissitudes brought about various progressive and regressive changes in adaptation, functional shifts that were often reflected in changes of either form or content in the artist's work.

Even the fragmentary biographical information available makes clear that, in terms of overt behavior, each of the three artists differed from the others. To put these differences of character briefly, in the shorthand of psychoanalysis: Rosso tended to be negativistic, brittle, and paranoid; Parmigianino gradually slipped into a withdrawn state and mystical preoccupations; Pontormo was vulnerable to depression, obsessive rumination, and hypochondriasis. When these aspects of personality are viewed in terms of the modes of functioning postulated by psychoanalytic theory, however, they are largely referable to those maladaptive conditions that approach the realm of personal disintegration but stop just short of psychosis.

In contingencies of that kind, the threat of loss of personality integration is generally experienced subjectively in mistakenly concrete terms, as ominous alterations in body image, self-feeling, or somatic functioning. Alternatively, the sense of disintegration may be projected onto the external world, usually accompanied by a loss of reality sense that in turn casts doubt on sensory perceptions.[25] I believe it is precisely this set of subjective experiences that were reflected in the innovations of the painters under discussion, mostly in the realm of artistic style: alterations of body image are prominent in the work of each master. Altered subjective states were portrayed by the manner in which both Pontormo and Parmigianino rendered human flesh as if it were inanimate, and bodies as deprived of the capacity for real action. The unreliability of perceptions and a sense of inner fragmentation are conveyed by irrational arrangements of scale and space (once again found in the work of Jacopo and Francesco) and the use of unnatural colors (in that of Pontormo).[26]

One of the most common avenues of self-healing in psychologi-

cal emergencies of the kind these artists probably encountered is self-stimulation by means of erotic fantasies or enactments wherein the sexual object possesses no independent volition. Another way to put this is that a resort to perversion can be an effective home remedy in case of threatened disintegration. The specific perversion selected will, of course, vary, partly as a function of the opportunities available. For a visual artist, voyeurism is the most accessible of these avenues—or, if you will, the production of art tinged with pornography is a natural antidote for the disturbing malaise preceding a psychological emergency. This may explain the unprecedented prurience to be found in some of Rosso's work. The fetishistic flavor I see in that of Parmigianino betokens an even deeper regression, one in which excitement is no longer possible in a purely *human* context.[27]

In summary, the principal psychological determinants of Italian mannerist painting appear to have been the sequelae of the regressive propensities of many of the individuals who pioneered the anticlassical insurgency at a moment when the art of the High Renaissance could no longer be sustained as the optimal reflection of contemporary civilization or the supreme technical achievement of an avant-garde. In this sense, the psychology of the cohort of painters who deflected art in the mannerist direction has much in common with that of the post-Impressionist masters (Seurat, van Gogh, Gauguin, and Cézanne) who led Modernism away from the realism that was the touchstone of the generation preceding theirs.[28] At such crucial junctures, when social and intradisciplinary considerations open the way for an art of subjectivity and unbridled emotion, personalities who might be handicapped whenever order and serenity have the upper hand will find opportunities for the successful exercise of their talents to create art expressing the profound disorders of their inner experience.

•

Paul Cézanne: Psychopathology, Subject Matter, and Formal Innovation

Occasionally, as in the case of Caravaggio (see chapter 10), contrasting mental dispositions are kept apart through a chronic split in the mind,[1] and such a state of affairs may keep even a psychotic process segregated from a person's creative activities. In other instances, such a separation between an artist's oeuvre and his disturbed mental processes has to be effected through deliberate effort. It was such a planned change in the direction of his painting (urged upon him by Camille Pissarro, a helpful mentor to several younger colleagues) that eliminated disturbing and disturbed narrative content from the art of Paul Cézanne. By concentrating mostly on landscapes and still lifes (and, to a lesser extent, on portraits of the few individuals with whom he felt at ease), Cézanne was enabled to exploit his supreme *formal* talents.

Before this programmatic shift, the artist produced interesting work, bursting with emotion, often about themes such as rape and murder, orgies and brothel scenes. In such expressionist works, Cézanne certainly showed great raw talent while also betraying paranoid anxieties about women. From biographical sources, we know that the painter was literally afraid of the potential destructiveness of females qua sexual predators: as a consequence, he was categorically unable to work from nude models.[2] Meritorious as Cézanne's early work in this expressionist mode was, it did not call

upon those capabilities that were to distinguish him from his con-
temporaries—the talents that Cézanne himself declared to have had
no precedent for two hundred years, presumably since the era of
Nicolas Poussin.[3]

Cézanne's pathological character has been noted by numerous
observers; probably the earliest to do so was his childhood friend, the
future novelist Emile Zola, whose observations have been summed
up as follows: "The painter was about as illogical in his ideas and
behavior as one could be. . . . The stubbornest of men . . . age and
experience have not changed him at all. . . . Sensitive and easily
offended, touchy and hot-tempered, he had to be handled with
extreme care."[4] Zola's characterization of his friend rigorously
avoided the technical vocabulary of psychiatry, an example best fol-
lowed to this day, because the biographical evidence does not permit
any precise psychopathological diagnosis. From time to time
Cézanne clearly lapsed into delusional states; on other occasions he
seemed to be free of them—for much of his life we are simply not
in a position to make any judgment about his mental status. Perhaps
Aaron Esman's verdict, that "Cézanne . . . was engaged through his
adult life in a continuous struggle against dark inner forces that
threatened constantly to disrupt his psychic integrity" is the best we
can do at this time.[5]

Probably the best documented of Cézanne's delusional episodes
occurred when, in 1894, his friend and colleague Monet generously
organized a luncheon in his honor. In the presence of Renoir, Sisley,
and other close associates, Monet toasted the fifty-five-year-old
Cézanne, expressing his personal affection and admiration for his
work. As one biographer puts it, "Paul stared at him in consterna-
tion and answered in a voice, shaken with regrets and reproaches,
'You too are making fun of me,' snatched his overcoat, and rushed
off."[6] Moreover, this pathetic incident was by no means unusual for
Cézanne; much more serious crises may have occurred that were not
witnessed by so many reliable observers.

The gravest incident to have been recorded was an abortive
episode of "falling in love" with a servant girl, when Cézanne was
forty-six years of age. One incoherent and somewhat absurd letter
composed by the artist (but mercifully never sent) has survived to
document the incident.[7] The girl must have been extremely inap-
propriate, for Cézanne's mother and sister then pushed him into
marrying Hortense Fiquet, by whom he had an illegitimate son of
fourteen, despite Hortense's notable dullness and lack of social
advantages. Although Paul passively let himself be guided into this

unwanted marriage, thereafter he became pathologically irritable. For instance, after allowing his wife to nag him into a trip to Switzerland, he became infuriated by seeing an antireligious demonstration in Fribourg. Thereupon, Cézanne disappeared among the crowd and was "lost" for several days. He then wrote Hortense from Geneva, asking her to rejoin him. It is very likely that, in the interval, he may have been disoriented.[8]

Even more significant than the occurrence of time-limited crises of this kind was the artist's persistent paranoia about his own father, the self-made industrialist and banker, Louis-Auguste Cézanne. Both the painter and his friends (particularly Zola) described this patriarch as a domestic tyrant, and several commentators have understood the son's psychology in terms of inhibited (oedipal) wishes in rivalry with him. Such a hypothesis is particularly plausible because Paul's parents only married when he was five, following the birth of a younger sister, a situation likely to stimulate a small child to wish to protect (and possess!) his mother. Zola saw it as authoritarian controllingness when Cézanne *père* urged Paul to enroll (as a law student) at the university in Aix; Zola was passionately urging his friend to join him in Paris in pursuit of artistic glory. Yet it was Louis-Auguste who proved to have the correct view of Paul's readiness to leave home: this alleged tyrant soon allowed his son to go to Paris, whence he quickly returned, defeated by the task of managing on his own.[9]

Until his father's death, in 1886, Cézanne continued to fear him and to claim that he had to comply with the old man's dictates because he was financially dependent on the latter's bounty. Consequently, he tried to conceal from his father the entire affair with Hortense and the existence of an illegitimate child—an obstinate and irrational policy he maintained even after Louis-Auguste confronted him with documentary evidence of the facts! Cézanne's attitude toward his father was hostile and depreciating, on the one hand, and, on the other, an awe-struck delusion about a bogeyman. In actuality, Louis-Auguste retired from business shortly after the war of 1870 and signed over the family assets to his children (in order to forestall the possibility of the institution of inheritance taxes). His son-in-law, Maxime Conil, stated that this transfer of property took place in 1872; it certainly preceded 1882, when Cézanne acknowledged the true state of affairs in a letter to Zola. Yet he maintained his paranoid claims about Louis-Auguste until the latter's death. Thereafter, the artist suddenly changed his attitude and lavished praise upon Louis-Auguste for his financial genius in making his children rich.[10]

The fact that such paranoid characteristics were deeply significant in Cézanne's emotional life is underscored by an incident of his old age, reported by his admiring disciple Emile Bernard. As one biographer sums this up,

> Coming home . . . they took a shortcut on steep ground. Paul, ahead, caught his foot and almost fell. Bernard took hold of his arm to steady him. Paul exploded with rage, cursed furiously, pushed Bernard off, and dashed away throwing wild, terrified glances over his shoulder. Bernard followed him to the studio and tried to explain, but Paul, with his eyes starting out of his head, wouldn't listen. "I allow no one to touch me. Nobody can put his *grappin* [hook] on me."[11]

It is evident that Cézanne was unable to tolerate any loving contact, misperceiving it as threatening enslavement. In his best moments, the artist had some awareness of the nature of his difficulty: in 1874, he wrote his mother, "Once I am in Aix, I am no longer free; when I wish to return to Paris, for me it becomes a struggle I need to sustain. Although your opposition to my return is not absolute, I am much affected by the resistance I experience on your part. I have the strong wish not to have my liberty of action constrained."[12]

Although these incidents add up to a picture of an extremely severe personality disturbance, with frequent lapses into acute psychosis, they reveal only one aspect of a complex man. In contrast to this posture, he maintained a close tie to his mother and was devastated by her death; he doted on his son (named Paul, after himself); he was a member of a band of adolescent chums who remained faithful to each other for many years. As already mentioned, Cézanne was able to make use of Pissarro, whose assistance he gratefully acknowledged as paternal, at a decisive juncture in his career, in the middle of his fourth decade. His human relations seem to have changed for the worse about ten years later, in parallel with his realization that his best friend, Zola, had begun to see him as a failure. More than one character in Zola's novels was loosely modeled on Cézanne; when, in 1886, in *L'Oeuvre* (or *The Masterpiece*), he was portrayed as a mediocre painter destined for suicide, the artist frostily ended their relationship.[13]

However, Cézanne's volcanic emotionality was present throughout his life. We have evidence about its manifestations in adolescence in the form of a considerable body of poetry (mostly in imitation of Latin verse). His translation of Virgil's second *Eclogue* (deal-

ing with the homosexual love of two youths) points to his passion-
ate attachment to Zola, although his later fears about being touched
indicate that overt homosexuality was never likely to have been
acceptable to Cézanne.[14] Ultimately, this rejection of his yearnings
for intimacy with men was to lead to the loneliness of Cézanne's late
years. But the feelings most prominent (and troublesome) during
Cézanne's adolescence were not simply sexual, but a great struggle
against inner violence. His poems deal with rape and attempted rape,
cannibalism, an encounter with Satan, the destruction of women
through sexual aggression, and—as if to defend against all this—
worshipping girls from afar, because he is too timid to approach
them.[15]

The fact that these themes remained vital for Cézanne is affirmed
in much of the subject matter of his early paintings. It must be noted
that even before 1872 narrative themes only constituted about a
third of his output of paintings (the rest was more or less evenly
divided among portraits, landscapes, and still lifes). Among those
that survive, he dealt, once again, with rape (V. 101), attempted rape
(V. 94), murder (V. 121, V. 123), encountering the devil (V. 15), orgy
(V. 92), and the bordello (V. 112). For good measure, there is an
autopsy (V. 105) and (echoing adoration from afar) a *Temptation of
St. Anthony* (V. 103), a *Judgment of Paris* (V. 16), and *A Modern
Olympia* (V. 106), an ironic brothel scene in which Cézanne himself
is portrayed as the voyeur. Four additional works (V. 104, V. 113, V.
114, and V. 1520A) depict female nudes as bathers; these pictures
foreshadow Cézanne's long series of *Bathers*, male and female, a
motif he gradually deprived of merely narrative connotations.[16]

Cézanne's collaboration with Pissarro did not turn him away
from his passionate themes in any abrupt manner, although after
1872 there is no depiction of any destructive act in his painting. The
closest he came to portraying any violence after that date was in two
versions (V. 379, V. 380) of *The Battle of Love*, dating from the mid-
1870s, portraying sexual aggression in an orgiastic context. By the
mid-1880s narratives all but disappeared from Cézanne's output;
one of the last he produced was a reprise of the *Judgment of Paris* (V.
537). In the mid-1870s he made a second *Modern Olympia* (figure
14.1—V. 225), several brothel scenes (V. 223, V. 224, possibly V.
266), three *Bathshebas* (V. 252, V. 253, V. 255), two *Temptations of
St. Anthony* (V. 240, V. 241), and he painted over twenty versions of
Bathers. Later in his career, after abandoning narrative painting,
Cézanne created more than forty additional canvases on the *Bathers*
theme.

FIGURE 14.1. Paul Cézanne, *A Modern Olympia*, ca. 1872. Oil on canvas.
Musée d'Orsay, Paris.

In summary, Pissarro somehow succeeded in conveying to
Cézanne that he had best avoid the subject matter of his own bizarre
fantasies. In his series of *Bathers*, the painter learned to treat the
human figure as if it were an abstract element of the landscape (see
figure 14.2—V. 722). The emotional fervor that had characterized
Cézanne's early subject matter became focused in his mature work
on the formal aspects of his compositions. If the human figures in
these works seem reduced to the role of architectonic elements,
Cézanne's trees, hills, houses, or kitchen paraphernalia became
vibrant symbols of an anthropomorphic universe (figure 14.3—V.
600). This change of direction in midlife turned Cézanne from an
interesting eccentric into the seminal painter who ushered in the new
century. [17]

Starting with Meyer Schapiro, several historians have discerned
that, in Cézanne's mature art, the passion formerly implicit in sub-
ject matter flourishes, albeit under strict control, in the very *meth-
ods* he used to create the works. About Cézanne's still lifes in partic-
ular Schapiro writes: "[This] is a model world . . . carefully set up on
the isolating supporting table, like the table of the strategist who

mediates imaginary battles between the toy forces he has arranged on his variable terrain."[18] Schapiro rightly characterizes the still life as the depiction of perfectly submissive, manipulable objects, but his metaphor about the strategist applies equally well to Cézanne as a landscapist, portraitist, or painter of bathers. This is particularly noteworthy because each of these genres may be used metaphorically. Cézanne insisted that his human models pose "as still as an apple," and he required endless sittings in order to subordinate his perceptions of natural objects to his conceptions of form.[19]

Thus Cézanne, in his triumphant creativity, became the active *metteur-en-scène* of an ideal microcosm—an extraordinary contrast to his private fears of falling into passivity and bondage. His unique mode of perceiving, what he called his *sensations*, constituted an unprecedented attack on the spectator's customary ways of perceiving his surroundings. I conclude that it was this act of aesthetic

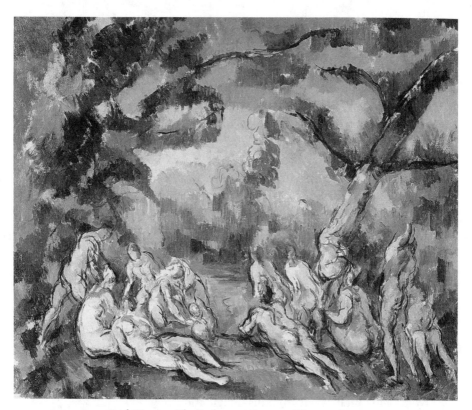

FIGURE 14.2. Paul Cézanne, *The Bathers*, 1900–1902. Oil on canvas. *Art Institute of Chicago, the Amy McCormick Memorial Collection, 1942.457.*

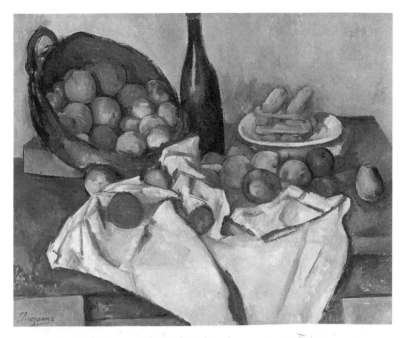

FIGURE 14.3. Paul Cézanne, *The Basket of Apples*, ca. 1895. Oil on canvas. *Art Institute of Chicago, Helen Birch Bartlett Memorial Collection, 1926.252.*

aggression that aroused the storm of opposition that Cézanne's art encountered for half a century. *The Battle of Love* turned into a struggle over alternative ways of seeing.

Thus Cézanne enhanced his creativity by externalizing his inner conflicts about control and aggression, transforming them into acts that compelled viewers to accept his unique vision. In this successful effort he deliberately eschewed dealing explicitly with the fantasies that had found their way into his poetry and paintings for more than twenty years. One way to describe this shift is to call it suppression of the artist's romantic excesses, in favor of an art that aspired to classical perfection by ordering a private universe filled with terrifying chaos (a form of creativity described by Gilbert Rose).[20] Clearly, such disorganization threatened Cézanne most acutely in certain human situations—probably those he characterized as people getting their hooks into him. It is therefore highly significant that Cézanne demanded absolute submission from his model whenever he worked on a portrait and that he painted his *Bathers* not from living models but from his imagination.

Many scholars have agreed that Cézanne's male bathers (a theme he painted in over thirty versions) deal with memories of adolescent

excursions with Zola and other friends to the banks of the river Arc, near Aix.[21] There are almost as many paintings of *Bathers* in which all the figures are female; in my judgment, this change in the sex of all protagonists merely disguises a bit further the personal significance of these scenes in terms of their creator's past experiences and fantasies.[22] In only a handful of versions of *Bathers* are male and female figures present together, and that sexual differentiation is equivocal even in these instances. The existence of sexually charged narrative themes in Cézanne's earlier work demonstrates that the artist used the theme of *Bathers* to deal with something other than male-female relations: when he wished to depict the latter, he was entirely explicit about that intention.

In terms of their manifest imagery, the *Bathers* offer little sexual appeal, despite the openly erotic situations they display for the viewer. I infer that this was precisely their function in Cézanne's own mental economy: by means of repetitively desexualizing situations charged with potential homosexual implications, the artist attempted to master temptations that had never been consciously acceptable for him. Because he was apparently successful in this psychological effort, Cézanne was enabled to remain productive despite his obsessive preoccupation with these disturbing possibilities.[23]

Only on rare occasions did overt homosexual imagery invade Cézanne's depictions (probably without his conscious awareness); Esman has noted that in *The Battle of Love* "the two nude figures grappling in the center of the composition are both unmistakably female." It is of interest that this painting is not usually classified as one of the *Bathers* series. Esman's conclusion, that the sexual segregation in that series is, in part, determined "by the pressure for gratification of . . . unconscious homosexual urgings" differs from my own—in my view, the *Bathers* invariably present an effective defense against acknowledgment of such urges. Esman reads Cézanne's late, classicizing versions of *Bathers* as depictions of figures isolated from each other, thus better serving a defensive function.[24] It is widely agreed that Cézanne's greatest achievements among the *Bathers* are the latest (and most classical) in the series. In my judgment, therefore, it is legitimate to assert that he was able to execute works of the highest order when neither the medium nor the subject matter impinged on his innermost world and its chaos.

Another way to put the matter is that latent homosexuality was not at the *center* of Cézanne's difficulties—if anything, it probably functioned as a safeguard against more disturbing (and more primitive) issues, like the propensity for violence against women, a predis-

position Cézanne also curbed by means of behavior that made him seem timid. In his early work, the painter gave vent to this violence not only through the narrative content of many works (listed above) but also by using techniques that have been rightly described as "brutal." Meyer Schapiro interpreted Cézanne's subsequent humility in dealing with his subject matter "as if in atonement for the violence of his early paintings," and Reff, writing about Cézanne's development of a systematic use of brush strokes, attributed this achievement to "an effort to master [his] turbulent impulses."[25]

If we look upon the violent, even murderous, themes of Cézanne's adolescent poetry, echoed in his early paintings, as the equivalent of the daydreams reported by psychoanalytic patients, we can only conclude that he was seriously troubled by murderous impulses, particularly toward women who had the power to arouse him sexually. It is certainly clear that Cézanne tended to confuse sexuality with aggression. The meager information we possess about the artist's childhood is congruent with these interpretations. The family maintained a tradition that Paul displayed severe temper tantrums, starting around the age of three. The artist's sister Marie was born when he was two, so that his rage reached this crescendo during her infancy. As a young child, he is reported to have admonished Marie to stay still lest he hit her hurtfully. Apparently this destructiveness was gradually mastered through inhibition, to such an extent that Marie became the dominant sibling. Paul became a docile child, and his sister is described as bossy, albeit protective toward him. During the last decade of Cézanne's life, he relied on her more than ever, and their relationship exactly replicated these childhood patterns.[26]

Such an intense conflict about sibling rivalry is insufficient, by itself, to explain Cézanne's later vulnerability and the self-imposed avoidance of intense involvements with most people. Clearly, something had gone radically wrong in the artist's upbringing. He was not only rageful as a child but also relatively helpless, so that the bossiness of others—whether Louis-Auguste, or Marie, or Emile Zola—was never entirely unwelcome to him, however he protested against it. He managed to arrange his life in a manner that literally never left him to his own devices. In other words, Cézanne was condemned to a symbiotic way of life that he simultaneously experienced as repugnant.[27]

In 1896 Cézanne wrote a young admirer, "I am not master of myself, a man who does not exist, and you try to be a philosopher who in the end will annihilate me altogether." It seems that Cézanne

felt in danger of losing his sense of personhood in the face of inaccurate (albeit favorable) descriptions of his achievements. It is possible that some aspects of the artist's fragility reflected an identification with his mother, who has been called "restless, passionate, and quick to take offense." In her old age she is said to have lapsed into "querulous senility."[28] When she died, Cézanne was overwhelmed with grief and was apparently unable to work for several months.

Despite the significance of such a permanent bond between Cézanne and his mother, the intensity of the artist's hostility to women and his fearfulness about their power to enslave him suggest that their *entente cordiale* must have been preceded by a time of troubles.[29] We simply do not know enough about Cézanne's childhood even to hazard speculations about the precise cause of these putative difficulties—as I have discussed in chapter 3, they may supervene simply because the future genius may be constitutionally so different from expectable norms that her childhood needs remain incomprehensible to the caretakers.

At any rate, Cézanne came out of his "prehistoric" childhood with a quasi-paranoid need to avoid women and a complementary propensity for passive longings in relation to men. The messy relationship with Hortense Fiquet and the bizarre affair with a servant girl only reinforce the conclusion that his relations with women were ambivalent, fearful, and passive. In *L'Oeuvre* Zola suggested that Lantier (the character modeled on Cézanne) lost interest in sexual relations soon after making the girl who posed for him his mistress; this may well have been what happened to Cézanne. In 1885, a year before Zola published his novel, the artist confided to him in a letter that he frequented the local bordello.[30] In other words, it was real intimacy Cézanne then needed to avoid, not sexual relations as such. The most likely explanation for this pattern of behavior is that Cézanne feared losing his independent volition in the context of affectionate contact with people. If this conjecture is valid, it follows that the murderous fantasies that emerged in the artist's poetry and paintings served to assure him that, in such a psychological emergency, he had the power to regain his autonomy through an act of violence.

If we review the paintings in which these emotional issues are most openly dealt with, it becomes apparent that the sexual power of women, seen as an irresistible *grappin*, forms the overt subject matter of the three versions of *The Temptation of St. Anthony* (v. 103, V. 240, V. 241), the two *Modern Olympias* (V. 106, V. 225), and *The Eternal Feminine* (V. 247), and a recently discovered *Lot and His*

Daughters (not in V.). Successful self-defense through violence is depicted in *The Rape* (V. 101), *The Murder* (V. 121), *The Strangled Woman* (V. 123), and the two versions of *The Battle of Love* (V. 379, V. 380). In the three versions of *Bathsheba* (V. 252, V. 253, V. 255) masculine vulnerability is somewhat mitigated by the royal status of the voyeur, David. In both versions of *Olympia* and in a more subdued *Idyll* (V. 104) the voyeur is portrayed as Paul Cézanne undisguised. These images convey in a powerful manner the artist's fear of his own propensity for falling into masochistic bondage.

This catastrophic predisposition was spelled out in a letter to Zola, written when Cézanne was twenty. Paul was then interested in a young seamstress whom he did not dare to approach. He reported the fantasy that the smoke of his cigar assumed the girl's form: "There she is, it is she; how she glides! She flutters, yes, it is my little girl. How she laughs at me! She flies through the eddies of smoke; look, look! She is going up, she is going down, she frolics, she turns over, but she laughs at me. Oh, Justine, at least tell me that you don't hate me! She laughs. Cruel girl, you enjoy making me suffer."[31] Unadulterated masochism could not be expressed more eloquently. Cézanne was undoubtedly fully justified in avoiding such situations as much as possible by isolating himself from women who could evoke his love.

From the psychological vantage point, then, we may postulate that Cézanne was able to develop his masterful late style through a tenacious struggle to overcome his emotional vulnerability. This triumph took place in two principal stages: first, the artist stopped enacting his problems on the stage of everyday life, confining these vulnerabilities to the narrative content of his early work; second, he eliminated even these vestiges of his difficulties from his artistic subject matter and poured his emotionality into the formal innovations that enabled him to create great art.[32]

PART FIVE

•

Conclusions

•

The Artist's Emotional World: Eugène Delacroix as Prototype

In previous chapters I have used the biographies of a wide range of creative persons to illustrate a variety of specific issues in the realm of emotional life (and its development), vectors that have some role in promoting or inhibiting creativity. Here, I should like to adopt the opposite strategy: to attempt to show, through the example of one great artist, the convergence of numerous significant issues, discussed in relative isolation elsewhere in this volume, as prime determinants of the creative process. As my prototype for the creative personality, I have chosen Eugène Delacroix (1798–1863), the outstanding exemplar of Romanticism in French painting and progenitor of the Parisian avant-garde that created modernism in art.

The conclusion that Delacroix is an ideal representative of the Artist is scarcely new: as early as 1842, when he was in mid-career, the painter became the hero of Balzac's roman à clef, *The Black Sheep (La Rabouilleuse),* where he is described—only lightly disguised—as a man utterly absorbed in his art, in a way that completely armors him against the vicissitudes of life. He is entirely calm in the face of mortal dangers—as Delacroix seemed to be about the lifelong tuberculosis that ultimately killed him. Balzac's hero has an unshakable certainty about himself, his greatness, and his destiny—a reflection of the author's admiration for Delacroix's boldness in defying the conservative artistic establishment almost single-handedly.[1] No

doubt, this fictive portrait is something of a Romantic exaggeration, but that does not diminish the significance of Delacroix having been singled out in his lifetime as an ideal prototype.

Actually, Delacroix had good reason to feel that the summits of artistic achievement should be accessible to him, for he was descended from one of the greatest artistic figures of the eighteenth century. His mother was born Victoire Oeben; she was the daughter of Jean-François Oeben, the leading cabinetmaker of the court of Louis XV. Oeben died relatively young, in 1763, and his widow then married his successor as the outstanding *maître-ébéniste* (master cabinetmaker), Jean-Henri Riesener, whose work reached its highest standard during the reign of Louis XVI. Riesener did not die until 1806, so that the child Delacroix also had the inspiring living example of this great family figure available to him. Moreover, Victoire's half brother, Henri-François Riesener, became a distinguished painter, in mid-career when Eugène was born.

Although the artist never gave any indication that he had any doubts about his paternity, it was universally believed that he could not have been a legitimate child. His putative father, Charles Delacroix, was foreign minister in the government of the Directorate of the late 1790s, so that his activities were very much in the public eye. Thus it was common knowledge that, at the time Eugène was conceived, Charles Delacroix was suffering from a testicular tumor that had grown enormous, so that in contemporary newspapers the minister was caricatured as a pregnant woman. Even the removal of this tumor was widely reported—both because its success constituted a surgical breakthrough and because during the operation Charles Delacroix conducted himself with conspicuous bravery.

Some months before Eugène's conception, Charles lost his position as foreign minister and was sent to Amsterdam as ambassador to Holland. His successor at the ministry was the celebrated statesman Talleyrand, who graciously permitted Mme. Delacroix to continue to reside on the premises. Consequently, it was widely assumed that Talleyrand must have been Eugène Delacroix's natural father, although there is no actual evidence for this appealing conjecture. There is no way to know what the artist really thought about his paternity, but he had every reason to believe that it was extremely distinguished, whichever version of the story he favored. In adult life, Delacroix rigidly adhered to the proprieties by keeping on the best of terms with his official paternal relatives in Lorraine and Champagne.[2]

In December 1799, Napoleon came to power and Charles Delacroix became a staunch supporter of his regime. He was rewarded by appointment as the prefect of Marseille (later of Bordeaux). A Napoleonic prefect had absolute authority in the region under his supervision; in other words, as Eugène Delacroix was becoming aware of his position in the world, he learned to see himself as a scion of the great and the powerful. Whether Delacroix's peerless connections included the covert support of Talleyrand is unclear; it is certain, however, that even after Charles Delacroix's death in 1806, when the future artist was barely eight years old, the family enjoyed the special favor of the Bonapartes. Eugène's older brothers were officers in Napoleon's army; one was killed during the victorious 1809 campaign against Prussia (this glamorous captain of dragoons was Eugène's childhood hero), but the eldest, Charles Henri, attained the rank of general before Napoleon was finally ousted. He was so loyal to Bonaparte that he refused to serve under the restored Bourbon dynasty; his decision led the entire family into political opposition, but it solidified the support they were to receive from the Bonapartist faction, which remained strong for generations. Interestingly, these political nuances are accurately depicted in *The Black Sheep*—Balzac's inside information about Charles Henri was as detailed as it was about Eugène.

Delacroix also had an older sister, Henriette. All three of his siblings were almost twenty years older than Eugène, so that Henriette was already married during his infancy. Jacques-Louis David's 1799 portrait of her, as *Mme. de Verninac*, is one of the glories of the Louvre (figure 15.1). Eugène grew up with this family treasure; it meant so much to him that when, after Henriette's death, her irresponsible son sold it, Delacroix purchased the painting, and it hung in his bedroom until he died. No doubt it was the memento of a beloved sister and a relic of his own childhood, but it also represented Delacroix's early commitment to the art of painting and his reverence for the proud traditions of French art.

Delacroix's mother apparently led a life of sexual irregularity; after her husband's death, she engaged openly in an affair with a General Cervoni. To permit her to join Cervoni in Marseille, Victoire placed Eugène in a boarding school, although she returned to Paris after Cervoni's death in battle, in 1809. Some scholars believe that Cervoni may have been Eugène's father.[3] At any rate, the care of this child of Mme. Delacroix's middle age was from the first largely entrusted to nursemaids—an expectable circumstance in the family's

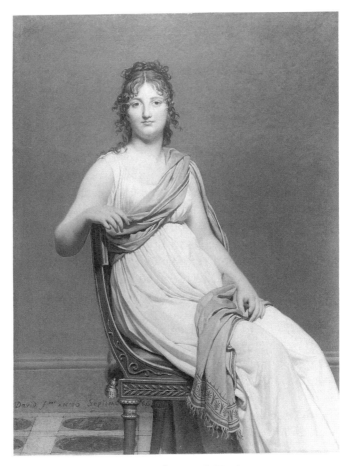

FIGURE 15.1. Jacques-Louis David, *Mme. de Verninac*, 1797.
Oil on canvas. *Louvre, Paris.*

social circles. This combination of events had a decisive influence on
the artist's character and oeuvre, as I shall attempt to show. In terms
of their immediate impact on the child, we possess only a few scraps
of evidence. In adult life, Delacroix repeated an anecdote suggesting
that his ambitions were kindled by these difficult circumstances: he
recalled being taken for a walk by his nursemaid and encountering a
madman who prophesied, "This child will become a great man and he
will know great anguish and make his mark in history." Such "screen
memories," which sum up important personal issues in one dramatic
scenario, are almost obligatory components of the personal myth
great artists often weave about themselves.[4] Another aspect of
Delacroix's myth was a series of memories of having been placed in
life-threatening situations through the negligence of his caretakers.

Despite his highly cavalier upbringing, Delacroix remained closely attached to every member of his family. Thus, after his older brother, the general, married a servant- girl, the artist was the only relative who did not sever relations with him. Delacroix's mother died of consumption when Eugène was sixteen years of age. In a poignant letter written three years later, the young artist graphically described his despairing inability to reconcile himself to his loss: "Even now, [I] cannot grasp the fact of my loneliness: I look around me in search of that which vanished so swiftly, and I lost my mother without repaying her for what she suffered on my behalf and for her kind love for me. . . . I was too young to show her, at every moment, how much I loved her!"[5]

Shortly after his mother's death, Delacroix (an excellent scholar) finished his classical education at the Lycée Louis le Grand. With the help of Henri Riesener, he entered the Ecole des Beaux Arts and became a student of Pierre-Narcisse Guérin, one of David's most prominent followers. (Some months earlier, in the wake of Waterloo, David himself had to go into exile, so that Delacroix's placement with Guérin constituted the very best training available at the time.) It was in Guérin's studio that the adolescent met the mentor whose influence pulled him into the Romantic movement, the painter Théodore Géricault (1791–1824), who had also preceded him at the Lycée Louis le Grand. (The families happened to live only a few doors apart on the rue de l'Université.) In the fall of 1817 the older artist had just returned from a year's study in Italy.[6] Delacroix participated in Géricault's heroic enterprise, the enormous revolutionary painting *The Raft of the Medusa*, by posing for one of the protagonists. Four decades later he wrote in his journal that Géricault's power, vigor, and audacity were qualities missing even in David (the *chef d'école* of the previous era).[7]

In 1819 Géricault passed on a commission for an altarpiece to his younger colleague: the arrangement was made in secret and the painting (now in Ajaccio Cathedral) is signed "Géricault." (It is difficult to differentiate for which of these young men the secret sharing was more important!) What the relationship must have meant to Delacroix might be inferred from numerous references in his correspondence to his great loneliness. For instance, "Tears spring to my eyes when I think of my loneliness, and on the other hand of all those who have shown some fondness for me. I am only happy, completely happy when I am with a friend. . . . This is no exaggeration; all is empty around me without the presence of the one I love."[8] This condition represented the emotional scars left by his caretakers'

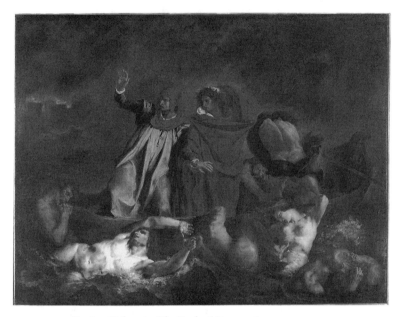

FIGURE 15.2. Eugène Delacroix, *The Bark of Dante*, 1822.
Oil on canvas. *Louvre, Paris.*

negligence, the wounds that Delacroix also encoded in his screen
memories of exposure to mortal dangers. The theme of the lonely
artist was to form one recurrent subject in Delacroix's art, for
instance in two paintings of the great poet Torquato Tasso, impris-
oned in a madhouse (R. 88, R. 199).[9]

Géricault spent most of 1820 and 1821 in England; when he
returned to Paris, his health was already gravely impaired, and his
steady downhill course ended in death, scarcely two years later.
Although the loss of his friend hit Delacroix extremely hard, it did
not interfere with his productivity. In the latter half of 1821,
Delacroix had begun work on his first masterpiece, *The Bark of
Dante* (figure 15.2), exhibited at the Salon of 1822 and immediately
acquired by the French state. Not only did Géricault respond favor-
ably to this painting; important heirs of David, such as Gérard and
Gros, were also positively impressed. (Gros may have been the first
to note the derivation of Delacroix's style from that of Rubens, a
connection that became more and more overt as Delacroix gained
confidence in his art.) This success also brought the influential critic
Adolphe Thiers into the circle of Delacroix's supporters. Delacroix's
connection to Thiers proved to be of inestimable value, because in
1830 (after the overthrow of the Bourbons) Thiers became minister
of public works and during his tenure gave Delacroix the cream of

the great public commissions. The novelist Henri Beyle (Stendhal) was another recruit to the young artist's cause. Thenceforth, only his periodic debilitation by tuberculosis interfered with Delacroix's creativity. (He suffered his first serious attack of fever and hemoptysis in September 1820.)

This rapid success in establishing a distinguished career was all the more amazing in view of the fact that, shortly after his mother's death, the adolescent artist was left quite alone in Paris. Moreover, he was expected to act as the custodian of the family apartment and to keep an eye on his sister's son, who was only two years his junior. It is of some relevance that Charles Delacroix had shown preference for this grandson over Eugène. In financial terms, his mother did not leave the future artist well off, and his brother-in-law soon wasted the family's capital through unwise investments. Clearly, Eugène had the capacity to summon to his aid memories of those he loved— as he recounted in the letter already cited.

In September 1822, upon learning that the state had purchased *The Bark of Dante*, Delacroix began his journal. In his second entry, he noted that he had launched this enterprise on the eighth anniversary of his mother's death. This association suggests that the theme of Dante's visit to the inferno, which constitutes an echo of book 11 of the *Odyssey* (recounting how Odysseus descends to Hades to encounter his mother's spirit), was a choice partly dictated by an unresolved process of mourning. It is significant that the episode from Dante depicted in the painting is the visit to the city of Dis, where the wrathful suffer eternal torment. Delacroix had good reason to be enraged as a result of his relations with his family, however effectively he managed to disavow his grievances against them. We should therefore credit the artist's statement as an older man that, as a child, he had been a "monster."[10]

Many of the artist's greatest works deal with the sadistic mistreatment of women, albeit generally within a historical or literary context, such as *Massacre at Scio* of 1824, *Greece on the Ruins of Missolonghi* of 1827—both commemorating atrocities during the Greek War of Independence—or *The Death of Sardanapalus*, also 1827, and *Rape of Rebecca by the Templar Bois-Guilbert* of 1846, after Byron and Walter Scott. It has been suggested that Delacroix's numerous depictions of lions and tigers are covert self-representations. At the very least, the lion was the painter's totemic figure, as the bull came to be for Picasso. Some contemporaries characterized Delacroix as feline, a designation suggesting that the artist had to wage a constant struggle against his own

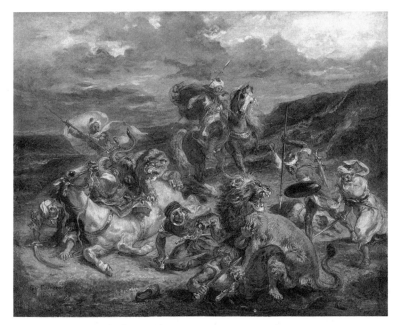

FIGURE 15.3. Eugène Delacroix, *Lion Hunt,* 1860–1861. Oil on canvas.
Art Institute of Chicago, Potter Palmer Collection, 1922.404.

ferocity. His several great versions of *Lion Hunt* (figure 15.3 is
that of 1861, which was the last) are allegorical representations of
the triumph of civilization over savagery. Yet this was also the
story of this artist's inner life.[11]

On the stage of everyday life, the young Delacroix enacted his
misogyny through a promiscuous *vie de Bohème,* including noto-
rious orgies, recorded in his journals with entries in Italian! In 1819
he abandoned a young woman he had impregnated. In the mid-
1820s he had a lengthier affair with a woman of greater substance,
but she was somewhat older and he grew tired of her. Thereupon he
packed her off to Algiers, where she was to become a teacher of
drawing. After his sister died of consumption in 1827, Delacroix
moderated his youthful excesses, although in none of his extant
writings does he indicate his awareness in any way that his very life
depended on conserving his strength. A high erotic charge had
characterized many of Delacroix's paintings, especially his steamy
nudes (see R. 106, R. 139, R. 140, R. 175, R. 383), but he did not
return to this theme as frequently after 1827. All this, as well as
Delacroix's unusual sexual excitability well into adulthood, sug-
gests that as a child Eugène had been well aware of his mother's
sexual conduct and that part of his wrathfulness was a reaction to

having been sexually overstimulated and (simultaneously) frustrated. That Delacroix was keenly cognizant of jealousy and sexual rivalry is made explicit by his passionate depictions of men fighting for possession of a woman, such as the *Combat Between the Giaour and the Pasha* of 1826 (figure 15.4).

Henriette's death seemingly reopened the wound of the artist's incomplete mourning for his mother. Most authorities believe that the deathbed portrait Delacroix painted (R. 1311) represents Henriette and was probably begun at the time she died. A probable connection between Delacroix's work of mourning and the evolution of his *Massacre at Scio* has been noted: the definitive version prominently features a dead mother whose living child is trying to nurse at her breast; preliminary sketches show this woman alive, even giving suck to her baby. The change suggests the artist's preoccupation with having been deprived of maternal care. On the same theme Delacroix painted two poignant canvases of *Orphan Girl in a Cemetery* (R. 66 and 67); although the loss and grief are displaced to

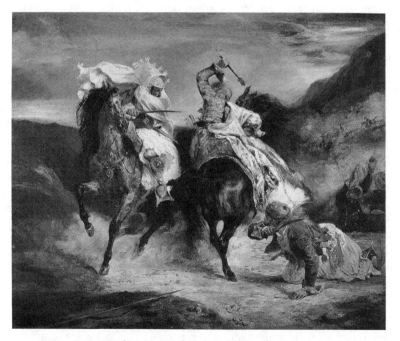

FIGURE 15.4. Eugène Delacroix, *Combat Between the Giaour and the Pasha*, 1826. Oil on canvas. *Art Institute of Chicago. Gift of Mrs. Bertha Palmer Thorne, Mrs. Rose Movius Palmer, Mr. and Mrs. Arthur M. Wood, Mr. and Mrs. Gordon Palmer, 1962.966.*

a young woman, these works of circa 1823–1824 clearly indicate the artist's empathy for the bereaved.[12]

In the late 1820s Delacroix produced a series of large history paintings, culminating in 1830 with *Liberty Leading the People*, which celebrates the overthrow of the Bourbons on July 28 of that year.[13] This immense canvas has become the most celebrated icon of modern France—for many years it was hung at the head of the great staircase of the Louvre, sharing this place of honor with the *Victory of Samothrace*. (It is reproduced on the current one hundred franc note.) Of course, it also marked the passage of Delacroix from political opposition to the status of the painter most favored by the successor regime of Louis-Philippe. In my judgment, Delacroix was the last painter in Europe who had the ability to infuse history paintings with conviction, probably because he could feel genuinely identified with their great protagonists: he was not merely descended from a great artist—after all, Charles Delacroix had been one of the regicide deputies who, in January 1793, voted to execute Louis XVI, and Talleyrand was one of the statesmen who at the Congress of Vienna created nineteenth-century Europe. It is also worth noting that Delacroix's religious paintings are equally convincing (see R. 176, 181, 602, 768, 986, 995, 1034, 1219, 1377, and the fresco cycle in the church of St. Sulpice, R. 1339–1345, for example), despite the artist's lack of overt religiosity.[14]

The watershed event in Delacroix's life was his decision late in 1831 to accompany in an official capacity a diplomatic mission to Morocco. His observations and sketches of this romantic journey of six months provided him with the predominant orientalizing subject matter of a career that lasted thirty years longer, such as *Women of Algiers in Their Harem* of 1834 or the many versions of *Lion Hunt*. Shortly after his return to Paris, the thirty-year-old artist reorganized his life into the pattern that was to remain unaltered until his death. Toward the end of 1833 he began an affair with a distant cousin, the Baroness de Forget, a married woman who had only shortly before given birth to an illegitimate child. The parallels between her and the painter's mother need not be belabored. Although their intimacy endured, Delacroix always kept a greater distance between them than Mme. de Forget desired. When in the later 1830s her husband died, she seemingly wanted to marry the artist, but he resolutely remained a bachelor. Of course, the affair with this cousin was neither the first nor the last of Delacroix's liaisons with married women.

Concurrently with this romantic liaison, Delacroix hired a Breton

servant, Jenny le Guillou, to be his housekeeper. It is not known whether he had sexual relations with this loyal retainer, but she was his confidante and a fierce protector of his privacy and health. (One of the persons she kept away much of the time was the foremost admirer of Delacroix's later years, the great poet and critic Baudelaire.) With this splitting of erotic from caretaking functions between separate women, Delacroix stabilized his emotional life. Although Mme. de Forget's promiscuous tendencies no doubt provoked the artist's jealousy, he was able to maintain his equilibrium and their relationship because he never allowed himself to depend on her. Perhaps the reliable Jenny recreated for the artist a dependable relationship with one of his childhood nursemaids,[15]—perhaps her stable affection was an experience unprecedented in his life. In either case, these arrangements permitted Delacroix to focus more and more single-mindedly on his art. Outwardly, he seemed to embrace solitude, gradually withdrawing from the active social life that characterized his youth. Of course, he did continue a few friendships with artists he respected, like the sculptor Barye, the composer Chopin, the poet Baudelaire, and the novelist George Sand, but as he aged, Delacroix became almost unapproachable.

Through these prudent adaptive measures, Delacroix kept his earlier vulnerability under control. His youthful complaints about loneliness and feeling empty disappeared. The artist was explicit in pinpointing that he forestalled such problems through his creativity: with a project in mind, working at his easel, or confronted with a wall to be painted, he was *full*—or fulfilled. By implication, he was in equilibrium because he was successful in living out the childhood prophecy that he would become a great man. Contemporary observers, like Théophile Gautier, noted his regal bearing—because of the artist's swarthy complexion, Gautier called Delacroix a maharaja with the manners of an English gentleman.[16]

The most impressive testimony about the Olympian impression Delacroix made in his maturity was that of Odilon Redon, one of the greater artists of the next generation and one favored by Delacroix. When they attended a soiree together, Redon did not dare to accompany the older artist when he was leaving. The aloof Delacroix proceeded to take a solitary nocturnal walk through Paris, and Redon trailed behind him for hours, in silent homage.[17] In my judgment, these outward changes in the artist's adaptation reflected a consolidation of his inner life as well. Perhaps the clearest evidence for this improvement is the newfound ability of the painter successfully to tackle the theme of the abuse of young children by their mothers—

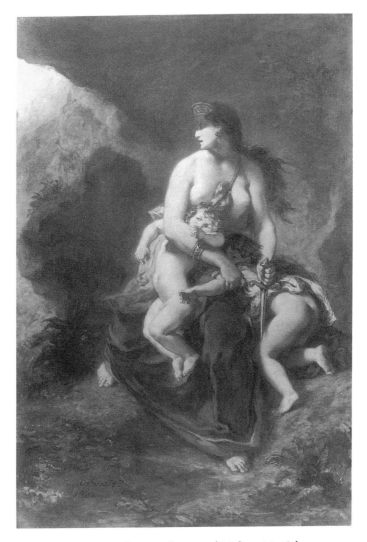

FIGURE 15.5. Eugène Delacroix, *The Fury of Medea*, 1862. Oil on canvas, *Louvre, Paris.*

subject matter that had long preoccupied him. In five versions (R. 667, 668, 1503, 1436, and 1437) of *The Fury of Medea* (figure 15.5), spanning the years between 1838 and 1862, Delacroix portrayed his mistreatment as a child in terms of a mother as infanticidal monster. In these works not only does Delacroix depict an aggrieved woman as a murderous witch; he also gives us a hint about his quasi-mythic conception of his own origins through his pictorial metaphor, for both Jason and Medea had gods among their progenitors![18]

In parallel with the foregoing developments, Delacroix resumed

work on his journal, which he had abandoned in 1832. For the last fifteen years of his life, the artist steadily kept up this literary activity, producing a vast compendium on the nature of art, creativity, aesthetics, and the human spirit as well as current events and relationships. As he grew older, Delacroix became more confident about asserting his own greatness. By the mid-1850s the journal was clearly addressed to posterity, and even the greatest predecessors—those he most honored—such as Michelangelo, Rubens, or Géricault, are discussed as his own peers, from a critical vantage point. In 1855 he indicated his agreement with the famous dictum of Molière, "I have had enough of these models; from now on I look within me and about me." Delacroix added, "I am striking off the last of the chains that bound me." And in October 1862, "God is within us. He is the inner presence that causes us to admire the beautiful."[19] But such an inner voice spoke more clearly to Eugène Delacroix than to any of his contemporaries.

I trust that even this condensed résumé of Delacroix's biography may suffice to underscore the importance for his fate as a creative person of many topics singled out in previous chapters. Perhaps the most obviously cogent among these issues was the healing effect of the painter's creative achievements on a personality rendered vulnerable to losses and disappointments by less than satisfactory family relations in childhood.

Both the taint of illegitimacy and the irregularities of his mother's sexual behavior threatened to undermine Eugène's self-esteem until he succeeded in proving his worth as at least the equal of his distinguished grandfather and stepgrandfather. (The opportunity to identify with family members active in the domain of the arts facilitated Delacroix's commitment to his vocation.) Prior to his triumph as an artist, the child Delacroix boosted his self-esteem through grandiose fantasies (such as the "prophecy" of his future greatness) and an unusual form of imposture, that of maintaining, contrary to incontrovertible evidence, that his birth was legitimate. He also seems to have formed the illusion that being the victim of actual misfortune is the harbinger of future greatness—a creative fantasy that apparently helped him to accept his lengthy struggle against tuberculosis with unusual equanimity. In his late adolescence, when his mother died, Delacroix's letters reveal emotional vicissitudes often encountered in young people heading for a life of chronic depression or addiction. But this youngster was saved from such a destiny by the ease of adhering to the tradition of his mater-

nal forebears, Oeben and the Rieseners, of making art at the highest levels of ambition. The early recognition of his great talent, facilitated by his family connections, repaired whatever wounds his self-esteem had suffered through his dubious paternity and the continuing sexual unconventionality of his mother. Thus Delacroix's adolescent crisis proved not to be a harbinger of psychopathology but a sign of the creative reorganization of his personality. The most important feature of this new identity was the absolute priority accorded to his artistic vocation.

Next in importance, in my judgment, was the availability for the young artist of a series of idealized models: the grandfather(s) who were enshrined as artistic luminaries of the old regime, the great painters of the Napoleonic era who portrayed family members or became Delacroix's actual instructors, the older halfbrothers who served as exemplars of courage and commitment, and, most significant of all, the mentor who pioneered the way Delacroix was to follow, Théodore Géricault. The collaborative relationship of these young revolutionaries when Delacroix was in his early twenty's gave him essential support before his first public success at twenty-four. And the intellectual and artistic milieu of Paris, in Delacroix's lifetime still *the* European metropolis, provided him with invaluable stimulation through contact with creative personalities in other fields, such as Victor Hugo, Alfred de Musset, or Hector Berlioz, in addition to those previously mentioned.

At the very start of Delacroix's career, Géricault was literally his secret sharer; it is not entirely clear whether he ever made similar use of his later associates. It is certain, on the basis of his well-documented biography, that Delacroix was extraordinarily skilled in enlisting a variety of people as a team of helpers to facilitate his creative life. The devotion of his servant, Jenny, his mistress, Mme. de Forget, the critic and patron, Thiers, and artistic peers such as Stendhal and Baudelaire attests to his capacity to inspire loyalty, his excellent judgment about human character, and his ability to accept assistance. At the same time, Delacroix had the ability to bear artistic isolation: after the death of Géricault, he waged war against the official artistic establishment, essentially for the rest of his life.

There can be little doubt that Delacroix's "love affair" with his artistic vocation gradually displaced his great need for human affection, so that he appeared to become more and more solitary. At the same time, he never withdrew from a few essential relationships that provided him with unconditional acceptance. In addition to these stable human attachments, the artist seemed to have mastered

his residual emotional problems by repeatedly portraying their solution in the subject matter of his work—for instance, in dealing with loss and bereavement, with overcoming aggression and savagery, or with the parental abuse of small children. In this sense his artistic efforts can be construed in terms of reparation for his ferocity as well as a triumph of order over chaos.

For more than forty years, Delacroix had an ultimately losing struggle with tuberculosis, and on several occasions his periodic relapses prevented him from painting for variable periods. He was able to adapt to these obstacles to his productivity without untoward emotional consequences because his creativity was not confined to a single medium. Not only was his output of drawings prodigious (and he kept up this activity even when he was forced to take lengthy rest cures in country locations), in addition, he gradually increased his productivity as a serious writer. Although the journal is the best-known and most extensive of his literary efforts, he also published a considerable body of criticism. Thus he was always in a position to switch his creative efforts to domains that did not overstrain his physical resources.

The case of Delacroix also demonstrates that the originality of a creative artist often brings with it relegation to a minority that incurs hostility and discrimination. Although Delacroix received governmental encouragement even under the Bourbons, and this official support increased under the aegis of Thiers, to reach its flood tide after 1848 when the Bonapartists recaptured state power, this patronage (and civic honors like nomination to be an officer of the *Légion d'Honneur*) were not paralleled by recognition from the painter's artistic colleagues. Ever courageous, like his brothers, Delacroix repeatedly applied for election to the Académie Française but was only admitted on his *eighth* attempt, in 1857. By contrast, his great rival, Ingres (1780–1867), was elected on his first attempt, in 1825. While Delacroix's entries at the official exhibitions, the salons, always received some critical support, the majority of critics forever remained hostile. Apparently the vicissitudes of his early life inured the artist against such assaults on his self-esteem.

Further, the instance of Delacroix demonstrates the overriding importance of the qualities of personality organization (what psychoanalysts often call "character structure") for creativity. To have been able to wage a lonely struggle for several decades to overcome the prevalent prejudices of the French artistic world against what it termed "Rubéniste" painting, Delacroix needed unshakable self-confidence, unusually keen ambition, great social savoir faire, and

the ability to invest himself emotionally in his creative work in preference to any other commitments.

Moreover, Delacroix's temperament was specifically suited to the depiction of the subject matter we now designate as "Romantic" (witness his lithographs illustrating *Hamlet* or *Faust*, his paintings of North Africa or the Greek War of Independence, his depictions of great cats, and so on). He was predisposed to such interests by the erotic atmosphere of his childhood as well as the example of his glamorous older brothers; his emotionally charged approach to this subject matter was but a reflection of his intense personal emotionality. Naturally, his great inborn talent as a colorist made it possible for the artist to render these dramatic scenes in the tradition of Rubens and his great Venetian predecessors. It seems likely, however, that such a constitutional gift had been promoted into usable capacities by childhood vicissitudes that did not inhibit the experience of a full range of emotions. Delacroix was keenly aware that his ambition had been stimulated by the injuries to self-esteem he had suffered in childhood—in this respect, he compared himself to the club-footed Lord Byron.[20] In old age, he wrote in the journal, "I am a happy man after all . . . like those trees that grow in poor soil, where they grow slowly and with difficulty, and whose branches are twisted and knotty."[21]

Unfortunately, we have no detailed information about the behavior of the child Delacroix, so that there is no way to determine whether what he experienced as an upbringing that exposed him to mortal risk was truly negligent or merely unable to cope with a child of exceptional difficulty. We may be sure, however, about the future artist's superior endowments: not only was he an excellent student at an elite school (a circumstance rather unusual for a future practitioner of painting)—his adolescent letters also reveal linguistic talent of a high order and his mature critical writings attest to his great cognitive skills.

Vir heroicus sublimis: a man of heroic and sublime virtues.

CHAPTER SIXTEEN

•

Psychoanalytic Contributions to Creativity Studies

On Native Endowment and the Formation of Character

The focus of this monograph differs from that of previous psychoanalytic writings on creativity in giving priority to the fact that, whatever the *sources* of creative behavior may be, in an immediate context every human action must necessarily reflect those structured psychological dispositions we call personality or character. I have attempted to survey the characterological attributes that seem to be prerequisites for significant creative accomplishments of whatever kind (chapter 2) and to illustrate most of these through the example of Eugène Delacroix (chapter 15). Conversely, I have also provided several illustrative instances of particular attributes that permit successful responses to specific creative opportunities (chapters 12–14). In chapters 3–5 I reviewed the manner in which unusual constitutional endowments may lead to the crystallization of special talents through fortunate nurture; the other side of the same coin is the difficulty of raising children who are constitutionally atypical with respect to having special endowments—a challenge that defeats many families and often leads to characterological vulnerabilities in the unusual child.

These legacies of an atypical childhood predispose persons who possess creative gifts to an incidence of psychopathology perhaps greater than that of the general population, especially in the realm

of self-esteem regulation. However, such a conclusion does not imply that creativity is a *function* of such pathology (see chapter 8). On the contrary (as I discuss in chapter 7), creative success often makes it possible to overcome emotional difficulties, even if they have their genesis in problems unconnected to either the creative life or to matters we usually classify as essentially "psychological" (for instance, somatic illness). Any interference with continuing creative accomplishments can prove to be a trigger for serious deterioration in adaptation (see chapter 9, and, for the special case of psychoses, chapter 10). At the same time, commitment to creative endeavors constitutes a challenge of considerable magnitude, one that may overburden a vulnerable personality and lead to psychopathological developments, as described in chapter 6. In some cases, the creative challenge can only be met insofar as the psychopathology is walled off and kept apart from the subject matter of the creative work (see chapter 11).

The foregoing hypotheses about "creative personalities" depart radically from the views prevalent in the psychoanalytic literature, the most significant of which are summarized in chapter 1 and are further discussed at various appropriate junctures in this volume. What I wish to emphasize here once again is that the question of personality (including the vicissitudes of its formation in specially endowed children) is the decisive one in facilitating or standing in the way of all creative ambitions.

The Prospect Before Us

The development of the psychoanalytic theory of creativity outlined in this book implies that the area of our most significant uncertainty, and, therefore, the most urgent investigative task before us, does not lie within the research domain of clinical psychoanalysis. Priority in creativity research should go to attempts to correlate various types of early experience with the development of unusual cognitive (especially perceptual) abilities. These extraordinary skills, possessed by persons who have major creative accomplishments to their credit, will have to be studied through the methods of cognitive psychology and brain science.

Psychoanalysis should, however, be able to make major contributions to this field by engaging in further comparative studies of the *personality types* most suited to various distinctive creative endeavors. The focus of such investigations should differ from that of previous psychoanalytic writings on creativity in giving priority to

those structured psychological dispositions we call character. In this volume I have attempted both to survey those characterological attributes that seem to be prerequisites for significant creative accomplishments in general and to provide numerous illustrative instances of particular attributes that permit successful responses to specific creative opportunities. I have also reviewed the manner in which fortunate nurture may lead to the crystallization of special talents or to characterological vulnerabilities whenever the parents are unable to cope with the special needs of a child who possesses unusual constitutional endowments.

Understanding the similarities and the differences in personality among creative people of various types will undergo progressive refinement if the clinical theories of psychoanalysis continue their progressive evolution. In the one hundred years since Freud launched the psychoanalytic enterprise, our understanding of human psychological vicissitudes has been immensely broadened and deepened with the advent of every new generation within the discipline, and there is every reason to hope that psychoanalysis will maintain this vitality as it heads into the twenty-first century.

NOTES

●

1. Creativity and Its Psychoanalytic Conceptualizations

1. I have discussed the contrast between the creativity that contributes to high culture and the creativity of everyday life in the epilogue of my *Portraits of the Artist*, pbk. ed. (Hillsdale, N.J.: Analytic, 1989).

2. Biographical data about Gorky are scattered in various sources. I have relied on D. Waldman, *Arshile Gorky* (New York: Abrams, 1980); H. Rand, *Arshile Gorky: The Implications of Symbols* (Montclair, N.J.: Allanheld and Schram, 1981); M. Lader, *Gorky* (New York: Abbeville Press, 1985); and L. Corvin, "Toward Armenia: Notes of a Journey," in *Arshile Gorky, 1904–1948* (London: Trustees of the Whitechapel Art Gallery, 1990), pp. 160–183; and M. Auping, *Arshile Gorky* (Fort Worth: Modern Art Museum of Fort Worth and Rizzoli, 1995). For Graham, see E. Green, *John Graham: Artist and Avatar* (Washington: Phillips Collection, 1982).

3. The concept of the personal myth was proposed by Ernst Kris in 1956. See "The Personal Myth: A Problem in Psychoanalytic Technique." In E. Kris, *Selected Papers* (New Haven: Yale University Press, 1975), pp. 272–300.

4. Freud initially postulated such a hypothesis in a letter to his scientific mentor, Joseph Breuer; this has been published as "Sketches for the 'Preliminary Communication' of 1893," *Standard Edition*, 1:147–156 (London: Hogarth Press, 1966).

This hypothesis was elaborated in a draft of 1895, unpublished in Freud's lifetime, known as the "Project for a Scientific Psychology," *Standard Edition*, 1:283–397. Perhaps the clearest statements of the hypothesis were Freud's 1915 paper "The Unconscious," *Standard Edition*, 14:166–204, and part 4 of the 1923 monograph "The Ego and the Id," *Standard Edition*, 19:3–66 (1961). Freud's last restatement of the hypothesis occurred in a posthumous publication, "An Outline of Psychoanalysis," *Standard Edition*, 23:141–207 (1964)—see especially p. 163.

5. The first restatement, in response to a searching critique by C. G. Jung, occurred in 1914. See S. Freud, "On Narcissism: An Introduction," *Standard Edition*, 14:67–102 (1957). In 1920 Freud proposed a more radical revision in "Beyond the Pleasure Principle," *Standard Edition*, 18:3–64 (1955). For the ultimate elaboration of drive theory, see H. Hartmann, "Comments on the Psychoanalytic Theory of Instinctual Drives," in *Essays in Ego Psychology* (New York: International Universities Press, 1964), pp. 69–89.

6. Freud introduced the concept of sublimation in 1905, in "Three Essays on the Theory of Sexuality," *Standard Edition*, 7:125–243 (1953), and gave it a more precise definition in "The Ego and the Id." The definitive statement of the hypothesis was H. Hartmann's "Notes on the Theory of Sublimation," in *Essays in Ego Psychology*, pp. 215–240.

7. S. Freud, "Creative Writers and Daydreaming." *Standard Edition*, 9:142–156 (1959).

8. The theoretical revision was articulated in Freud's "The Ego and the Id."

9. Kris's interdisciplinary works were collected in the volume *Psychoanalytic Explorations in Art* (New York: International Universities Press, 1952). For Kris's theoretical work, see his *Selected Papers* (New Haven: Yale University Press, 1975); and H. Hartmann, E. Kris, and R. Lowenstein, *Papers on Psychoanalytic Psychology* (New York: International Universities Press, 1964).

10. Kleinian authors (see note 19, chapter 7 for specific references) have managed to coin a new hypothesis to account for creativity on the basis of drive psychology: they have postulated that in creative activities libido may be used to overcome aggression (past and/or potential in the future). This notion has been summed up through designation as "reparation." Lacan never discussed creativity, but he did make a critique of Freud's theory of sublimation. This seminar of 1959–1960, "L'Ethique de la psychoanalyse," was published in 1986 (Paris: Seuil).

11. See P. Greenacre, "Studies in Creativity," in P. Greenacre, *Emotional Growth*, 2:399–615 (New York: International Universities Press, 1971). This section on creativity in Greenacre's collection of her best papers discusses many issues beyond the matter of sublimation, notably the childhood of creative persons and women as artists.

12. See also L. Kubie, "The Fallacious Misuse of the Concept of Sublimation," *Psychoanalytic Quarterly*, 31:73–79; and H. B. Levey (Lee) "A Critique of the Theory of Sublimation," *Psychiatry*, 2:239–270. Kris stated this most explicitly in the section on "Creation and Re-creation" in *Psychoanalytic Explorations in Art*, pp. 56–63.

13. K. R. Eissler, "Psychopathology and Creativity," *American Imago*, 24:35–81.

14. J. Coltrera, "On the Creation of Beauty and Thought," *Journal of the American Psychoanalytic Association*, 13:634–703.

15. The exciting debates that led to this result culminated in a volume including contributions from most of the major participants in the controversy and espousing both the older viewpoint and the need for its replacement. See M. Gill and P. Holzman, eds., *Psychology Versus Metapsychology*, Psychological Issues, monograph 36 (New York: International Universities Press, 1976).

16. G. Klein, *Psychoanalytic Theory* (New York: International Universities Press, 1976).

17. J. Gedo, "On the Psychology of Genius." *International Journal of Psycho-Analysis,* 53:199–203.

18. W. Niederland, "Clinical Aspects of Creativity," *American Imago,* 24:6–34; and "Psychoanalytic Approaches to Artistic Creativity," *Psychoanalitic Quarterly,* 45:185–212.

19. P. Noy, "The Psychodynamic Meaning of Music: A Critical Review of the Psychoanalytic and Related Literature," *Journal of Music Theory,* 3:126–34, 4:7–23+. See also Noy, "A Revision of the Psychoanalytic Theory of the Primary Process," *International Journal of Psycho-Analysis,* 50:155–178; and A. Esman, "The Nature of the Artistic Gift," *American Imago,* 36:305–312.

20. This is the dynamic Niederland misconceived as a universal in the publications cited in note 18.

21. See Greenacre, "The Childhood of the Artist," in Greenacre, *Emotional Growth,* 2:479–505.

22. For the Kleinian references, see note 19, chapter 7. The work on creativity and mourning is best summarized by G. Pollock in "On Siblings, Childhood Sibling Loss, and Creativity," *Annual of Psychoanalysis,* 6:443–481. Gilbert Rose, in his 1980 monograph *The Power of Form* (New York: International Universities Press), has explained the capacity of creative activity to overcome internal chaos, without elevating this occasional finding into an inclusive theory.

23. D. W. Winnicott, "The Location of Cultural Experience," *International Journal of Psycho-Analysis,* 48:368–372.

24. For demonstrations that creativity stems not from psychopathology but from healthy aspects of the personality, see A. Modell, "The Transitional Object and the Creative Act," (*Psychoanalytic Quarterly,* 39:240–250.

25. A. Rothenberg, *Creativity and Madness* (Baltimore: Johns Hopkins University Press, 1990). For the statistical evidence, see A. Ludwig, *The Price of Greatness* (New York: Guilford, 1995).

26. H. J. Eysenck, "Creativity and Personality: Suggestions for a Theory," *Psychological Inquiry,* 4:147–178+.

27. See J. Gedo, *Portraits of the Artist,* chapter 7, for a detailed discussion of this issue.

28. Ibid., p. 7

29. Ehrenzweig's position was spelled out in 1953 in *The Psychoanalysis of Artistic Vision and Hearing,* 3d ed. (London: Shelton, 1975), and further elaborated in *The Hidden Order of Art* (Berkeley: University of California Press, 1967).

30. Similar ideas were later proposed by A. Rothenberg, albeit using different terminology, in "The Process of Janusian Thinking in Creativity," *Archives of General Psychiatry,* 24:195–205; and P. Noy in "About Art and Artistic Talent," *International Journal of Psycho-Analysis,* 53:243–49. For further bibliography and more detailed discussion on this issue, see J. Gedo, *Portraits of the Artist,* chapter 2.

31. Noy, "A Revision of the Psychoanalytic Theory."

32. W. Bucci, "The Development of Emotional Meaning in Free Association: A Multiple Code Theory," in A. Wilson and J. Gedo, eds., *Hierarchical Concepts in Psychoanalysis* (New York: Guilford, 1993), pp. 3–47.

2. The Creative Personality: A Portrait

1. Technically, these circumstances have been named "separation guilt." See A. Modell, "On Having the Right to a Life: An Aspect of the Superego's Development," *International Journal of Psycho-Analysis*, 46:323–31.

2. For an up-to-date account of Gauguin's life and career, see Francoise Cachin's *Gauguin*, Eng. ed. (Paris: Flammarion, 1990).

3. For an excellent overview of varied approaches to the study of creativity, consult M. A. Runco and R. S. Albert, eds., *Theories of Creativity* (Newbury Park, Cal.: Sage, 1990). The specific issue of social facilitation of a vocational choice is addressed by Albert in "Identity, Experiences, and Career Choice Among the Exceptionally Gifted and Eminent," pp. 13–34. That chapter includes an extensive bibliography of relevant research reports.

4. My differences with traditional psychoanalytic hypotheses about creativity, those I have discussed in some detail in chapter 1, were first articulated in 1972 in a report dealing with the irresistible pull of this pleasure in exercising an exceptional talent. See J. Gedo, "On the Psychology of Genius," *International Journal of Psycho-Analysis*, 53:199–203. This theme was further elaborated in 1983 in my *Portraits of the Artist*, pbk. ed. (Hillsdale, N.J.: Analytic, 1989); see, especially, "The Psychology of Genius Revisited," pp. 85–99.

5. See *Plutarch's Lives* (New York: Modern Library, n.d.), pp. 1022–1040. Some psychoanalytic students of creativity have been so impressed with anecdotal evidence of this kind that they postulate that preexisting injuries to self-esteem constitute the universal driving forces of creative endeavors. W. Niederland, in particular, has stressed the frequency of physical handicaps, such as that of Demosthenes, as the cause of the self-esteem problem. See note 18, chapter 1, for references.

6. The inevitable tension between the need for repetition and that of the search for novelty has been brought to my attention as a crucial psychological issue of universal significance by George Moraitis. He has noted that, in this sense, the converse of creativity is a phobic attitude. See G. Moraitis, "A Reexamination of Phobias as the Fear of the Unknown," *Annual of Psychoanalysis*, 16:231–249; and "Phobias and the Pursuit of Novelty," *Psychoanalytic Inquiry*, 11:296–315.

7. For a reliable survey of Picasso's entire career, consult R. Penrose, *Picasso: His Life and Work*, rev. ed. (New York: Icon Editions, 1973).

8. See Freud's letter of January 3, 1926, to Oskar Pfister in H. Meng and E. Freud, eds., *Psychoanalysis and Faith* (New York: Basic Books, 1963).

9. The most discerning of the numerous Mozart biographies are W. Hildesheimer's *Mozart* (New York: Farrar, Straus, and Giroux, 1982), and M. Solomon's *Mozart* (New York: Harper Collins, 1995). Solomon provides an excellent annotated bibliography of the Mozart literature.

10. The incident is covered in detail in P. Gay's recent biography, *Freud: A Life for Our Time* (New York: Norton, 1988). For primary evidence, consult J. Masson, ed., *The Complete Letters of Sigmund Freud to Wilhelm Fliess* (Cambridge: Harvard University Press, 1985). The psychological significance of this friendship was first assessed in the terms I am using here in H. Kohut's "Creativeness, Charisma, Group Psychology: Reflections on the Self-Analysis of Freud," in J. Gedo and G. Pollock,

eds., *Freud: The Fusion of Science and Humanism* (New York: International Universities Press, 1976), pp. 379–425.

11. *The Secret Sharer* is included in J. Conrad's *"Twixt Land and Sea"* (Harmondsworth: Penguin, 1988). Its meaning for the novelist was first articulated by Bernard Meyer in his discerning psychoanalytic biography, *Joseph Conrad* (Princeton: Princeton University Press, 1967). I discussed the general applicability of Conrad's insight to creative personalities in my *Portraits of the Artist*; see especially pp. 16–22, 110, 120.

12. My views on van Gogh's psychology are elaborated in *Portraits of the Artist*, chapters 7 and 8. Details about Theo van Gogh's terminal illness were made public in 1991. See A. Sheon, "Vincent van Gogh's Understanding of Theories of Degeneration in the 1880s," in J. Mashek, ed., *Van Gogh—100* (Westport, Conn.: Greenwood, 1995.)

13. For the psychology of the Picasso-Braque partnership, see Mary M. Gedo's *Picasso: Art as Autobiography* (Chicago: University of Chicago Press, 1980).

14. For the clearest expression of the technical views opposed to the analyst catalyzing the creativity of patients, see K. R. Eissler, "Psychopathology and Creativity," *American Imago*, 24:35–81; the relevant passage is on pp. 77–78. Eissler's position is a logical correlate of his acceptance of the concept of sublimation.

15. I discuss Gauguin's psychology in J. Gedo, "The Inner World of Paul Gauguin," *Annual of Psychoanalysis*, 22:61–109, as well as in *Portraits of the Artist*, chapter 8.

3. What Is Bred in the Bone

1. But see P. Greenacre's *Emotional Growth*, 2:479–505 (New York: International Universities Press, 1971).

2. For a recent discussion of the maturation of the central nervous system in terms of infantile experience, see F. Levin, *Mapping the Mind* (Hillsdale, N.J.: Analytic, 1990). The best work on sensory deprivation and its consequences for psychological development is that of D. A. Freedman, especially "The Sensory Deprivations," *Bulletin of the Menninger Clinic*, 43:29–68; and "The Effect of Sensory and Other Deficits in Children on Their Experience of People," *Journal of American Psychoanalytic Association*, 29:831–67. See also S. Fraiberg and D. Freedman, "Studies in the Ego Development of the Congenitally Blind," *The Psychoanalytic Study of the Child*, 19:113–169 (New York: International Universities Press, 1964).

3. For example, D. Harrington, "The Ecology of Human Creativity: A Psychological Perspective," in M. A. Runco and R. S. Albert, eds., *Theories of Creativity* (Newbury Park, Cal.: Sage, 1990), pp. 143–169; and D. Brenneis, "Musical Imaginations: Comparative Perspectives on Musical Creativity," in Runco and Albert, *Theories of Creativity*, pp. 170–189. For a more extensive discussion of the nature/nurture controversy, see J. Gedo, *The Biology of Clinical Encounters*, chapter 2 (Hillsdale, N.J.: Analytic, 1991.)

4. For further discussion of Mozart's childhood and the relevant bibliography, see J. Gedo, "Childhood Experience and Personal Destiny: Mozart and the Magic Flute," in J. and M. Gedo, *Perspectives on Creativity*, chapter 2 (Norwood, N.J.: Ablex, 1992).

5. For the classification of the relevant components of both music and the visual arts, I have relied on A. Ehrenzweig's *The Hidden Order of Art* (Berkeley: University

of California Press, 1967). I have discussed these issues in some detail in *Portraits of the Artist*, pbk. ed. (Hillsdale, N.J.: Analytic, 1989), chapter 2. See also J. Gedo, "Thoughts on Art in the Age of Freud," *Journal of the American Psychoanalytic Association*, 18:219–45.

6. See N. Mandelstam, *Hope Against Hope* (New York: Atheneum, 1970).

7. See I. Gibson, *Federico García Lorca* (New York: Pantheon, 1989).

8. A. Rothenberg, "The Process of Janusian Thinking in Creativity," *Archives of General Psychiatry*, 24:195–205.

9. See also A. Ehrenzweig, *The Psychoanalysis of Artistic Vision and Hearing*, 3d ed. (London: Sheldon, 1975).

10. I discuss Jung's career in detail in *Portraits of the Artist*, chapters 12–14. The interested reader can find detailed documentation for my account of Jung's biography in that work.

11. C. G. Jung, *Memories, Dreams, Reflections* (New York: Vintage, 1963).

12. *New York Times*, August 5, 1992.

13. M. Pagnol, *The Glory of My Father and the Castle of My Mother: Marcel Pagnol's Memories of Childhood.* (Berkeley: North Point, 1987.)

14. Flaubert's response to Taine is reprinted in F. Steegmuller, ed., *The Letters of Gustave Flaubert, 1857–1880* (Cambridge: Belknap Press, 1982), pp. 96–97. For a recent biography, see H. Lottman, *Flaubert* (Boston: Little, Brown, 1989).

15. See note 4, chapter 2.

4. The Burdens of Talent

1. The biographical "facts" sanctioned by the artist are summarized in R. Hughes, *Lucian Freud Paintings*, rev. ed. (London: Thames and Hudson, 1989). See also C. Lampert, *Lucian Freud: Recent Work* (London: Whitechapel Art Gallery, 1993); L. Gowing, *Lucian Freud* (London: Thames and Hudson, 1982); C. Blackwood, "Portraits by Freud," (*New York Review of Books*, December 13, 1993, pp. 18–19).

2. J. Richardson, "Paint Becomes Flesh," *New Yorker*, December 13, 1993, pp. 135–143.

3. I have discussed Nietzsche's emotional development in "On the Lamentations of Doctor Faustus," in *Portraits of the Artist*, pbk. ed. (Hillsdale, N.J.: Analytic, 1989), chapter 10. Among the numerous Nietzsche biographies, I found W. Kaufman's *Nietzsche: Philosopher, Psychologist, Antichrist*, 3d ed. (New York: Vintage, 1968), to be most revealing. See also Kaufman's *Discovering the Mind: Nietzsche, Heidegger, Buber*, vol. 2 (New York: McGraw Hill, 1980).

4. See A. Païs, *"Subtle is the Lord"* . . . (New York: Oxford University Press, 1982), chapter 3, which also contains an annotated bibliography of previous biographies of Einstein.

5. W. F. Nietzsche, *Ecce Homo*, in W. Kaufman, ed., *"On the Genealogy of Morals" and "Ecce Homo"* (New York: Vintage, 1967).

6. See J. Richardson's *A Life of Picasso* (New York: Random House, 1991); and M. Gedo's *Picasso: Art as Autobiography* (Chicago: University of Chicago Press, 1980) for these opposing interpretations of Picasso's childhood.

7. For the correlation of talent and depression, see N. C. Andreasen, "Creativity and Mental Illness: Prevalence Rates in Writers and Their First-Degree Relatives," *American Journal of Psychiatry*, 144:1288–92; and K. R. Jamison, "Mood Disorders

and Patterns of Creativity in British Writers and Artists," *Psychiatry*, 52:125–34. For a contrary view, see A. Rothenberg, *Creativity and Madness* (Baltimore: Johns Hopkins University Press, 1990). The concept of psychoticism is succinctly reviewed by H. J. Eysenck, "Creativity and Personality: Suggestions for a Theory," *Psychological Inquiry*, 4:147–178 and 238–246. I have commented on Eysenck's hypotheses in J. Gedo, "Creativity, Constitution, and Childhood," *Psychological Inquiry*, 4:193–196.

8. Most prominent of these creativity scholars is W. Niederland. For his relevant publications, see note 5, chapter 2.

9. See R. Hayman, *Proust* (New York: Harper Collins, 1990), chapters 1 and 2.

10. M. Proust, *Remembrance of Things Past*, 3 vols. (New York: Random House, 1981). For *Swann's Way*, see 1:3–462.

11. K. R. Eissler, "Genius, Psychopathology, and Creativity," *American Imago*, 24:35–81.

5. The Nurturant Matrix

1. See S. Lee, "Adult Development and Female Artists: Focus on the Ballet World," *Medical Problems of Performing Artists*, 4:32–37. I have learned more about these issues at the 1988 Aspen Conference on Medical Problems of Musicians and Dancers, especially from members of the Psychological Clinic of the St. Luke's Hospital, New York, who serve a number of ballet companies and their schools.

2. See J. Ardagh, *France Today* (London: Penguin, 1990), especially "Culture in the Provinces," pp. 309–322.

3. See W. Hildesheimer, *Mozart* (New York: Farrar, Straus, and Giroux, 1982); and E. Anderson, ed., *The Letters of Mozart and His Family*, (New York: St. Martin's Press, 1966).

4. I have previously cited the evidence for this view in J. Gedo, "Childhood Experience and Personal Destiny: Mozart and the Magic Flute," in J. and M. Gedo, *Perspectives on Creativity* (Norwood, N.J.: Ablex, 1992), pp. 13–24.

5. See J.-E. Cirlot, *Picasso: Birth of a Genius* (New York: Praeger, 1972).

6. R. Helson, "Creativity in Women: Outer and Inner Views Over Time," in M. A. Runco and R. S. Albert, *Theories of Creativity* (Newbury Park, Cal.: Sage, 1990), pp. 46–60.

7. See P. Gay, *Freud: A Life for Our Time* (New York: Norton, 1988); and E. Jones, *The Life and Work of Sigmund Freud*, 3 vols. (New York: Basic Books, 1953–1957).

8. E. Freud, ed., *The Letters of Sigmund Freud, 1873–1939* (New York: Basic Books, 1960).

9. The atmosphere of the patient's childhood transactions with his peers is well conveyed by W. Golding's novel of a children's community deprived of adult input, *The Lord of the Flies* (New York: Putnam, 1959).

10. I have previously described Cézanne's relationship to his father in "Paul Cézanne: Symbiosis, Masochism, and the Struggle for Perception," in M. Gedo, ed., *Psychoanalytic Perspectives on Art*, 2:187–202 (Hillsdale, N.J.: Analytic, 1987).

11. See V. S. Pritchett, *The Gentle Barbarian* (New York: Ecco, 1986). Pritchett provides an excellent bibliography on both Turgenev and Pauline Viardot.

12. See C. Gray, *The Great Experiment: Russian Art 1863–1922* (New York: Abrams, 1962).

6. The Price of Commitment

1. S. Freud, "Creative Writers and Daydreaming," *Standard Edition*, 9:142–156 (London: Hogarth Press, 1959).

2. R. Hughes, "The Rise of Andy Warhol," *New York Review of Books Anthology* (New York: New York Review of Books, 1993), pp. 205–224.

3. In addition to F. Cachin's *Gauguin*, Eng. ed. (Paris: Flammarion, 1990), extensive up-to-date biographical data may be found in the National Gallery of Art exhibition catalogue *The Art of Paul Gauguin* (Washington, D.C.: National Gallery of Art, 1988).

4. D. Remnick, "The Exile Returns," *New Yorker*, February 14, 1994, pp. 64–83.

5. This point has been given its greatest emphasis by A. Miller in *The Drama of the Gifted Child: How Narcissistic Parents Form and Deform the Emotional Lives of Their Talented Children* (New York: Basic Books, 1981). For the effect of such exploitation in the case of Mozart, see J. Gedo, "Childhood Experience and Personal Destiny: Mozart and the Magic Flute," in J. and M. Gedo, *Perspectives on Creativity* (Norwood, N.J.: Ablex, 1992), pp. 13–24.

6. The first three examples cited are from the nineteenth century: Byron lived from 1788 to 1824, Tolstoy from 1828 to 1910, and Lautrec from 1864 to 1901. For Balthus, see S. Rewald, *Balthus* (New York: Abrams, 1983); the artist's actual name is Balthazar Klossowski.

7. A. Trollope, *Can You Forgive Her?* (London: Chapman and Hall, 1865; Harmondsworth: Penguin, 1986).

8. For further details about this artist, see chapter 5 in J. Gedo and M. Gehrie, eds., *Impasse and Innovation in Psychoanalysis* (Hillsdale, N.J.: Analytic, 1993).

9. The case of this scholar is described at greater length in J. Gedo, *The Biology of Clinical Encounters* (Hillsdale, N.J.: Analytic, 1991), pp. 68–72.

10. The best statement of this hypothesis is P. Greenacre's "Woman as Artist," in P. Greenacre, *Emotional Growth*, 2:575–591 (New York: International Universities Press, 1971).

11. See B. Genné, "Two Self-Portraits by Berthe Morisot," in M. Gedo, ed., *Psychoanalytic Perspectives on Art*, 2:133–170 (Hillsdale, N.J.: Analytic, 1987). This article contains a good bibliography of the scanty Morisot literature.

12. L. Wilson, *Louise Nevelson: Iconography and Sources* (New York: Garland, 1981). See also L. Wilson, "Louise Nevelson, the Star and Her Set: Vicissitudes of Identification," in M. Gedo, ed., *Psychoanalytic Perspectives on Art*, 1:225–240.

13. The standard source for biographical data on Monet is Daniel Wildenstein, *Monet*, 5 vols. (Paris: Bibliothèque des Arts, 1974–1992). For the psychological significance of these data, I consulted M. Gedo's *Monet and the Human Figure* (Chicago: University of Chicago Press, forthcoming).

14. "Some are born great, some achieve greatness, and some have greatness thrust upon 'em." *Twelfth Night*, 2:5.

7. Creativity and Self-Healing

1. A. Trollope, *An Autobiography* (London: Blackwood, 1883). The passage is quoted N. J. Hall's *Trollope: A Biography* (Oxford: Clarendon Press, 1991), p. 1.

2. Letter of June 8, 1876, quoted in Hall, *Trollope*, p. 381.

3. N. J. Hall, ed., *The Letters of Anthony Trollope*, 2 vols., (Stanford: Stanford University Press, 1983); see appendix A. Quoted in Hall, *Trollope*, p. 43.

5. Hall, *Trollope*, p. 81.

6. *The Complete Letters of Vincent van Gogh*, 2d ed., 3 vols. (Greenwich, Conn.: New York Graphic Society, 1959), 1:194.

7. In my judgment, successful psychoanalytic treatment also produces its results by finding optimal adaptive uses for the repetitive patterns of the analysand's motivations. For the theoretical underpinnings of this statement, consult "The Hierarchical Model of Mental Functioning" in J. Gedo, *The Biology of Clinical Encounters* (Hillsdale, N.J.: Analytic, 1991), pp. 25–44; see also J. Gedo, "Between Reductionism and Prolixity: Psychoanalytic Theory and Occam's Razor," *Journal of the American Psychoanalytic Association,* 39:71–86.

8. P. Greenacre, "The Childhood of the Artist," in P. Greenacre, *Emotional Growth,* 2:479–504 (New York: International Universities Press, 1971).

9. This issue is discussed in greater detail in J. Gedo, *Portraits of the Artist*, pbk. ed. (Hillsdale, N.J.: Analytic, 1989), chapter 8.

10. *Complete Letters of van Gogh,* 1:199.

11. J. van Gogh-Bonger, "Memoir of Vincent van Gogh," in *Complete Letters of van Gogh,* 1:xv–liii.

12. See M. E. Tralbaut, *Vincent van Gogh* (New York: Viking, 1969), p. 243.

13. Most revealing is Freud's correspondence with Wilhelm Fliess, in J. Masson, ed., *The Complete Letters of Freud to Wilhelm Fliess* (Cambridge: Harvard University Press, 1985). For an annotated bibliography of the extensive literature on Freud's life, see P. Gay, *Freud: A Life for Our Times* (New York: Norton), 1988), pp. 741–779.

14. I have discussed this incident in some detail in *Portraits of the Artist,* chapters 12 and 13.

15. The quote is from a letter to E. Jones, cited by the latter in his *The Life and Work of Sigmund Freud,* 3:16 (New York: Basic Books, 1957).

16. The biographical data and psychological conclusions about them are those of M. Gedo's "Creativity and Adaptation: Goya as His Own Physician," in J. and M. Gedo, *Perspectives on Creativity* (Norwood, N.J.: Ablex, 1992), pp. 25–82.

17. Ibid., p. 79.

18. Ibid.

19. M. Klein's views on creativity were stated most clearly by her students, the psychoanalyst H. Segal, "A Psycho-Analytical Approach to Aesthetics," in M. Klein, P. Heiman, and R. Money-Kyrle, eds., *New Directions in Psychoanalysis* (New York: Basic Books, 1957), pp. 384–405; and historian/critic A. Stokes, "Form in Art," in M. Klein, P. Heiman, and R. Money-Kyrle, eds., *New Directions in Psychoanalysis*, pp. 406–420. See also A. Stokes, *Painting and the Inner World* (London: Tavistock, 1963).

8. *Creativity and Psychopathology*

1. See E. Heller, *The Artist's Journey into the Interior* (New York: Harcourt, Brace, Jovanovich, 1976); and S. Freud, "Civilization and Its Discontents," *Standard Edition,* 21:59–147 (London: Hogarth Press, 1961).

2. E. Kris, *Psychoanalytic Explorations in Art* (New York: International

Universities Press, 1952); see especially p. 288. Kris repeatedly cites the statements of T. S. Eliot on this subject. For Nabokov, I have relied on B. Boyd, *Vladimir Nabokov*, 2 vols. (Princeton: Princeton University Press, 1990 and 1991); the novelist's own best presentation of this viewpoint is his last Russian-language work, *The Gift* (New York: Vintage International, 1991), which deals with the manner in which a major author develops his fictions.

3. G. Vasari, *The Lives of the Painters, Sculptors, and Architects*, 4 vols. (London and New York: Everyman's Library, 1963). See vol. 3, pp. 234–254. Additional references pertinent for Pontormo's biography will be listed in chapter 13.

4. For Picasso's vow, see J. Richardson, *A Life of Picasso*, vol. 1 (New York: Random House, 1991), especially chapter 3. See also M. Gedo, "The Living Subject: Therapeutic Encounters or Organized Research," in J. and M. Gedo, *Perspectives on Creativity* (Norwood, N.J.: Ablex, 1992), pp. 149–159. For a broader approach to Picasso's creativity, consult M. Gedo, *Picasso: Art as Autobiography* (Chicago: University of Chicago Press, 1980).

5. The best exposition in the psychoanalytic literature of the consequences of untamed grandiosity is to be found in H. Kohut's *The Analysis of the Self* (New York: International Universities Press, 1971).

6. See A. Bell, *Cervantes* (Norman: University of Oklahoma Press, 1947); and W. Starkie's "Introduction" to Cervantes, *Don Quixote de la Mancha* (New York: Signet, 1964). Cervantes's "The Man of Glass" is available in his *Six Exemplary Novels* (Woodbury, N.Y.: Barron's Educational Series, 1961).

7. See note 1, chapter 2.

8. See R. Hayman, *Proust: A Biography* (New York: Harper Collins, 1990). As his bibliography reveals, in his work Hayman has made extensive use of psychoanalytic ideas.

9. I have recounted this dramatic story in greater detail in "And I Will Gather the Remnant of My Flock of All Countries Whither I have Driven Them," in J. Gedo, *Psychoanalysis and its Discontents* (New York: Guilford, 1984), pp. 74–97.

10. For a view of psychopathology in general, principally conceived in such terms, see J. Gedo, *The Mind in Disorder* (Hillsdale, N.J.: Analytic, 1988).

11. C. Malvasia, *The Life of Guido Reni* (University Park: Pennsylvania State University Press, 1980).

12. R. Spear, "*La Necessità* of Guido Reni," in Bologna: Pinacoteca Nazionale, Accademia Clementina, Fondazione Cesare Gnudi, *Il Luogo ed il Ruolo della Città di Bologna tra Europa Continentale e Mediterranea* (Bologna: Nuova Alfa Editoriale, 1992), pp. 313–335. I am indebted to Professor Spear for discussing with me the life and psychology of Guido Reni and sharing with me the manuscript of a work in progress on the life and work of the artist.

13. Malvasia, *The Life of Guido Reni*, p. 35.

14. Spear, "*La Necessità*," p. 331.

9. The Frustration of Lying Fallow

1. See D. Waldman, *Arshile Gorky* (New York: Abrams, 1980), pp. 13–60.

2. See N. Till, *Rossini: His Life and Times* (New York: Midas, 1983).

3. F. O'Connor, "The Psychodynamics of the Frontal Self-Portrait," in M. Gedo, ed., *Psychoanalytic Perspectives on Art*, 1:169–221 (Hillsdale, N.J.: Analytic, 1987).

4. See D. S. Mirsky, *A History of Russian Literature* (New York: Vintage, 1958), pp. 83–102, 120–124.

5. B. Boyd, *Vladimir Nabokov*, vol. 2, chapters 2, 3, 4, and 6 (Princeton: Princeton University Press, 1991).

6. See R. Hayman, *Proust* (New York: Harper Collins, 1990), especially chapter 24.

7. F. O'Connor, "Jackson Pollock: The Black Pourings," in *Jackson Pollock: The Black Pourings—1951 to 1953* (Boston: Institute for Contemporary Art, 1980), pp. 1–25.

8. S. Spender, "Introduction," in Malcolm Lowry, *Under the Volcano* (New York: New American Library, 1971), pp. xi–xxx.

9. F. Dostoievsky, *The House of the Dead* (Harmondsworth: Penguin, 1985), originally published in 1862.

10. For references, see note 2, chapter 1. Gorky's paintings have been catalogued in J. Jordan and R. Goldwater, *The Paintings of Arshile Gorky* (New York: New York University Press, 1982).

11. For example, *Xhorkom* (Gorky's native village), *Image in Xhorkom*, many versions of *Garden in Sochi* (a Russian resort on the Black Sea—a place name Gorky explicitly substituted for an Armenian one), or *How My Mother's Embroidered Apron Unfolds in My Life*.

10. Psychosis and the Art of Inner Necessity

1. The history of these developments has been well summarized by J. M. MacGregor, *The Discovery of the Art of the Insane* (Princeton: Princeton University Press, 1989).

2. H. Prinzhorn, *Artistry of the Mentally Ill* (New York: Springer Verlag, 1972).

3. See MacGregor, *The Discovery of the Art*, chapters 16 and 17, for the influence of psychotic art on Surrealism and other major artists. Wölfli is extensively discussed in MacGregor's chapter 13, Josephson in chapter 14, and Corbaz in chapter 17, albeit in lesser detail. For Luis, see M. C. Melgar and E. López de Gomara, *Imágenes de la Locura* (Buenos Aires: Kargieman, 1988).

4. For Ernst and Klee, see W. Rubin, *Dada, Surrealism, and Their Heritage* (New York: Museum of Modern Art, 1968); for Dubuffet, P. Selz, *The Work of Jean Dubuffet* (New York: Museum of Modern Art, 1962); for Lindner, S. Prokopoff, *Richard Lindner* (Chicago: Museum of Contemporary Art, 1977); see also H. Arnason, *History of Modern Art* (New York: Abrams, 1968), pp. 256–259; 347–350; 521–524; 577–578.

5. MacGregor, *The Discovery of the Art*, chapter 1.

6. For a more detailed discussion of Ensor's illness and its effect on his art, see J. Gedo, "More on the Healing Power of Art: The Case of James Ensor," *Creativity Research Journal*, 1(3):33–57. The most reliable biography of Ensor is F. C. Legrand, *Ensor cet Inconnu* (Brussels: La Renaissance du Livre, 1971).

7. M. Thévoz, "Arte y psicosis," *Revista Argentina de Arte y Psicoanálisis*, 1:12–19.

8. See A. Strindberg, *The Plays of Strindberg* (New York: Modern Library, 1966), especially "The Ghost Sonata," pp. 419–467. Also R. M. Rilke, *The Notebooks of Malte Laurids Brigge* (New York: Vintage, 1985). For Wölfli's poetry, see W.

Morgenthaler, *Madness and Art: The Life and Works of Adolf Wölfli*, vol. 3 (Lincoln: University of Nebraska Press, 1992).

9. D. Schreber, *Memoirs of My Nervous Illness* (London: William Dawson, 1955), originally published in 1911. See also S. Freud, "Psycho-Analytic Notes on an Autobiographical Account of a Case of Paranoia (Dementia Paranoides)," *Standard Edition*, 12:9–82 (London: Hogarth Press, 1958).

10. Currently, acute psychotic reactions are routinely treated with pharmacotherapy. The effects of these drugs interfere with patients' capacity to make art— a development MacGregor deplores. See MacGregor, *The Discovery of the Art*, pp. 10, 310.

11. For the most recent sample from the Heidelberg archive exhibited in America, see *The Prinzhorn Collection* (Champaign, Ill.: Krannert Art Museum, 1984). See also note 3 for Melgar and de Gomara.

12. G. Grass, *The Tin Drum* (New York: Vintage, 1964).

13. C. Lombroso, *The Man of Genius* (London: Scribner, 1891).

14. See "Interview with Joanne Greenberg" in A.-L. Silver, ed., *Psychoanalysis and Psychosis* (New York: International Universities Press, 1989), pp. 313–333.

15. MacGregor, *The Discovery of the Art* , chapter 8, especially p. 141.

11. *When the Wind Is Southerly*

1. For a rancorous dialogue involving such a dispute, see J. Gedo, "Paul Cézanne: Symbiosis, Masochism, and the Struggle for Perception"; T. Reff, "John Gedo and the Struggle for Perception"; J. Gedo, "Interdisciplinary Dialogue as a *Lutte d'amour*"; and T. Reff, "The Author, the Authority, the Authoritarian"—all in M. Gedo, ed., *Psychoanalytic Perspectives on Art*, 2:187–202, 203–222, 223–236, and 237–243, respectively (Hillsdale, N.J.: Analytic, 1987).

2. The clearest exposition of such possibilities was given by D. W. Winnicott, "Psychoses and Child Care," in D. W. Winnicott, *Collected Papers* (London: Tavistock, 1958), pp. 219–228; see also H. Searles, *My Work with Borderline Patients* (New York: Aronson, 1986), especially the introduction. For my views on this topic, see *The Mind in Disorder* (Hillsdale, N.J.: Analytic, 1988), chapter 5.

3. See J. Gedo, *Portraits of the Artist*, pbk. ed. (Hillsdale, N.J.: Analytic, 1989), chapter 9; for more recent biographical findings about Caravaggio, consult Gianni Papi, "Cenni biografici," in Mina Gregori, *Michelangelo Merisi da Caravaggio: Come Nascono i Capolavori* (Electa: Milano, 1991), pp. 75–84.

4. For details of the manner in which the Roman criminal justice system pursued convicted murderers, see M. Calvesi, "La realtà del Caravaggio," *Storia dell'arte*, 53:51–85.

5. For the concept of splitting of the mind, see S. Freud, "Fetishism," *Standard Edition*, 21:149–57 (London: Hogarth Press, 1961), and "Splitting of the Ego in the Process of Defense," *Standard Edition*, 23:271–78 (1964). See also S. Ferenczi, "The Psyche as an Inhibiting Organ," in *The Theory and Techniques of Psychoanalysis*, pp. 379–382 (New York: Basic Books, 1952).

6. See M. Gedo, "Homesick and Heartsick: René Magritte's Artistic and Personal Crisis of the 1940s," in M. Gedo, *Looking at Art from the Inside Out*, pp. 204–226 (Cambridge and New York: Cambridge University Press, 1994). For the latest Magritte scholarship, consult D. Sylvester, *Magritte: The Silence of the World* (New York: Abrams, 1992).

7. For instance, in the 1992–1993 Magritte exhibition (London/New York/Houston/Chicago)—see S. Whitfield, *Magritte* (London: South Bank Centre, 1992).

8. M. Gedo, "Homesick and Heartsick," pp. 220–225.

9. See Whitfield, *Magritte*, no. 75.

10. See P. Wapnewski, "The Operas as Literary Works," in U. Müller and P. Wapnewski, eds., *Wagner Handbook* (Cambridge: Harvard University Press, 1992), chapter 1; see especially pp. 14–95.

11. See B. Magee, *Aspects of Wagner* (Oxford: Oxford University Press, 1988), especially pp. 3–5.

12. Magee, *Aspects of Wagner*, p. 26.

13. P. Gay, *Freud, Jews, and Other Germans* (New York: Oxford University Press, 1978), p. 217.

14. D. Borchmeyer, "The Question of Anti-Semitism," in Müller and Wapnewski, *Wagner Handbook*, chapter 5. The quotations are from pp. 171 and 179.

15. Borchmeyer, "The Question of Anti-Semitism," p. 181.

16. Wapnewski, "The Operas as Literary Works," p. 13. For a superior psychological assessment of Hitler, see R. Waite, *The Psychopathic God: Adolf Hitler* (New York: Basic Books, 1977).

17. Borchmeyer, "The Question of Anti-Semitism," p. 184. In this regard, see J. Kuhnel, "The Prose Writings," in Müller and Wapnewski—particularly pp. 582–589, 597, 601, and 616.

18. C. G. Jung, *Memories, Dreams, Reflections* (New York: Vintage, 1963); see also note 10, chapter 3.

19. D. W. Winnicott, "Review of C. G. Jung, *Memories, Dreams, Reflections*," *International Journal of Psycho-Analysis*, 45:450–455.

20. See L. Frey-Rohn, *From Freud to Jung* (New York: Putnam, 1974); and C. Meier, *Jung's Analytical Psychology and Religion* (Carbondale: Southern Illinois University Press, 1977).

21. Jung, *Memories, Dreams, Reflections*, p. 237.

22. Gedo, *Portraits of the Artist*, chapter 13.

23. Jung, *Memories, Dreams, Reflections*, chapter 6.

24. H. Ellenberger, *The Discovery of the Unconscious* (New York: Basic Books, 1970), p. 672.

25. See W. McGuire, ed., *The Freud/Jung Letters* (Princeton: Princeton University Press, 1974), no. 178. It is of relevance that Jung explicitly identified himself as a descendant of Wotan and saw himself as the immediate successor of Nietzsche in a "golden chain" of major alchemists who were to create a new religion for Western man. See *The Freud/Jung Letters*, no. 338; and Jung, *Memories, Dreams, Reflections*, p. 318.

26. For a reliable biography of Kleist, see J. Maass, *Kleist* (New York: Farrar, Straus, and Giroux, 1983). Kleist's correspondence is available in P. B. Miller, ed., *An Abyss Deep Enough* (New York: Dutton, 1982). For the letters cited, see pp. 93, 95, 97.

27. H. von Kleist, "On the Puppet Theater," in Miller, *An Abyss Deep Enough*, pp. 211–216. For Kleist's stories, see *The Marquise of O and Other Stories* (Harmondsworth: Penguin, 1978).

28. For the passage from *The Schroffenstein Family*, see Miller, *An Abyss Deep*

Enough, p. 81. *Penthesilea* and *The Prince of Homburg* are available in English in E. Bentley, ed., *The Classic Theatre*, vol. 2 (Garden City, N.Y.: Anchor, 1959).

29. These events were first discussed from a psychological viewpoint by R. Sterba and E. Sterba, "The Anxieties of Michelangelo Buonarroti," *International Journal of Psycho-Analysis*, 37:7–11. For more extensive psychoanalytic assessments of Michelangelo's personality, see R. Liebert, *Michelangelo* (New Haven: Yale University Press, 1983); R. Sterba and E. Sterba, "The Personality of Michelangelo Buonarroti: Some Reflections," *American Imago*, 35:156–177; J. Oremland, "Mourning and Its Effect on Michelangelo's Art," *Annual of Psychoanalysis*, 8:317–351; and J. Gedo, "Mourning, Perversion, and Apotheosis," in M. Gedo, ed., *Psychoanalytic Perspectives on Art*, 1:269–302 (Hillsdale, N.J.: Analytic, 1985).

The original source materials for the artist's biography are G. Vasari, *Lives of the Painters, Sculptors, and Architects*, 4:108–192, 4 vols. (London: Dent/New York: Dutton, 1963); A. Condivi, *The Life of Michelangelo*, trans. A. Wohl, ed. H. Wohl (Baton Rouge: Louisiana State University Press).

30. Liebert, *Michelangelo*, pp. 115–117.

31. R. Linscott, ed., *Complete Poems and Selected Letters of Michelangelo*, trans. C. Gilbert (New York: Modern Library, 1965), p. 135.

32. Sterba and Sterba, "The Personality of Michelangelo."

33. Linscott, *Complete Poems*, p. 16.

34. See note 5, this chapter.

12. The Psychology of Performance

1. See H. Lottman, *Flaubert* (Boston: Little, Brown, 1989), chapters 15–17; and G. Flaubert, *Madame Bovary* (New York: Modern Library, 1982).

2. *The Unknown Masterpiece* is at present unavailable in English. For the French original, see H. Balzac, *Le Chef d'Oeuvre Inconnu* (Paris: Schoenhof, 1970).

3. W. B. Yeats, "Among School Children," in *Poems* (New York: Limited Editions, 1970).

4. See note 5, chapter 2.

5. "The Fine Art of Criticism," in *Satires and Epistles of Horace*, trans. S. P. Bovie (Chicago: University of Chicago Press, 1959), p. 80.

6. Perhaps teamwork does facilitate creativity in scientific research, judging by the results achieved by major biomedical and technological centers.

7. Creativity as an activity subserving a relationship to an object of fantasy was first adumbrated by Karl Abraham in 1911. See his "Giovanni Segantini: A Psycho-Analytic Study," in Abraham, *Selected Papers*, 1:210–261 (New York: Basic Books, 1955). This theme is prominent in the writings of the British aesthetician/critic Adrian Stokes, such as *Painting and the Inner World* (London: Tavistock, 1963). For further adherents of this viewpoint, see note 19, chapter 7.

8. G. di Lampedusa, *The Leopard* (New York: Pantheon, 1960). For an account of the genesis of this work, see A. Colquhoun, "Giuseppe di Lampedusa," in *Lampedusa: Two Stories and a Memory* (New York: Grosset and Dunlap, 1968), pp. 19–39.

9. See B. Meyer, *Joseph Conrad* (Princeton: Princeton University Press, 1967), for details of the novelist's tragic childhood: his parents' exile to Siberia, his mother's

death when he was four, his father's subsequent psychological collapse and eventual death when the boy was eleven.

10. H. Bloom, *The Anxiety of Influence* (London: Oxford University Press, 1973).

11. Unless otherwise noted, for these and other routine references to musical history I have relied on H. Weinstock's *What Music Is* (Garden City, N.Y.: Doubleday, 1968); and Joseph Kerman's "Music in the Modern World," in H. W. Janson and J. Kerman, *A History of Art and Music* (Englewood Cliffs, N.J.: Prentice-Hall, 1968), pp. 257–292.

12. For an assessment of Picasso as innovator, see A. Barr, *Picasso: Fifty Years of His Art* (New York: Museum of Modern Art, 1966). Regarding Picasso's need for secret sharers, consult M. Gedo, *Picasso: Art as Autobiography* (Chicago: University of Chicago Press, 1980).

13. See M. Eger, "The Bayreuth Festival and the Wagner family," in U. Müller and P. Wapnewski, eds., *Wagner Handbook* (Cambridge: Harvard University Press, 1992), pp. 485–501.

14. See note 1, chapter 8.

13. *The Anticlassical Insurgency*

1. For an overview of the history of Italian art in the period under consideration, see F. Hartt, *History of Italian Renaissance Art* (New York: Abrams, 1974).

2. For the historical context of the anticlassical insurgency, see J. Shearman, *Mannerism* (Harmondsworth: Penguin, 1967).

3. N. Machiavelli, *The Prince and the Discourses* (New York: Modern Library, 1950).

4. These varied developments are well summarized by A. Smart, *The Renaissance and Mannerism in Italy* (London: Thames and Hudson, 1971).

5. Hartt, *History of Italian Renaissance Art*, p. 518.

6. J. Gedo, "Life Histories Within a Creative Cohort: The Journey Into Abstraction," in J. and M. Gedo, *Perspectives on Creativity* (Norwood, N.J.: Ablex, 1992), pp. 115–132.

7. E. Carroll, *Rosso Fiorentino: Drawings, Prints, and Decorative Arts* (Washington, D.C.: National Gallery of Art, 1987).

8. S. J. Freedberg, *Painting of the High Renaissance in Rome and Florence*, 1:539–550, 2 vols. (New York: Harper and Row, 1972). See also Hartt, *History of Italian Renaissance Art*, pp. 508–510.

9. B. Cellini, *Autobiography* (Harmondsworth: Penguin, 1956).

10. L. Caron, "Monkey Business: The Puzzle of Rosso's Ape," *Source*, 13(2):25–30.

11. For Rosso, see G. Vasari, *Lives of the Painters, Sculptors, and Architects*, 2:355–364, 4 vols. (London: Dent/New York: Dutton, 1963).

12. Hartt, *History of Italian Renaissance Art*, p. 510.

13. Ibid., pp. 516–518.

14. K. Oberhuber in *The Age of Correggio and the Carracci* (Washington, D.C.: National Gallery of Art, 1986), pp. 167–170.

15. Oberhuber, in *The Age of Correggio*, pp. 170–172.

16. Hartt, *History of Italian Renaissance Art*, pp. 516–518.

17. See Vasari, *Lives of the Painters*, 3:6–14, for his discussion of Parmigianino.

18. For the description of such a syndrome, see H. Kohut, *The Analysis of the Self* (New York: International Universities Press, 1971). In Kohut's terms, this is a "narcissistic personality disturbance." See also O. Kernberg, *Borderline Conditions and Pathological Narcissism* (New York: Jason Aronson, 1975).

19. Hartt, *History of the Italian Renaissance*, pp. 500–508.

20. See Vasari, *Lives of the Painters*, 3:234–255, for his discussion of Pontormo.

21. L. Berti, *L'Opera Completa di Pontormo* (Milano: Rizzoli, 1973), pp. 85–87.

22. Vasari, *Lives of the Painters*, 3:255.

23. For Pontormo's diary, see Berti, *L'Opera*, pp. 7–10.

24. For my assessment of such conditions, see J. Gedo, *The Mind in Disorder* (Hillsdale, N.J.: Analytic, 1988), chapter 10.

25. See J. Gedo, *The Mind in Disorder*, chapter 3.

26. Similar distortions of space in Picasso's *Demoiselles d'Avignon* have been attributed by Mary Gedo to the externalization of a sense of inner fragmentation. See her *Looking at Art from the Inside Out* (Cambridge and New York: Cambridge University Press, 1994), chapter 5.

27. For an extensive discussion of regressive manifestations of sexuality, see J. Gedo, *The Mind in Disorder*, chapter 15.

28. For my views on the personalities of van Gogh and Gauguin, see J. Gedo, *Portraits of the Artist*, pbk. ed. (Hillsdale, N.J.: Analytic, 1989), chapter 8. Concerning Cézanne, see chapter 14, this volume, and J. Gedo, "Paul Cézanne: Symbiosis, Masochism, and the Struggle for Perception," in M. Gedo, ed., *Psychoanalytic Perspectives on Art*, vol. 2 (Hillsdale, N.J.: Analytic, 1987). For an assessment of Seurat's character, I have relied on M. Gedo, "The *Grande Jatte* as the Icon of a New Religion: A Psycho-Iconographic Interpretation," *The Art Institute of Chicago Museum Studies*, 14:223–237.

14. Paul Cézanne: Psychopathology, Subject Matter, and Formal Innovation

1. See note 5, chapter 11.

2. The most useful biographies of Cézanne are G. Mack, *Paul Cézanne* (New York: Knopf, 1935); J. Lindsay, *Cézanne, His Life and Art* (New York: Harper and Row, 1972); and J. Perruchot, *Cézanne* (New York: Universal Library, 1963).

3. Lindsay, *Cézanne*, p. 322.

4. R. Niess, *Zola, Cézanne, and Manet* (Ann Arbor: University of Michigan Press, 1968), p. 93.

5. A. Esman, "Cézanne's *Bathers*: A Psychoanalytic View," in M. Gedo, ed., *Psychoanalytic Perspectives on Art*, 3:230 (Hillsdale, N.J.: Analytic, 1988).

6. Lindsay, *Cézanne*, p. 253.

7. P. Cézanne, *Correspondance*, ed. J. Rewald (Paris: Grasset, 1937), pp. 199–200.

8. See Lindsay, *Cézanne*, p. 238. Lindsay does not believe that Cézanne was disturbed by the demonstrators' religious views; he asserts that the artist was panicked by the unruly crowd in itself. If his conclusion is valid, it follows that Cézanne got in touch with his wife as soon as he recovered from what must have been a dissociative episode.

9. Mack, *Paul Cézanne*, pp. 98–112.

10. These transactions are discussed in some detail in my dialogue with T. Reff in

Gedo, *Psychoanalytic Perspectives on Art*, 2:187–243, where Reff supports the importance of father-son rivalry in Cézanne's relationship with his father and I contend that, to the extent that this was present, it was hollow.

11. Lindsay, *Cézanne*, p. 327.

12. Cézanne, *Correspondance*, p. 119.

13. E. Zola, *The Masterpiece* (Ann Arbor: University of Michigan Press, 1968). It is also noteworthy that Cézanne allowed himself to be pushed into his unwanted marriage only three weeks after reading Zola's hurtful portrayal of him.

14. English translations of much of Cézanne's adolescent verse are available in Lindsay, *Cézanne*, chapters 3 and 4, pp. 22–53.

15. See Cézanne, *Correspondance*, p. 54.

16. Cézanne's paintings are identified by the numbers assigned to them in L. Venturi, *Cézanne, son art, son oeuvre* (Paris: P. Rosenberg, 1936) as "V. #."

17. For assessments of Cézanne's place in the history of art, see J. Rewald, *Paul Cézanne* (New York: Simon and Schuster, 1948); M. Schapiro, *Paul Cézanne* (New York: Abrams, 1952); or J. Rewald, *The History of Impressionism*, 4th ed. (New York: Museum of Modern Art, 1973), and *Post Impressionism from van Gogh to Gauguin*, 3d ed. (New York: Museum of Modern Art, 1978). For his early work specifically, consult M. Lewis, *Cézanne's Early Imagery* (Berkeley: University of California Press, 1989); and L. Gowing, *Cézanne: The Early Years 1859–1892* (New York: Abrams, 1988). For Cézanne's greatest achievements, see *Cézanne: The Late Work* (New York: Museum of Modern Art, 1977).

18. M. Schapiro, "The Apples of Cézanne: An Essay on the Meaning of Still-Life," in M. Schapiro, *Modern Art: Nineteenth and Twentieth Century*, pp. 1–38 (New York: George Braziller, 1968). See p. 27 for this quotation.

19. See Mack, *Paul Cézanne*, p. 43.

20. G. Rose, *The Power of Form* (New York: International Universities Press, 1980).

21. For instance, T. Reff, "Cézanne's Bather with Outstretched Arms," *Gazette des Beaux Arts*, 59:173–190.

22. See also Esman, "Cézanne's *Bathers*," pp. 225–238; and Gedo, "Paul Cézanne: Symbiosis, Masochism, and the Struggle for Perception," in Gedo, *Psychoanalytic Perspectives on Art*, 2:187–201.

23. For another instance of productivity preserved by splitting mental operations into autonomous segments, see J. Gedo, *Portraits of the Artist*, pbk. ed. (Hillsdale, N.J.: Analytic, 1990), pp. 161–187, where I discuss the case of Caravaggio.

24. Esman, "Cézanne's *Bathers*."

25. Schapiro, *Paul Cézanne*, p. 27; T. Reff, "Cézanne's Constructive Stroke," *Art Quarterly*, 25:214–226.

26. For Cézanne's childhood, see Lindsay, *Cézanne*, pp. 3–22.

27. For a detailed discussion of personality development that eventuates in such an impasse, see J. Gedo, *The Mind in Disorder* (Hillsdale, N.J.: Analytic, 1988), pp. 121–132.

28. For the letter of 1896, see Mack, *Paul Cézanne*, p. 354, and, regarding Cézanne's mother, p. 359; and A. Vollard, *Paul Cézanne* (New York: Crown, 1937), p. 16.

29. In the construct language of psychoanalysis, one would call Cézanne's reactions to women in his adult life "transference reactions" whereby he relived certain

emotional constellations from the childhood past without being aware that he was repeating rather than remembering that past.

30. Lindsay, *Cézanne*, p. 219.

31. Cézanne, *Correspondance*, p. 54.

32. This point was noted by K. Badt, *The Art of Paul Cézanne* (Berkeley: University of California Press, 1965), p. 81. However, Reff (in Gedo, *Psychoanalytic Perspectives on Art*, 2:243) credits Meyer Schapiro with priority for this notion.

15. The Artist's Emotional World: Eugène Delacroix as Prototype

1. H. Balzac, *The Black Sheep* (Harmondsworth: Penguin, 1976). For a plot summary, see W. Conger, J. Gedo, and M. Gedo, "Autobiography, Biography, Fiction: A Symposium," in G. Moraitis and G. Pollock, eds., *Psychoanalytic Studies of Biography* (Madison, Conn.: International Universities Press, 1987), pp. 403–404.

2. For Delacroix's life, see R. Huyghe, *Delacroix ou le combat solitaire* (London: Thames and Hudson, 1964); A. Piron, *Eugène Delacroix, sa vie et ses oeuvres* (Paris: Claye, 1865); or F. Trapp, *The Attainment of Delacroix* (Baltimore: Johns Hopkins University Press, 1971). I am most indebted, however, to J. Spector's "Delacroix: A Study of the Artist's Personality and Its Relation to His Art," in M. Gedo, ed., *Psychoanalytic Perspectives on Art*, 2:3–68 (Hillsdale, N.J.: Analytic, 1987), where the data relevant for a psychological assessment are presented in a concise manner. Spector makes clear that both Charles and Victoire Delacroix went to extraordinary lengths to substantiate the contention that Eugène could have been legitimate, and he lists the reasons for skepticism about these claims as well as certain clues that suggest the artist was on some level convinced of his illegitimacy; see note 7, p. 55, and pp. 14–15, respectively.

3. Spector, "Delacroix," for one; see p. 12.

4. Ibid., p. 7. For the concept of a personal myth, see note 3, chapter 1. For screen memories, see S. Freud, "Screen Memories," *Standard Edition*, 3:301–22 (London: Hogarth Press, 1962).

5. See J. Stewart, *Eugène Delacroix: Selected Letters, 1813–1863* (New York: St. Martin's Press, 1970).

6. For data about Géricault, see "Documentazione," in J. Thuillier and P. Grunchec, *L'Opera Completa di Géricault*, pp. 83–85 (Milano: Rizzoli, 1978).

7. *The Journal of Eugène Delacroix* (New York: Viking, 1972), p. 574.

8. E. Delacroix, *Selected Letters, 1813–1863* ed. J. Stewart (London: Eyre and Spottiswood, 1971).

9. Numbers preceded by "R." refer to the catalogue raisonné of Delacroix's paintings in E. Chesneau and A. Robaut, eds., *L'Oeuvre complet d'Eugène Delacroix* (Paris: Charavay, 1885). For another example of the painter's use of this theme, see J. Spector, "An Interpretation of Delacroix's *Michelangelo in His Studio*," in Gedo, *Psychoanalytic Perspectives in Art*, 1:107–131.

10. See Spector, "Delacroix," p. 8 and note 10, p. 56.

11. E. Kliman, "Delacroix's Lions and Tigers: A Link Between Man and Nature," *Art Bulletin*, 64:446–466.

12. M. Gedo, "Significant Themes in Delacroix's Oeuvre," in Conger, Gedo and Gedo, "Autobiography . . . ," p. 386.

13. The female figure of Liberty is one of the rare presentations of a woman in Delacroix's oeuvre in which she is neither victim nor victimizer.

14. See Conger, Gedo, and Gedo, "Autobiography," pp. 391–393.

15. Spector, "Delacroix," p. 52, has noted that in an essay on the art of Gros, Delacroix indicated that, like Gros, he had difficulty in regulating his life without external assistance. It is well to remember in this connection that Gros ended his life by suicide.

16. "Documentazione," p. 85.

17. For Redon, see "Documentazione," p. 86.

18. For the ancestry of Jason and Medea, consult O. Seyffert, *Dictionary of Classical Antiquities* (New York: Meridian, 1969).

19. *The Journal of Eugène Delacroix*, p. 495 and p. 697.

20. Spector, "Delacroix," p. 29, first noted this and quotes the relevant data from Piron, *Eugène Delacroix*, p. 411.

21. Ibid., pp. 45–46, quoted from the journal for August 19, 1854.

INDEX

●